The Naked Truth About Sex

The Naked Truth About Sex

A Guide to
**Intelligent Sexual Choices
for Teenagers
& Twentysomethings**

Dr. Roger W. Libby

Book design by Debbie Wells and Bonnie Lambert
Cover design by Simon Jones
Photography by Skye Peyton

ISBN 1-893910-38-5
Printed in Canada

Published by Freedom Press
1801 Chart Trail
Topanga, CA 90290

Bulk Orders Available: (800) 959-9797
E-mail: info@freedompressonline.com

**This work is dedicated to
The Next Sexual Revolution.**

Foreword

Finally—a comprehensive sex guide for teenagers and young adults that respects your rights and responsibilities, and the fact that most of you are sexually active but in dire need of complete, scientifically accurate information about sexuality! Books about sex for teenagers and young adults typically have been geared more toward parents than yourselves, and they also have unduly emphasized abstinence from healthy sexual experiences. Moreover, too many of these books have adhered to the outmoded, gender-based double standard, especially slighting the sexual choices and satisfaction of young women.

I share Dr. Roger Libby's belief that teenagers and young adults deserve factually accurate, comprehensive sex education in schools and elsewhere. Unfortunately, the U.S. Congress and President George W. Bush have channeled federal funding toward sex-negative and dangerous "abstinence-only" programs. These programs do not provide accurate information about contraception and other aspects of sexuality, including non-heterosexual sex. Too many of these curricula grossly exaggerate the extent of condom failure, hence deterring many young people who are sexually active from using condoms and thereby reducing the risks of unwanted pregnancy and sexually transmitted infections.

The Naked Truth About Sex helps fill a void that is created by the lack of sound high school sex-education programs. For many of you sexually active teenagers and college students who do not otherwise have enough information to make your sexual choices wisely, it can literally be a lifesaver. Building on the famous Kinsey studies and subsequent research, Dr. Libby shows that most graduating high school seniors have experienced sexual intercourse and oral sex. Despite the growing number of abstinence-only programs in schools, most of you will likely continue to pursue sexual experience before marriage.

As a board-certified sexologist with years of experience as a researcher, educator and therapist, Dr. Libby brings a wealth of knowledge and experience to this book. While it is based on serious scientific research, *The Naked Truth About Sex* is also written in a lively, engaging fashion, and it is playful too. It incorporates the same

combination of science, experience and entertainment that illuminated Dr. Libby's *Pleasure Dome* radio show (on which I was a guest, discussing the too-prevalent censorship of sex information and sexual expression).

As the Supreme Court has held, you have fundamental rights to make your own choices about matters concerning your own bodies, minds, health and sexuality, including whether to use contraception and whether to have abortions. Under the law, you are not merely creatures of either the state or your parents. To be sure, as the Supreme Court has recognized, parents have fundamental, constitutional rights to raise you, including the right to transmit their own values to you. However, once you reach a sufficient level of maturity, you have your own constitutional freedoms, which the Court also has protected.

While the Constitution does prescribe certain minimum-age thresholds for a few specified purposes—as a qualification to vote or to run for federal office—it does not prescribe any such minimum ages for exercising individual rights. Accordingly, as the Court declared, in a case that affirmed a minor's right to decide whether to have an abortion:

"Constitutional rights do not mature and come into being magically only when one attains the state-defined age of majority. Minors, as well as adults, are protected by the Constitution and possess constitutional rights."

Respecting your constitutional rights to make certain basic choices in the realm of sexuality, Dr. Libby's book provides vital information to assist you in making informed and responsible choices.

I fully agree with Dr. Libby that too many politicians are engaged in a "war against lust and women." The current crackdown on broadcast "indecency"—a vague, subjective concept—endangers any expression with any sexual content or even sexual connotation. It not only violates free-speech rights, but also deprives all of us of important information and ideas.

The casualties of this crackdown have included serious television programming about everything from breast cancer to lesbian sexuality, including material in PBS documentaries. Given the paucity of comprehensive, scientifically accurate sex education in our schools, one particularly lamentable aspect of this media censorship is that it

further denies vitally important information about sex-related topics to many of you.

As I stated in my book, *Defending Pornography: Free Speech, Sex, and the Fight for Women's Rights* (2000), "Women's rights are far more endangered by censoring sexual images than they are by the sexual images themselves." Neither sex nor sexually oriented expression is inherently dangerous for young females or males. To the contrary, sexual activity that is conducted without full information about such matters as contraception and prevention of sexually transmitted infections can indeed be dangerous for all of you.

Dr. Libby's strong emphasis on sexual responsibility, including his chapters on conducting pre-sex discussions and using effective birth control and methods to prevent sexually transmitted infections, are especially welcome contributions to your health and happiness. In sharp contrast to too much writing and teaching about sexuality that have suppressed essential information, *The Naked Truth About Sex* consistently focuses on increasing information. In that spirit, it includes many citations and "The Yellow Pages for Sex," an important resource to guide you toward further information available from books and web sites. "The Yellow Pages for Sex" will also help you to locate services concerning birth control, emergency contraception, sexually transmitted infections, and sexual abuse, as well as gay, lesbian, bisexual and questioning youth.

I am also delighted that *The Naked Truth About Sex* enthusiastically affirms the work of the ACLU and other organizations in countering the constant efforts to suppress sexually oriented expression and information. I am proud that, since the ACLU's founding in 1920, we always have championed young people's rights, as part of our signature mission to defend all fundamental freedoms for all people. In that spirit, I am grateful that *The Naked Truth About Sex* will enhance your exercise and enjoyment of some of the most significant of those rights.

– **Nadine Strossen**
 President, American Civil Liberties Union
 Professor of Law, New York Law School
 Author, *Defending Pornography: Free Speech, Sex,
 ***and the Fight for Women's Rights* (N.Y.U. Press, 2000)**

Acknowledgements

I thank all the caring, courageous and creative souls at Freedom Press in Topanga, California, who helped make **The Naked Truth About Sex** *a unique publishing effort. Publisher David Steinman and editors Kim Henderson and Jeanne Ringe were enthusiastic and insightful, and they were always there for me. Kim's content editing, suggestions and faithful support and enthusiasm always kept me on an even keel. I also thank Cassandra Glickman for her consistent, top-notch copyediting as well as Sheila Huettl and Jodey Brown for the assistance they provided.*

Publishing consultant Nigel Yorwerth helped determine the market. The cover design by Simon Jones sexed up the book. The design by Debbie Wells and Bonnie Lambert gave dimension to my words. Thank you to Jeannine Addams for all of her PR efforts that ensured the book's success.

I appreciate the love, time and support to burn the proverbial midnight oil from my wife, Barbara, and my children, Tim and Amy.

Reviews and comments from Dr. Doug Grier, Dr. Jim Rice, Dr. Lisa Conaghan, Dr. Roger Shelton, Alice Coad-Chapman, ARNP, and Merrily Wyman assured the medical accuracy of the STD and birth control chapters.

Additional insights, references and encouragement came from Librarian Jennie Correia, formerly with SIECUS and now with Planned Parenthood, ACLU President Nadine Strossen (who also wrote a wonderful foreword), Kinsey reports co-author Dr. Paul Gebhard, author Paul Joannides, Todd Klueger, Dick and Dona Gilmore, Dr. Robert and Jane Pickett, Dr. Ira and Harriet Reiss, Bill Farley at Playboy, *Kathy Wagstaff, Ralph Speas, Ron Mazur, Oxford University Professor John Wilson, Howie Ruppell and Ted McIlvenna at the Institute for the Advanced Study of Human Sexuality, Dr. Patricia Fawver, Dr. Paul Weikert, Mike Malloy and Kathy Bay, Emily Alexander, Randy Smyther, Dana Dean Doering, ARNP, Stefan Gilmore, Bob Perlman, Rebecca Levin at the Kaiser Family Foundation, Ann Rose, Jane Weaver, Health Editor, MSNBC.com, Rebecca Wittman, Managing Editor, Zogby International, Lauren Hoffman, and Dr. Judith Seifer.*

Adrian Zorrozua patiently helped me deal with computer problems and operator mistakes so I could sleep at night. Thank you also to attorney Judy Tabb for her legal expertise and support, Scarleteen.com creator Heather Corinna for her useful insights and support, and advertising writer Gary Towers.

I thank my co-host, Yvonne Monet, and my producer, Doug Harding, 99X and the Morning X, Jon Sinton, my avid listeners, callers and e-mail

correspondents for making my radio show, **The Pleasure Dome,** *a terrific success and a springboard for this book. I also appreciate the interaction I have had with college students who have heard my campus-wide presentations on sex and relationships. Thank you especially to the focus group participants: Anastacia Snyder, Susie Faist, Isaac Siegal, Emily Spoor, Jon Maus and Tarik Swift.*

It is time for this book to go to bed (with you)!

Roger Libby, Ph.D.
February, 2006

Table of Contents

Preface

This book is written for you. There are several books about teenage and young adult sex written for parents. This is not one of them. *The Naked Truth About Sex* is an honest book about your sexual pleasure.

Plenty of sexual information is included. This is a fairly sophisticated sex-positive guide—not a boring primer or textbook. My goal is to guide you toward healthy and responsible sexual choices with a positive and rational approach. This book is intended to balance the scales toward accurate, sex-positive information and commonsense advice.

I am a board-certified sexologist (sex educator, therapist and researcher) who disagrees with the "ignorance-is-bliss" and "just-say-no" abstinence-only approach to teenage and young adult sex and sex education. *The Naked Truth About Sex* includes questions from mostly 15- to 22-year-olds who listened to *The Pleasure Dome*, my Atlanta radio show, for three years on 99X—one of the largest alternative rock stations in the country.

You are the most sexual generation yet to be researched. In spite of claims that you are less sexual now than in the past (*The Real Truth About Teens and Sex* by Sabrina Weill, 2005), according to a national survey (2004) conducted by the Centers for Disease Control and Prevention in 2003, 61.6% of 12th grade students (62.3% of females and 60.7% of males) have experienced intercourse. Since this figure would undoubtedly be higher at graduation—about 70%, and higher yet—80-90%—at college graduation, sound information and advice are relevant and necessary.

Using data collected from 12,571 Americans, the National Center for Health Statistics found that over half of those 15 to 19 and about 70% of 18- and 19-year-olds have had oral sex, nearly all teenagers who report intercourse also experienced oral sex, 12% of males and 10% of females have had heterosexual oral sex but not vaginal intercourse, and about 20% of both sexes report heterosexual anal intercourse. Anal intercourse is more common for 22- to 24-year-olds, with 34% of males and 32% of females participating (Tamar Lewin, *New York Times*, 2005; Laura Sessions Stepp, Washingtonpost.com,

2005; National Center for Health Statistics, 2005).

How do you define sex? Sex is not limited to intercourse. Sex includes kissing, petting, dry humping, oral sex and more. Chicken parties (sex parties) focus on teenage girls performing oral sex on teenage boys. Some teenage and college women—and men—believe they are virgins even though they casually engage in oral sex—often with hook-ups, sex buddies or dates (see chapters 4 and 5). You are not abstaining from sex by avoiding intercourse when you enjoy making out, petting and oral sex!

I hope you are smart, responsible and safe about sex.

Intercourse is not the safest way to satisfy your desires. Even though I recommend that you wait until you graduate from high school to have intercourse, most of you aren't waiting. On a positive note, a government study shows that more teenagers put off intercourse until age 18 or 19, and a majority report using condoms (CDC, December 10, 2004).

Instead of worrying about getting pregnant, getting a sexually transmitted disease (STD) or getting hurt, why not take it a little slower and savor other erotic acts along the way? Rather than allowing fear to run your life—or throwing all restraint to the winds—why not use some common sense? Once you have more knowledge about emotional and relationship/boundary issues—and about STDs and contraception—it is safer to enjoy intercourse too.

To understand and enjoy sex, you need to talk openly about your feelings and desires. I urge you to figure out what is honest—and dishonest—about sex from teachers, professors, media, parents and friends. You are faced with a constant and often contradictory flow of so-called "facts" and sexual beliefs that range from repressive to liberating. As the following e-mail illustrates, your sex education has often been narrow and inaccurate:

"I have already been in Sex Ed. and I have learned nothing I did not already know. We spent all the time learning abstinence and diseases and no time on stuff we need to learn. Like if we do decide to have sex, we need to be sure we are ready and we need to know where we can get stuff to make sure we have 'safe sex.' Our teacher says there is no such thing. I have learned a lot from listening to your show. You are the only person most of us teenagers have that we can ask these questions. Neither my mom nor my dad

are comfortable discussing 'it' and I don't feel comfortable asking them questions."

Too many adults conclude that you can't have a mind of your own until you are an adult, but you have to think for yourself to make intelligent choices. You need information so you will make choices that are sensible, mutually desired and joyful.

Sadly, we have the most unwanted pregnancies and the most STDs—not just HIV—of any developed country. Why? Many adults have failed to guide you toward safe and responsible choices that minimize sexual dangers and maximize sexual pleasure. Adults are often too uptight and misinformed to help, but in the end only you can be accountable for your behavior.

When the government and many parents advocate abstinence, they usually mean you should abstain from intercourse and other intense sexual acts until marriage. Governmental attempts to require anti-pornography filters on library and school computers are prime examples of collective ignorance and political correctness inappropriately intended to keep you from being sexual.

In a futile attempt to eradicate non-marital sex, our government is trying to make pleasure frightening by denying truthful information about condoms and other ways to prevent unwanted pregnancy and STDs. This misguided, mean-spirited strategy features disinformation and restricts your access to birth control and abortion.

Unfortunately, the federal government distorts the proven effectiveness of condoms by limiting funding for sex education to abstinence-only school programs. Government web sites routinely fail to tell the truth about condoms. This is dangerous, unrealistic and unhealthy.

A national study which followed 12,000 teenagers for six years (Bearman and Bruckner, 2001) concluded that those—mainly younger teenagers—who pledged not to have intercourse before marriage delayed intercourse for 18 months, but when they broke their pledge, they were much less likely to use a condom than those who never made such a promise. Consistent with Britney Spears—a highly visible pop star and former poster child for abstinence—**88% of pledgers and 99% of non-pledgers reported they eventually had premarital intercourse** (Jason Straziuso, 2004). As Dr. Ira Reiss and Harriet Reiss (1997) correctly observe, "Vows of abstinence break far more easily than…condoms."

The same national study also revealed that teenagers pledging virginity until marriage are **more likely** to experience oral and anal sex than others who have not had intercourse. Pledgers were six times more likely to experience oral sex than those who remained abstinent from a pledge (*Bloomberg News*, 2005).

The Sexuality Information and Education Council of the United States (SIECUS) reviewed studies to conclude that abstinence-only "education" neither delays intercourse nor has a positive effect on sexual behavior. True believers for abstinence-only "education" cite their own inadequate studies as proof that their programs are effective, but no credible study has yet found that they delay first intercourse (SIECUS Fact Sheet, 2001).

By contrast, research shows that comprehensive sexuality education helps put off first intercourse and convinces you to use a condom when you choose intercourse (SIECUS Fact Sheet, 2001). One study found that safer-sex education was especially effective in reducing HIV sexual risk behaviors with sexually experienced African American teenagers, and may have more long-lasting effects on responsible sex than abstinence programs (John B. Jemmott III, et al., 1998). More education about sex, including information about birth control and STDs, leads to more enlightened and sensible sexual choices.

Some senators and representatives recognize the lack of balance by funding abstinence-only programs. Representative Barbara Lee (D-CA) and Senator Frank Lautenberg (D-NJ) are the first to introduce a bill that would provide $206 million a year to states for comprehensive, medically accurate and science-based sex education. The act is called The Responsible Education About Life Act (REAL).

The sex-has-to-be-a-problem approach is inaccurate and dishonest. Teenage and young adult sex is not a disease. It is **unbalanced** to emphasize the dangers of sex without acknowledging the pleasures! It is easier to be responsible if adults are open and honest. Too many parents, teachers, professors, government researchers and clergy obsess about sex as a "risk behavior" or view all non-marital sex as immoral. Sex is often thrown in with the risks of alcohol, drugs, violence and suicide.

There are potential risks, such as unplanned pregnancy, STDs and emotional and self-esteem concerns, but older adults rarely con-

sider the positive and pleasurable advantages of teenage and young adult sex. Parents usually mean well, but some don't know how to talk about sex without dictating what should and should not be done.

Communication is two-way. You can help your parents by initiating discussion with humor and forthrightness. You don't have to reveal every fantasy or your entire sexual history. If they press you for details, you can politely state that you are not comfortable turning a discussion into a confession. Hopefully, your parents will provide examples of their sexual choices to illustrate how they dealt with the same dilemmas.

It is also useful to converse with other trustworthy adults. Some of your friends' parents and your teachers and college professors may be good conversationalists. You need to do your part to open up communication. Don't be shy. Ask questions and discuss your feelings with those you trust to listen without expecting you to reveal your entire sexual journey. See Chapter 9 for more on how to talk with your parents.

Most of your parents and other adults define maturity and what is moral as conforming to their values. I disagree with them. Maturity is whatever works for you, as long as you are honest, responsible and sensitive. Maturity is a value judgment. **As citizens, you have a right to develop your own values.** Your parents are not you!

I encourage you to discuss all of this with your parents, but I emphasize conversation, not a lecture or confession. When older adults yell that you should be "sensible," they usually mean you should think about sex, but not act on your thoughts and fantasies. It isn't sensible or reasonable to repress normal desires and fantasies!

The Plan for This Book

Almost all of you worry whether you are **normal**. Sex is no exception. In **Chapter 1**, you will learn about the many definitions of normal and abnormal. You don't have to worry; your friends have the same insecurities. They fret about being accepted, having a bad reputation and being a good lover. Most of you are concerned about penis and breast size, body image, being sexy, overcoming shyness and the truth about sexual desire, arousal and orgasm. Once you read my answers to questions posed by others your age, you will learn to worry less and enjoy pleasure and friendships more.

I receive a gigantic volume of questions indicating absolute confusion about gay, lesbian, bisexual and heterosexual identities and behaviors. **Chapter 2** is devoted to discovering who you are and safely acting on your preference. My suggestions for a smoother journey toward self-knowledge, healthy self-esteem and awareness of erotic and emotional feelings will guide you to accept your sexual orientation—and to support those with a different preference.

I say preference, but none of us has a choice about whether we are gay, bisexual or straight. You can only choose how to express who you are. It takes some people years to figure out who they are. Relax and use this chapter as a basis for reflection and discussion.

Chapter 3 is a fun treatment of self-pleasuring, the most basic sexual activity. As a huge block of questions testifies, you are often worried, curious and excited about masturbation. Some of you have been inappropriately shamed into feeling guilty about pleasuring yourself by your parents and others. I encourage you to learn about your bodies by reveling in erotic fantasies and orgasms! Explicit sexual depictions on the Internet and erotic romance novels are candidly discussed. Questions concerning the normalcy and benefits of masturbation for both sexes are answered and common myths are exposed (no, it won't lead to mental degeneration or crossed eyes!).

As **Chapter 4** reveals, one of the most confusing and complicated topics is dating, hooking up, sexual friendships and variations of these sexual scripts for straights, gays, lesbians and bisexuals. Dating has a decidedly fuzzy etiquette. You have inherited a dysfunctional version of dating that promotes lying, cheating and manipulation. Early dating and sexual experimentation are usually experienced with little information or advice about the emotional part of being sexual.

There are few clear guidelines about what is proper and improper. It used to be that you dated around or you went steady. College students and other young adults have pioneered casual sexual encounters and relationships—hooking up and friends-with-benefits. These sexual choices are now common with high school students too.

If sheer lust is the only focus, ongoing friendships are difficult to maintain. If you prioritize both a caring friendship and sensual pleasure, a sexual friendship may prosper. Romance and love may become obvious even when you do not predict these intense feelings. You

will make fewer mistakes if you develop a game plan that makes sense. Whether you meet online, at a dance or through friends, communicate what you desire so you are on the same page with your lovers. Otherwise, someone is likely to get hurt or angry.

This chapter provides such an understanding. You may make different sexual choices with a new partner—and at various stages of your teenage and young adult years and beyond. Age differences, which person pays for a date and what is expected in return, as well as who initiates dates and sex are presented in a fresh light.

High school and college dances exhibit the uncertainty and inadequacies you feel about sex, love and dating. **Chapter 5** recognizes the lack of an agreed-upon sexual etiquette that makes it difficult to communicate your desires and expectations without being misunderstood or rejected.

You have unprecedented freedom to explore your sexual desires in your parents' home and your dorm or apartment. It is not surprising that much—perhaps most—sexual activity occurs in the home, whether it is empty at the time or not. The parked car is still a rite of passage for experimentation too. You are often confused about what it means to get on "first base" (usually kissing) and the next two bases, which are more ambiguous.

When are you no longer a virgin? When you have intercourse? Does oral sex count? Former President Clinton reinforced a false distinction between oral sex and intercourse, which allowed him to rationalize that he "did not have sex." This is similar to the mind games many of you play so you can enjoy sex and try to convince yourselves and others that you are still virgins! In this book, intercourse for those who are mature and beyond high school is viewed as a **gain in freedom**—not a loss of anything!

Safer sex is not just using a condom. Participating in a **Pre-Sex Discussion (PSD)** with potential lovers facilitates making good choices while lessening the odds of bad experiences. **Chapter 6** emphasizes your emotional and physical safety. Responsibility, honesty, openness, caring and getting beyond fear, including the fear of being hurt or abandoned from emotional vulnerability, are explained and advocated.

The emphasis is on how to conduct a PSD, and the importance of **continued open dialogue** with those you date or hook up

with. The many meanings and motives for sex, from love to lust, and each person's expectations and desires are openly examined. Sexual likes and dislikes, fantasies and playful eroticism should be part of ongoing conversations in a vibrant sexual friendship.

Sex must be clearly consensual. Mutual consent for specific sexual behaviors is more certain when you talk before you get aroused. The elements of mutual consent will be explored along with the erotic fruits of consent. My message: **If in doubt, don't do it!** Intercourse and oral sex can always wait–they will happen in time.

No treatment of sex is complete without addressing STDs, AIDS and unwanted pregnancies. **Chapter 7** explores safer sex, including proper condom use and other practical ways to prevent STDs. I include information about the most prevalent STDs–their symptoms, medical screening tests, how they are treated and where to go for help.

The effectiveness and side effects of birth control methods, including emergency contraception and drug-induced and surgical abortions, are presented in **Chapter 8**. A thorough understanding of STDs and birth control will give you confidence to deal sensibly with intercourse and oral sex when you choose these powerful sex acts. I recommend the combined use of condoms and the pill or another second method.

It is obvious that increased use of birth control–not less intercourse–is responsible for fewer unwanted pregnancies since the early 1990s. When emergency contraception is easier to get, the teenage and young adult pregnancy rate will decline even more. Research shows that the availability of emergency contraception does not increase the likelihood of unprotected intercourse.

My continued emphasis on conversations between your lovers, friends, brothers and sisters, parents, teachers, professors and other adults concludes in **Chapter 9**. I urge each of you to encourage your parents and other older adults to sit down and talk with you about this book. I want to help you bridge the trust gap between you and older adults.

I encourage schools to develop comprehensive, non-moralistic sex education–including parent education so parents will be more informed and open. My premise is that more information and better communication leads to more reasonable and fun sexual choices.

Suggestions are included to replace distorted thoughts with more rational and positive thoughts, including discussions of peer pressures, self-esteem and emotional and relationship/boundary concerns. Pleasure and intimacy are enhanced by equality, open and sensitive communication and by effectively dealing with emotional abuse and sexual aggression and force.

The dangers of censorship and abstinence "education" and the clear advantage of comprehensive sex education are presented. The cultural acceptance of violence and sexual repression are linked; my own cross-cultural research with university students shows that restraining sexual pleasure leads to more aggression and violence.

Insights for healthy, safe and fun sex culminate with my predictions about the future of sex with an eye to improving sexual intimacy. I close by advocating that you start The Next Sexual Revolution now!

Playful humor is crucial to open up lines of communication. If we are always serious about sex and love, we miss the rich possibilities for passion and fun. Sex is fun—and funny. The language we use to express ourselves needs to be positive and playful. Too many of the words we use are negative and fearful. We need to get beyond fear to make good choices as **responsible sexual enthusiasts!**

The Naked Truth About Sex ends with an appendix, The Yellow Pages for Sex, and References used to write the book. Selected books, Internet sites and professional groups that complement the sex-positive theme in this book are included to further your quest for sexual enlightenment. Resources and groups for gays, lesbians and bisexuals, and organizations and hotlines that provide much-needed information and referrals to deal constructively with STDs, birth control, sexual abuse, censorship, sex education, sex toys and specific sexual interests are included. Turn the page to learn what is normal about sex!

AM I NORMAL?
(Sex Doesn't Have to Be a Problem)

Hot and steamy. Parents are out for the evening. Nirvana is playing on the stereo and the bed is ready. Kissing, touching and opening the top button of her blouse. Sex. Not intercourse. Not oral sex. But sex, nevertheless. In passionate kissing, groping for a bra snap or fondling the hump beneath the blue jeans zipper. Grinding clothed bodies together in an orgasmic pitch of teenage ecstasy. Kissing and seeing where the first open button leads—warm lips and impatient fingers combine to raise the level of arousal. This is teenage sex before oral sex and intercourse become part of the picture. For most, making out and petting isn't a problem at all.

Does this sound familiar? Is what's happening to these teenagers normal? The answer is yes! Just say yes to sexual ecstasy! Responsible lust is healthy and normal—providing the driving force for honest affection and joy. Rather than labeling

lust a sin—or something to fear—you can benefit by encouraging this wonderful energy as a positive contribution to playful intimacy.

Your generation constantly asks me different versions of the same question: "Am I normal?" **Normal is whatever we define it to be.** Guys worry their penises aren't large enough and wonder whether they are skillful lovers. Girls obsess about their bodies, especially their breasts. They agonize that they aren't big enough.

They fret about getting a "bad reputation." The double standard that allows boys to have more sexual freedom than girls is losing power, but it still exists. It has never made any sense—let's get rid of it! The happiest people treat each other as equals—sex is no exception.

Some of you worry about what you perceive to be a sexual problem. Some guys think they are abnormal if they ejaculate quickly. Since so many are quick to ejaculate, this is a common and normal problem that can be solved.

If you are anxious about sex and relationships, you need to exchange negative thoughts for positive, rational and clear thoughts. It isn't healthy to have distorted thoughts about sex and relationships. If you try to read the minds of your dates and other friends and blame yourself or your partners when everything doesn't go as you expect—your thoughts are too rigid and unrealistic.

Other kinds of distorted thoughts include jumping to conclusions without evidence ("I just know she/he won't go out with me"), all-or-nothing thinking where everything is black and white (there are always shades of gray in between), and criticizing yourself or others with should statements ("You should have intercourse with me now") and should-not proclamations ("You should not date more than one person"). Once you get rid of distorted thoughts, your emotions, self-esteem and sex life will be more balanced and healthy (see chapters 5 and 9).

You may worry whether your fantasies are normal. Some wonder if it is OK to use explicit sexual materials to fantasize and masturbate—all normal. It is important to distinguish fantasy from reality. Most of you do. You enjoy fantasies to briefly escape boredom—or to energize your arousal and orgasms. Don't allow yourself to feel guilty about your fantasies! As long as you aren't hurting yourself or others, don't worry about being normal! Focus more on being happy, healthy and responsible.

Things could be worse—there used to be more sexual taboos. Oral sex, premarital intercourse, masturbation and homosexuality were all

much more stigmatized than they are today. America is still part puritan, but it has come a long way toward sexual sanity (see Chapter 9).

Even though there is more tolerance for sexual beliefs and behavior, what is normal is often what is **politically correct**. If we are political, we miss out on being unique and having fun.

Many define normal in terms of **what most people do**, or whether they consider a sexual act to be **moral**. This denies the importance of being true to yourself and making **your own choices** from a menu of options. We have different religious and political values—why should sex be an exception? The focus should be on decreasing distress and increasing a sense of healthy wellness. Why stigmatize someone else's choices?

Never give in to peer group pressures to be or not to be sexual. Real friends don't pressure you to be like they are—or like they want to be. Even if most of your friends are sexually active, you don't have to be active to be normal. It is normal to resist those who try to coerce you. I realize that most of you are pressured by your peer group to date by certain rules, or to hook up or abstain from all or some sex acts. Don't give in to manipulation and pressure—be your own person!

Others define normal by citing **sex laws**, but many laws are outmoded and rarely enforced.

Sex laws reflect what the most conventional element of society demands. Due to the lack of separation of church and state, oral sex and gay, lesbian and bisexual acts are still illegal in some states.

The age you can legally consent to intercourse varies by state; in some states, the age of consent is 16—in others it is 14 or 18. Statutory rape laws usually focus on men 17 or 18 and older who have intercourse with younger girls. Many states make a distinction according to the age difference—an adult in his 30s or 40s with a teenage girl is treated more harshly than an 18-year-old guy with a 16-year-old girl.

The flip side of what is normal is what is abnormal. **When does a behavior become abnormal?** If society's expectations are our guidelines for what is abnormal, then any form of sex can be labeled abnormal. Is sex abnormal when it upsets someone else? No! Is nonconformity abnormal? No!

The more a group feels the need to control sex, the more terms like "abnormal" reflect whatever sexual behavior they disapprove of

or are threatened by. Is it abnormal if a teenager violates the sexual expectations of parents or friends? No! **We all have to make our own sexual choices!** It is abnormal and unhealthy to repress natural sexual desires—or to impose your desires on anyone else.

Whatever your definition of normal, **it isn't normal to constantly make sex into a problem!** Negative labels, such as abnormal, sick, weird or sinful, can harm you more than the sex you experience. Sex can lead to self-knowledge and personal growth—part of being fully alive and joyful. It is normal to be excited by erotic feelings and to share your desires with those who feel the same way.

Both sexes are insecure about connecting with someone to date. You fret about asking someone out and whether you are a good flirt. You worry about being rejected, and you are anxious and depressed over whether you are accepted and liked by your peers. It is normal to be unique—it would be boring if we were all alike! Why worry? Everyone gets rejected sometime. Sometimes you run into someone you have a lot in common with and you click and become friends.

If you have **sexual chemistry**, you may hook up, become friends-with-benefits or date (see Chapter 4). Sexual chemistry is based on being attracted to another person's **smells**. The signals for smell are called **pheromones**. Mutual attraction is caused by the combination of pheromones, raging hormones and the magical power of hungry senses—all natural and normal.

Your body hair holds your totally unique scent. When the smell attraction is strong, it is usually mutual. Part of the smell turn-on is conscious—the rest is unconscious. Either way, you are left trying to explain why you occasionally feel a potent urge to make out, pet and devour each other out of irresistible lust. It would be chaos if every potential lover equally aroused you! Your looks, personality, sense of humor, interests and values are important too, but tantalizing smells spark animalistic lust.

It isn't normal to constantly make sex into a problem!

Animals have pheromones and so do you. Although the specifics of how human pheromones trigger lust are still a matter of scientific debate, the evidence is strong that your ravenous pheromones are

why you crave a specific lover. You aren't intensely drawn to most people—they don't have the scents that irresistibly draw you together like strong magnets ("I have a nose for you!").

Mutually agreed upon and responsible sex acts are normal, healthy and natural. Most of your sexual thoughts, feelings and behaviors are probably normal. Unlike most of Europe—which is much more sexually healthy—this country creates the illusion that erotic enjoyment should only occur among older adults, preferably in marriage.

This does **not** mean that 13-year-olds are ready for more than masturbation and light kissing. You will experiment more as you go through your teenage and young adult years. Don't rush ahead—move at a pace that will facilitate pleasurably learning about sex without undue hassles. Learning should be a **fun** part of growing up.

You can't get in touch with your sexuality if your sex education is distorted and limited. It makes no sense for older people to shame you into feeling guilty about sex. None of the moralistic sweep-sex-under-the-carpet nonsense shows any common sense, decency or a sense of class.

You are anxious about being normal because sex has for too long been a **dirty little secret** censored by adults and adult institutions. Abstinence-only "education" in the schools, some of your parents' lack of openness, computer blocking filters, false information about condom effectiveness on government web sites, and movie ratings that view sex and violence as equally bad for you are examples of unhealthy censorship. Your need for accurate sex information and advice makes you fear and obsess about what you don't know.

Mutually agreed upon and responsible sex acts are normal, healthy and natural.

As former U.S. Surgeon General Dr. Joycelyn Elders contends, "Treating sex as dangerous is dangerous in itself." It is dangerous for adults to censor sex information and to obsess about all the what-ifs. As a Planned Parenthood Fact Sheet concludes, "Abstinence-only programs force-feed students religious ideology that condemns homosexuality, masturbation, abortion, and contraception. In doing so, they endanger students' sexual health" (Planned Parenthood, "Abstinence-Only 'Sex' Education," 2004).

If your teachers, professors, parents, clergy and other adults are to be credible, they have to be honest about joy, adventure and intimacy. To be balanced, they also need to loosen up and be humorous about dating and sex.

The abstinence-from-all-sex edict promotes dishonesty and a lack of equality between the sexes. As sociologist Dr. Ira Reiss and Harriet Reiss (1997) contend, "Growing up sexually in America is like walking through a mine field, and few escape unscathed." Like myself, Dr. Reiss promotes **pluralism**—all young people can't be expected to make the same choices. Pluralism is at odds with the moralistic, all-teenagers-should-be-abstinent approach.

As Dr. Reiss points out, **Swedes try to prepare young people for sex, rather than trying to prevent them from enjoying it.** Swedes view teenage intercourse as a natural experience between equals. Unlike sex education in America, their K-12 sex education is sex-positive, objective and thorough. As a result, they have fewer unwanted pregnancies and STDs than American teenagers.

Finland's sex education is similar to that of Sweden—accurate, non-judgmental information helps Finnish teenagers make healthy choices. Finnish teenagers, on average, begin intercourse a year **later** than American teenagers. Instead of being preached to about sex, you deserve the honesty and openness of the Finns and Swedes.

It isn't normal to repress erotic desires. When our culture passes on distorted sexual expectations, you are forced to rethink them. You need to determine what sex **means** to you—and **why** you engage in various sex acts. As you will see in Chapter 4, you are constantly faced with competing sexual meanings and motives when you choose between dating one or more people, hooking up, friends-with-benefits and abstaining from some or all erotic acts. It is normal to express affection and love with sex. It is also normal to enjoy sex, because it's **fun**!

To develop a vibrant sense of yourself, you have to understand and accept your sexuality. To be mentally healthy, you need to feel positive about yourself. People with high self-esteem are more likely to make good choices—and to resist peer group pressures to conform to rigid and often inappropriate expectations. Your wellness depends on making choices that fit who you are and who you want to be.

British philosopher John Wilson (1965) observed that to many people, sex is an object to be preserved rather than a natural desire

to be expressed. We tend to barter sex for love—often for the **illusion** of love. In his book and in our discussions, John Wilson and I agree that we must explore and satisfy our desires, but we sometimes lack courage and we are bullied and beaten down by the battle. Some give in to sexually repressive thoughts and are intimidated by—and give in to—those who speak the loudest. Listen to your thoughts and dreams and be true to yourself!

Some of you struggle with the fear that you might not be normal and properly informed. I trust you will find my answers a refreshing contrast to the evasive approach taken by many adults and some people your age.

Some Answers to Your Questions About Being Normal

How Can I Have an Orgasm?

QUESTION: "I'm a teenage girl and I have never had an orgasm. Not with a guy, not even when I'm masturbating. It makes my boyfriend feel bad because he thinks he's not pleasing me. What should I do? It doesn't just affect him—it's also affecting me. I want to know why I can't have an orgasm. Please tell me what you think is wrong."

ANSWER: Relax. Your first orgasm should occur by yourself. You need to experiment further with self-pleasuring with your hands stimulating your clitoris—your pleasure button above your vagina inside your labia—while you fantasize about someone who turns you on. If you do aerobic exercise and free up your mind from negative thoughts, such as "I know I will never have an orgasm" or even, "Will I ever come?" you are more likely to have orgasms. It may not be easy to buy a vibrator as a teenager, but a good vibrator—preferably electrical rather than battery-operated—would probably stimulate your first orgasm (see chapters 3 and 5 and The Yellow Pages for Sex). Don't worry—you are normal.

 QUESTION: "I'm a female who is just becoming sexually active. How do I know if I am having an orgasm?"

ANSWER: If you experience a peak of pleasure after lots of heavy breathing and tantalizing movements—where you feel a release of tension and a sense of relaxation, even if only briefly—you probably have had an orgasm. Some females have one orgasm, while others have multiple orgasms. It is best to discover orgasm through mastur- bation and then tell your partners what you have learned about your arousal and orgasms so they can help stimulate your orgasms too.

QUESTION: "My girlfriend is here with me. She doesn't know if she is having orgasms. She says it feels good. She is 18 and she never masturbates. Do young girls have this problem often? Another thing is that she gets really dry often. Is there anything we could do to add moisture with- out using K-Y Jelly?"

ANSWER: If she doesn't know if she is having orgasms, she proba- bly isn't. It would help a lot for her to masturbate to orgasm. The dry- ness may be related to a lack of arousal and possibly to a hormone imbalance. If she is on the pill, she may need a different pill. Have her discuss this with a gynecologist or with a professional at Planned Parenthood. Finally, I recommend trying Astroglide® or K-Y® Jelly for manual stimulation and for any penetration. There is nothing wrong— and a lot right—about using additional lubrication when a girl does not lubricate well.

QUESTION: "My question is: Me and my girlfriend have a wonderful intimate life, but I feel that it can be so much better. The reason is that she is never able to have an orgasm. As far as I know, she has never had one. She comes close two

31

or three times every time we are intimate, but she says she just can't go through.

"She is from a very strict Catholic family, and I think that is part of the problem. I have tried and I still try to let her know that it is OK to let go, but I don't want to sound like I am pushing her. I was wondering if there is any educational literature I could buy for her so she can find out by herself without feeling that I am pressuring her?"

ANSWER: Your girlfriend needs to masturbate to orgasm. She may profit from reading Chapter 3 in this book and *For Yourself* by Dr. Lonnie Barbach—see The Yellow Pages for Sex. If she feels guilt about pleasure, which is common for those reared in strict religious traditions, she will have to get rid of negative, fearful thoughts. She should do the Mood Log exercises in *The Feeling Good Handbook* by Dr. David Burns (see Chapter 9). If she still cannot orgasm, she should see a sex therapist.

Types of Female Orgasm

QUESTION: "I was just pondering this the other day, and I think maybe I'm missing something: So, there are two types of orgasms? Clitoral and G-spot? How is the G-spot stimulated during intercourse? Is that another type or does it have to do with the clitoral orgasm? I was trying to figure this out, with no luck."

ANSWER: There are actually three types of orgasms: clitoral, G-spot and blended, where both the clitoris and G-spot (two-thirds up the front wall of the vagina) are stimulated simultaneously. There are nerves connecting the clitoris and the G-spot, allowing for cross-activation of these two eager pleasure centers.

Intercourse can stimulate the clitoris from the pubic bone rubbing against the clitoris, and depending on the position of intercourse and the condition of the vaginal muscles, the G-spot may also be incited. During oral sex, the clitoris is stimulated, and if a finger or two is inserted in the vagina to massage the G-spot, a blended orgasm with a G-spot ejaculation of a clear liquid that is not urine (a "gusher") is quite possible.

> There are actually three types of orgasms: clitoral, G-spot and blended...

Penis Size

QUESTION: "I feel that I'm short, only six inches, and that is why I am asking: What is the best way to increase your penis length and thickness without any harm or side effects to the penis? If there are any side effects or harm, what are they?"

ANSWER: A six-inch penis is average to slightly above average. There is nothing you can do to safely enlarge your penis. Operations are expensive and dangerous and they often leave the penis more floppy and ugly, with unappealing ripples of skin resulting from the injection of fat cells. Who needs it? Your penis is just fine as it is. Enjoy it.

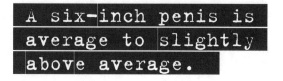

> A six-inch penis is average to slightly above average.

Breast Size, and Whether or Not to "Have Sex"

QUESTION: "I am a 13-year-old girl. I have been getting my period for about three weeks now, but I haven't grown in chest size at all. Is this normal? Also, I am together with this guy and I love him, but I was wondering if you thought it was a good idea to have sex with him. I mean, I don't know if I am ready yet. I think I am ready on some days, but on others I am not so sure."

ANSWER: You are too young to even **think** about having sexual intercourse. Forget it for now. You have plenty of time. As for your chest size, it may well become larger as you grow. You are just starting your period. You should not worry about this at all. Even if your breasts don't get larger, many guys prefer small, firm breasts to large breasts. Accept your body. Look in the mirror and see your beauty as you unfold over the years. You are like a flower beginning to bloom. Bloom with pleasure.

QUESTION: "Hello. I am a 15-year-old male. You present information in an appropriate, respectful way. What age do you think is an appropriate age to begin a sexual relationship? I know I am very young, but it's never too soon to plan my future."

ANSWER: I wish there were more accurate places to learn what you need to know to be responsible about sex. The schools are often moralistic and so are many parents. This wrong-headed approach often hurts teenagers, because you do not learn what you need to learn to be responsible and careful. I urge you to approach adults who seem helpful (see Chapter 9).

As for the age for anything beyond kissing and petting, people vary in maturity, but a ballpark figure would be 18 or 19 for intercourse. In some cases, an 18- or 19-year-old is not ready for intercourse—he/she may not know enough and may not be emotionally prepared to handle it yet.

Some are ready for petting and oral sex but not intercourse. A British government study concluded that teaching teenagers about oral sex cuts the rate of teenage pregnancy (Townsend, 2004). The results show you can learn to put off intercourse by accepting **"stopping points"** before intercourse. This study supports my approach—it is better to celebrate sexual pleasure short of actual intercourse than to abstain from all sex.

Almost no one abstains from all sex acts—kissing is intensely sexual. Those who are taught abstinence ("Just say no!") are more likely to get carried away, have intercourse, and end up with unwanted pregnancies and/or STDs as well as emotional traumas and premature marriages.

All of you don't need to put on the brakes with oral sex. Each of you will realize which stopping points and relationship boundaries make good sense. It is impractical to pin down exact stopping points for all of you. In spite of raging hormones—mainly testosterone for both sexes—you can learn to savor erotic gratification without rushing intercourse or oral sex before you are emotionally and physically prepared.

Trusted adults and friends can help you figure out which "stopping points" are realistic and appropriate. In the end, you must determine what is best **at your age and maturity level**. Some claim you cannot figure this out yourself, but who else is with you in the heat of passion except the other lover (unless you're alone at the time!)? You must calculate all of this with yourself—and with each lover.

You can learn to savor erotic gratification without rushing intercourse or oral sex before you are emotionally and physically prepared.

Overcoming Shyness

QUESTION: "I have a slight problem with girls. I always am somewhat afraid of girls. I never have the courage to ask a girl to go anywhere with me. I am not gay, but I relate well to guys. I always have this feeling that girls will reject me. It may be in part because when I was very young (second or third grade), I knew a girl who just broke my heart. Later in seventh or eighth grade when I dated a girl, people made fun of me.

"I am wondering if this is a purely emotional/mental problem? I have a school dance coming up and I want to go really bad, but I just can't get enough courage to ask anyone, because I fear rejection. If you could help me I would really appreciate it."

ANSWER: This is very typical for guys your age. It is too bad that girls expect boys to do all the initiating. It would be much more fun and more natural if girls would ask guys for a date or a dance rather than always waiting for the guy.

Go to a dance alone. You will have more fun dancing with different girls. Just ask them to dance and be playful and humorous. Use your imagination to converse with them. Once you do it, I bet you will find one or two girls to date. Maybe some girls will ask you to dance. You have to go to the dance for any of this to happen. Fear is irrational. You need to put fear behind you and go with the attitude that you will have fun and you probably will!

Shy About Kissing

QUESTION: "I am 15 and male. All of my friends have either kissed another person or have gotten further. They are

36

all bugging me about not kissing a girl.
I really want to, but for some reason I
can't. I have had four girlfriends. I am
pretty sure they have all kissed others,
but when I went out with them they didn't
seem like they wanted to kiss me. When
we broke up they said it was because I
wouldn't kiss them. Is there anything wrong
with me? What can I do to improve my rela-
tionships with girls? Thanks, A SHY GUY."

ANSWER: I wouldn't worry about kissing a girl. You will kiss plenty in time. There is no hurry. Don't worry about what others say to you. You have to be your own person. Just because you have had some awkwardness about kissing girls does not mean you will continue to be uncomfortable.

To say that girls "broke up" with you because you didn't kiss them is absolutely ridiculous. You aren't going steady just because you date someone. **Let go of the idea that you have to be a couple to date someone.** Be a single guy who enjoys dating several girls. Eventually you will develop friendships with a few girls, and then you will feel more comfortable kissing them.

Let go of the idea that you have to be a couple to date someone.

Penis Curvature

QUESTION: "I am 16. I have a question
about my penis. See, whenever I get
an erection, my penis curves off to the
right. I was wondering if this is normal
or should I see a doctor or something?
When I am soft, there is no sign of it
going off to the right, but then when I

get an erection, it goes off to the right. I read that it is normal and that it is no big deal, and the author said that sometimes it even benefits the girl because when you have intercourse, it might hit the G-spot. Any information will be gladly accepted."

ANSWER: Some curvature is normal. If your penis curves more than you are comfortable with, you may have Peyronie's disease, which is a buildup of plaque in your penile veins. You can try taking some vitamin E and PABA from a health food store. Take up to 400 IUs of E and three or four PABA a day. After a couple of months, your penis may straighten out some. If it does not, consult a urologist.

A Frowning Penis, and How to Tell If a Friend Is Gay

QUESTION: "I'm only 16, so I don't know a lot about sex. I have a few questions. I noticed that when I had a friend over one night, and he wanted to watch some pornography, that when he got erect his penis went up to meet his stomach. When I get erect my penis goes down like a frown. It still gets hard, but I was just wondering if that was normal for my age or for anyone.

"And second, I've noticed I like to be around this guy a lot. I don't think I'm gay, because I have a girlfriend. He's funny and he's just a ball to be around. My friend says that he is gay and that he likes me for more than a friend. I don't think I have an attraction to this guy. I

just love to be around him. Is that normal?

"There is only one thing that bothers me. When I'm around him, he is always staring at my forearms or my crotch. He also got erect when I asked him if he wanted to go skinny dipping, because a couple of us were going to go skinny dipping in this guy's pool as a joke. It wasn't my idea. I don't know what to do about the situation. Please help me if you can."

ANSWER: First, your downward erection could be affected by the relative size of your underlying penis in relation to the skin covering your penis. I am not certain why your erection is pointing down. You may not be getting fully aroused. I wonder if your erection is like this when you masturbate? As long as you can get fully erect, I don't think you have anything to be concerned about. If you want to feel more comfortable with your penis, consult a urologist about it.

Second, your male friend is probably gay or bisexual. He obviously is attracted to you. Since you do not feel an attraction for him, it is best to avoid getting aroused and watching pornography together. This puts you in an awkward situation. It is normal to enjoy a guy's friendship, and if you were bisexual or gay, it would be normal to be attracted to a guy too. If he persists in wanting to be nude with you and stares at you, make it clear you are not interested in having sex with him even though you like him as a friend.

QUESTION: "I am 17 years old. My penis arches 30 degrees upwards. I wanted to know if this is normal, if girls will care, and if it will affect my sexual experience when I get older. Plus, I have a friend who will give me head (just for the feelings, not gay relations). Is this OK at my age, or should I stop? Does this mean I have lost my virginity? I am not gay."

39

ANSWER: The penis usually arches up when erect at a 45-degree angle, but 30 degrees should not be a problem. If your male friend gives you oral sex, you are experimenting with gay behavior. I don't know if you are gay or bisexual yet, as you are so young. You will know in time (see Chapter 2).

Virginity is a subjective state. Most people equate having sexual intercourse with "losing" virginity, but this is silly! Having any kind of sex is not a loss. It is a **gain of freedom** as long as you are old enough to handle it (see Chapter 5). Former President Bill Clinton may disagree, but having oral sex is having sex. Intercourse is not all there is to sex. You are not a virgin in my book.

Erections at School

QUESTION: "I'm a 17-year-old male and just recently I've been having a problem. I'll be somewhere (mainly in school) and for no reason, I'll get an erection. It's not because I'm thinking sexual thoughts or fantasizing about something, because it has happened while I'm reading, taking a test or eating lunch. This has just started happening recently. Even though I don't think anyone notices, it's embarrassing. Do you know why this could be happening and what I could do to control it? I have perfect health and I am very athletic."

ANSWER: It is totally normal to get erect when your hormones and blood flow are raging from being in great shape from exercise, and sleeping and eating well. Girls experience similar arousal, sometimes with orgasm, at school and other places. You don't have to consciously fantasize about the girl with a great body near you. Sometimes your subconscious takes care of it for you. Whether during sleep or while awake in school, your penis will sometimes become alert and hard. Wear a loose shirt and don't tuck it in, and no one will notice.

Pain from Arousal

QUESTION: "Sometimes when I am out with my girlfriend and we start fooling around, I get an erection and it stays that way for the whole time that we fool around. Then I get these cramp-like pains in my testicles and it feels horrible. What can I do to prevent this?"

ANSWER: Any pain associated with prolonged arousal is due to an engorgement of blood (vasocongestion), which becomes painful if you don't ejaculate. In common language, this is called "blue balls." You need to masturbate to relieve the pressure. Depending on how comfortable you and your girlfriend are with each other, you could also have her stimulate you to ejaculation. Either way, the pain will go away.

Circumcision and Growth of the Penis

QUESTION: "I am not circumcised. Does this affect the growth of the penis? Are there any advantages from not being circumcised? Also, as you get older, does the foreskin go away if the penis gets bigger?"

ANSWER: Circumcision does not affect the growth of your penis. The foreskin does not go away no matter how big the penis becomes. There are advantages to not being circumcised—the skin that is cut off is very sensitive with nerve endings, adding to pleasure for the uncircumcised male. The foreskin is also functional in keeping the head of the penis moist. It is important to wash behind the foreskin so there are no bacteria lurking behind it.

Although the decision is not easy, the advantages of **not** being circumcised may outweigh any known advantages. Originally, circumcision was intended to stop masturbation, but this is pure folly because guys masturbate whether or not they have a foreskin. Unfortunately, infants do not have a choice about this painful procedure.

The First Time

QUESTION: "I'm a 22-year-old woman and I wonder if my first intercourse reflects the experiences of many women. I was 17 and the sex was good. It was fun even though it hurt a little. I didn't have an orgasm from intercourse, but I did from his giving me wonderful oral sex. The guy was very caring and we are still sex buddies. I have girlfriends that say their first time was one they would rather forget. I don't feel this way at all. I've had great safer sex with the first guy—better over time—and with other guys over the last five years. I'm open and honest and I require the same from any guy I enjoy sex with."

ANSWER: You are a sexual success story! Your honesty and openness are the key to your wonderful lock on pleasure. You are admirable for your relative ease as a young woman who enjoys men and who enjoyed intercourse from the first time on. Your story is a model for other women to follow. They can decide whether to have one or more lovers, but either way the sex-positive enthusiasm you exude is what our society needs to support!

Parents Finding Out About Having Sex

QUESTION: "Hi. My folks just found out that I have had intercourse. My mother told me I was a whore for doing this. Am I, since I am only 15? Please help me."

ANSWER: You are definitely not a whore. You have used bad judgment to have intercourse at your age. Don't do it again until you are

older, preferably at least 18 or 19. Unlike your mother, I don't see this largely as a moral issue, but rather one of using some common sense.

You could get yourself in big trouble—you are not emotionally ready for intercourse. You could get pregnant and you could contract STDs. When you are older, you will be able to minimize these risks. You are sexual, but intercourse is not the only sexual act. For now, I would limit intimate contact to making out and light petting.

Dating, Age Differences and Obsessive Behavior

QUESTION: "My brother is almost 18 and he's absolutely in love with a friend of mine (age 15). She doesn't like him back in that sort of way, but they're still friends. He constantly talks about her, and it's really pathetic.

"Also, I have another dilemma. A friend of mine who's soon to be 22 has a big crush on me and I'm seven years younger than him. I like him back a little, but I really don't know what I should do because if my parents ever found out that he likes me, they'd probably kill him. Could you please give me advice on these two things?"

ANSWER: Your brother is almost too old for your friend and he is obsessed with her in a very unhealthy way. This will drive her away. He needs to strengthen his self-esteem so he does not have to get a response from her to be confident. Tell him to stop focusing so much on her.

As for the 22-year-old guy, I would stay **far** away from him. This is not just an issue of what your parents would say or do. He is an adult who is interested in a young, less mature, teenage girl. He could well be exploitative and manipulative. At the least he is immature and possibly unaware that a 15-year-old girl is not ready for an intimate relationship with him.

It would not be a problem if you were 25 and he were 32, but age differences matter more when you are a young teenager. Depending on which state you live in, he could be legally charged with statutory rape if he has intercourse with a girl below that state's age of consent. See Chapter 4 for more insights about age differences.

How to Have a Stronger Sex Drive

QUESTION: "What can I do to make my sex drive and my arousal better? Does working out make it stronger?"

ANSWER: If you exercise daily, your energy—including your sexual energy—will be stronger. You also must **refrain from smoking**—nicotine restricts blood flow, making it impossible to be as aroused as a non-smoker. In addition, eat a healthy low-fat diet with fresh vegetables, sufficient protein and fruit and grains and get plenty of sleep. Keep caffeine intake low and pass up most fast foods.

Avoid alcohol–which affects full arousal and vibrant fantasies by numbing the brain. Also, heavy, long-term marijuana use lowers testosterone–especially in men–which may eventually lower sexual desire. Finally, a mind free of guilty feelings, inhibitions and emotional stress is a mind ready to fantasize and orchestrate ecstatic orgasms. Your mind is your main sex organ!

Spots on the Penis

QUESTION: "I have a question and I am very uncomfortable about this. I am only 16 and don't like talking to my parents or anyone about this. I have yellow spots on my penis. I had this problem a year ago and it went away, but now it has come back, and it's more than last time. There

are about six spots below the head. What
can I do without telling my parents?"

ANSWER: It is appropriate to approach your parents with health
questions. Just because your penis has spots does not indicate that
you have been sexually active. It sounds like you have a skin infec-
tion of some kind. You should see your family doctor or a dermatolo-
gist. At your age, you probably can't afford to go to a doctor without
your parents helping you. County and city health departments deal
with sexually transmitted diseases (STDs). They might also help you
eradicate your yellow spots.

The range of topics covered in this chapter is just a beginning.
In the next chapter, you will learn about the normalcy of being fully or
partially attracted to one or both sexes.

Avoid alcohol—which affects
full arousal and vibrant
fantasies by numbing the brain.
Also, heavy, long-term
marijuana use lowers
testosterone—especially in
men—which may eventually lower
sexual desire.

2

DISCOVERING WHO YOU ARE:
Gay, Lesbian, Bisexual and Heterosexual Preferences

"I am a 16-year-old male student in a suburban high school. I have always been confused about my sexuality, and at times this has forced me into great periods of depression and subsequent suicide attempts. Last year when I decided to be honest about my sexuality, I came under great scrutiny from the student body at my high school. Many of my friends began avoiding me, while other groups of students made threats and even threw food at me in the lunch line like I was an animal.

"At times I feel as though my situation will never get better—that I will always be terrorized and harassed by my peers. Over the past year I have realized that being honest about my sexuality may indeed strike discord with close-minded individuals. Moreover, it makes me a bolder person with a stronger sense of myself, and most importantly, someone who can finally say that they are happy.

"It truly is unfortunate that we as a society cannot accept the fact that people different from ourselves exist beyond the realm of our own ignorance."

This thoughtful guy has learned much about himself from painful experiences and from self-reflection. Gaining self-understanding and self-esteem is a huge part of accepting and loving yourself. Gays, lesbians and bisexuals may have a more difficult journey, but all people should be caring and encourage them to be proud of their sexual orientation—which is normal for them.

A day does not go by without negative comments about anyone who is not 100% heterosexual—usually by those who are **homophobic**, who express compulsive intolerance and hatred for gays because they fear that they too could be gay. No one should use disparaging labels that put down those who are different. Secure, healthy people do not put down others for being different—they do not worry what others will say if they affirm gays, lesbians and bisexuals.

Examples of discriminatory attitudes are found in the media, religion and law. Unfortunately, some religions view gays and lesbians as sinners. Laws still reflect discrimination through marriage, housing, child custody, adoption, medical insurance and employment. The media often adversely label anyone who is different. Minorities have experienced these injustices for years.

Homophobia sometimes causes violence—gay bashing and even murder are not uncommon in a society that discriminates against homosexuals. Newspapers report some of the most blatant examples of homophobic violence, but many incidents are never revealed in the media or the courts. Partly because of the anti-gay nature of society, **Gay Pride Marches are good** and necessary to create support in a celebratory atmosphere. The gay and lesbian rights movement provides education, political support and comfort. Same-sex couples have just as much of a right—not just a privilege—to love each other as other-sex (some use "opposite sex," but we aren't really polar opposites) couples do. We all have similar emotional and sexual needs to be free, loving and loved.

Most of you are heterosexual, but this does not mean you are superior or more normal than those who are gay, lesbian or bisexual—normal for 2-10% of Americans; 11.5% of women and 6.2% of men 18 to 44 report some same-sex sexual contact in 2002, compared with 4% of women and 4.9% of men in a similar 1992 survey (Associated Press,

MSNBC, September 15, 2005; Tamar Lewin, *New York Times*, 2005).

Your sexual preference is not a choice, and it may change over a lifetime. Sometimes it takes years to realize your sexual orientation. About 2% of females identify as bisexual (National Center for Health Statistics, 2005).

Some people falsely assume they are whatever their peer group pressures them to be. The best scientific evidence argues that sexual preference is directly linked to genetic programming. Like personality, it is part of our hardwiring.

Some scientists believe early family interaction can also affect sexual orientation, but either way, **no one can simply decide to change their preference**. Even sex therapy cannot change which sex turns you on. You can only choose a lifestyle that expresses who you really are—from abstinence from all or some sexual acts to being sexual with one or more lovers.

Many of the questions and comments in this chapter express confusion about a person's sexual identity—partly the result of a lack of openness and acceptance for gays and lesbians. You may still be discovering your sexual preference—this is OK. Your sexual journey may include some fantasies and experimentation with your own sex. This is normal.

Homosexuality is a complicated subject. Your sexual identity is a mix of your desires, fantasies and behavior. Being gay, lesbian, bisexual or heterosexual is a state of mind as much as actual sexual behavior. Confusion about your sexual preference arises from trying to put your-self and others in neat pigeonholes—to classify everything as extremes or opposites.

Having a few fantasies about sex with the same sex may indicate some willingness to experiment, but this does not mean you are homo-sexual. Unless you act on your fantasies with some regularity, it would be difficult to pin down your sexual preference for your entire life.

It does **not** mean you are gay if you wish you were the other sex. Most of you don't wish you were the other sex, but some feel they are trapped in the wrong body. A few **transsexuals**—more men than women—actually have genital operations and hormone treatments as adults to change their gender. I mention this to inform you about **transgendered** people who identify with the other sex.

There is much ado about little when it comes to the controversy about homosexuality. It is a myth that being around gay teachers or other gay people will make you gay. Sometimes you have to experiment with the same sex to figure out who you are. This does not mean everyone should experiment with the same sex. Nor does it mean oral sex and intercourse are the only gay and lesbian sex acts. Kissing, making out and dry humping are safe sexual behaviors for gay and lesbian teenagers, just as they are for straight teenagers.

Sometimes sexual orientation is confused with sexual politics—especially the false notion that women who support feminism must choose women as sex partners. Never succumb to pressure. Learn to be comfortable with yourself. Finding yourself may take awhile. Don't worry about it.

How you feel and act is what counts. What others think is not nearly as important as what you think and feel. Some of you are **in the closet** as gay, lesbian or bisexual. I understand why you choose to keep your sexual identity secret—except to a few friends and/or parents. **It is best to come out only when you are in a supportive environment.** Such loving affirmation may not occur until after high school, but those of you who are not straight will find it if you look in the right places.

Heterosexual readers can offer friendly encouragement to those who believe they may be—or are—gay, lesbian or bisexual. Loving someone who is lesbian or gay requires that you learn about these sexual preferences. All people need love. Similar relationship and sexual issues concern your gay friends as much as they affect you.

Most cities have teenage discussion groups that help clarify your sexual preference. These groups are organized by gay and lesbian groups and by a variety of community organizations. Unfortunately, such groups are harder to find in most small towns.

As long as you are selective, the Internet is a valuable resource for information. Those who don't have the opportunity to join discussion groups, and who do not have good bookstores nearby, can profit from informative web sites and chat rooms—**see The Yellow Pages for Sex**. No teenager should remain in the dark about their sexuality because they can't find accurate information and helpful feedback.

Gay and bisexual teenagers are more likely to be runaways or to commit suicide than straight teenagers. This underscores the impor-

tance of contact with healthy gay and straight role models who offer advice and encouragement for who you are. Once again, no one chooses to be straight, gay, lesbian or bisexual. Being homosexual offers some the chance to have satisfying relationships with the same sex. It is easier to live a good and intimate life if our society recognizes and approves of those who are attracted to their own sex.

In spite of some religious teachings, legal marriage between same-sex couples would be an appropriate and inevitable societal endorsement that would in no way detract from or hurt heterosexual marriage. The controversy will go on for years, but eventually lawmakers will rightly enact legislation that will give gays and lesbians the same rights heterosexuals take for granted. Same-sex couples deserve to be covered by a partner's health insurance and all of the other legal and social protections traditionally offered to straight married people.

Safer-sex practices, including the use of a condom for anal intercourse, and a **Pre-Sex Discussion** (see chapters 6 and 7) are crucial for gay and bisexual men. Being gay or bisexual is not a death sentence—it just means you need to be HIV conscious and doubly careful about any exchange of semen and blood.

Needle sharing among drug users and anal intercourse are primary ways to transmit AIDS. There remains much that is not known about the causes of AIDS. HIV is thought to be required for AIDS to develop, but the data are not all in. Future research is likely to shed more light on how AIDS is acquired and how it can be prevented and cured.

For now, sexually active teenagers and young adults should be tested for HIV, and all those who have vaginal or anal intercourse should consistently use condoms. It is also safer to use condoms during fellatio (oral sex on a male), as it is possible for HIV to be transmitted through fellatio if one or both lovers are HIV positive. It is far better to be safe than sorry.

Now for your questions—my answers will hopefully make for a smoother sexual journey toward increased self-awareness and self-acceptance no matter what your current sexual orientation may be. My goal is to provide insights and advice that will transform confusion, distorted thoughts and fear into clear thinking and a relaxed attitude so you can discover and celebrate your sexual preference.

Questions About Sexual Preference

So, You Are Confused About Your Sexual Preference?

QUESTION: "How do you know you are gay? I think I'm in love with a known lesbian. We haven't done anything, but we have great chemistry. We aren't dating. She is just a friend. I'm 19 years old, so I guess I'm a late bloomer."

ANSWER: You can have strong emotional feelings toward another woman and not necessarily be lesbian. If the chemistry you describe is sexual, there is a good chance you are bisexual or lesbian. Without knowing more about your dating and sexual history, it is difficult to say.

Since she is a known lesbian, you can feel comfortable asking her out or letting your interest be known. I would hope she would be open to whatever happens. You can't really predict how things will go until you get to know her better. Remember, a relationship is best when it is based on both friendship and attraction. No matter what happens, the sexual journey you are about to take will teach you much about who you are and who you want to become.

QUESTION: "I'm somewhat unsure of my sexuality because I am attracted to guys, although sometimes I find attraction to guys gross. I have almost no attraction towards women, so I'm pretty sure I'm not straight. I haven't had any sexual experience, just because it's hard to find a guy to play around with if you aren't out of the closet."

ANSWER: You probably are gay or bisexual. Since you have had no sexual experience, it is difficult to say. In time you will likely experiment with guys and perhaps with girls too. Your experiences will help you know more about who you are. You don't have to publicly come out to come on to a man who appeals to you. You should get to know him in other ways before you expose your secret to him. Since you value your privacy, make sure anyone you tell about your desires respects your wishes.

QUESTION: "The boarding school I went to was an all-girls school and there were lots of lesbians. I'm not homophobic, and I was a friend to all of them, but I was wondering if I too could be a lesbian or bisexual? I ask this not because I'm worried about it, but because I look at girls all the time, and think about how it would be to date a girl instead of guys. I love guys too. I love them more, I think. I'm not sure. I'm very confused about all of this. Can you help me?"

ANSWER: You appear to prefer guys. Your level of interest in girls has so far been curiosity more than actual experimentation. You may be bisexual or heterosexual. You will find out after acting on some of your desires and fantasies and reflecting on how you feel during and after these experiences. You can care for or love a person of the same sex without necessarily being bisexual or lesbian.

QUESTION: "I am 15, and I have very, very strong crushes on my friends who are also female. I have all kinds of fantasies about them. I have had a sexual experience with my best friend once, and that is the only homosexual thing that has ever happened to me. I enjoyed it and got very aroused. Am I gay? Are these feelings

normal? Is it just a phase? Should I tell my friends who turn me on? I need help."

ANSWER: Relax. You are 15. You have experimented with one girl and found it enjoyable. You may be bisexual or lesbian, but it is too early to know whether you prefer girls or boys. You should cautiously explore your desires with some common sense.

Do not come on to every female friend you are attracted to—you could lose some good friends. Some would understand and others would not. A safe way to see if a friend is interested is to say something in passing in a light way about same-sex attractions without saying it is you who has this interest. If the friend responds favorably, you can explain your interest.

QUESTION: "I am 16 years old and a virgin. I recently have been interested in girls and I guess I am just curious. I have never been with a girl before. It's always just been boyfriends. Well, I was wondering if there is a special hotline I could call that would be free for bi-curious or bisexual people, especially teenagers. This is the only way I could explore my curiosity right now. Is there any other way I could get in touch with other bisexual or bi-curious females?"

ANSWER: In most large cities there are discussion groups that explore bisexuality and sexual preference. Some are sponsored by gay and lesbian centers, and others are organized by schools or colleges and by other social organizations. The best way to find them is to call some of the listed gay, lesbian and bisexual groups. For hotlines and Internet sites, see The Yellow Pages for Sex.

QUESTION: "Sometimes I masturbate about having gay sex. I am 17 and I know I am not gay. Do you think this could just be my

hormones acting weird? Do you think any friends of mine might be doing the same thing?"

ANSWER: Masturbating while fantasizing about the same sex does not necessarily mean you are gay. Some guys have fantasies about other guys. Over fifty years ago, the extensive and pioneering Kinsey studies revealed that over a third of males have such fantasies by age 40. Fantasies are harmless. You are young. Sexual attraction varies according to lots of things, but hormones do not make you more attracted to either sex.

Sexual preference is mostly—if not entirely—genetic. There is much we don't know about why some people are straight and others are bisexual, gay or lesbian. **We don't have a choice about our sexual preference.** We can only choose how to act on our feelings and desires. Act on them responsibly and carefully!

QUESTION: "I am 16 years old in high school. I recently moved to Georgia and many changes have taken place in my life. My biggest concern is my sexuality. I have always, since I was about 11, been very interested in guys. I was always much more mature and further ahead than many of my friends.

"I went to New York for the summer to be with my family and friends. While I was there I was very serious with a guy. When I came back to Georgia, I started school again and I met somebody that had such an effect on my whole body and spirit. It was unbelievable. But, the problem is that it was a girl. It has utterly amazed me that I had this much emotion for her and never even spoke to her. Do you think these emotions are normal or just a phase?"

ANSWER: You appear to be primarily attracted to men, but emotionally you have an attraction for at least one girl. Teenagers and adults go through phases—this is normal. It is not easy to predict

where you will end up. Sometimes phases pass into other phases. You could end up with a bisexual identity with a preference for either sex. Or, you could end up gay or straight. I say "end up," but sexual preference can change later in life too. Some people don't discover that they are gay until they are adults. I know of one gay professor who did not discover his sexual identity until he divorced at age 49! This is nothing to worry about.

QUESTION: "I'm an 18-year-old male. I haven't had intercourse, and I don't plan to soon. I am strongly attracted to girls, like every guy, but I have this thing about anal sex. When I masturbate, I'm aroused more by thinking about anal sex than vaginal sex. Also, sometimes I have an attraction to guys and I want to have my own anus penetrated or give oral sex. I was wondering if this makes me a bisexual."

ANSWER: Not every guy is attracted to females, but most are. It's not a fetish to fantasize about anal sex. Masturbation is normal, whether the anus and/or the vagina is involved (see the next chapter). Anal sex fantasies are not limited to same-sex attractions. Some heterosexuals experience anal sex fantasies and sometimes engage in anal intercourse. Your same-sex fantasies do not necessarily make you bisexual, although you may eventually find that you are bisexual. You may also find out that you are gay or straight.

QUESTION: "I have a question about being bisexual or gay. I am a 20-year-old female who is happy with my male sex partners, but I fear that I might want more. How should I go about finding this answer?"

ANSWER: You might want a lot of things. You are normally curious about your sexual preference and your sexual desires. Why fear same-sex attraction? You enjoy men sexually and you may find that you also enjoy women. Or, you might experiment with women and

find that you really prefer men. There is nothing that says you can't celebrate sexual pleasure with both sexes. See what makes you most comfortable during and after experiences with both sexes.

How to Approach Others
Who May or May Not Be Gay

QUESTION: "Please help me! I have a friend who is gay! I want him to be straight. He is the perfect guy for me! My parents love him and he's wonderful to me! Some say I'm slowly but surely changing him. Do you think that this is true? Can someone change like that? He really doesn't act gay, and he is wonderful. Please help me! I want him so bad. He even told me that if he were straight he would go out with me!"

ANSWER: Keep him as a friend. If he seems attracted to you, you might go out with him. If he is gay, you can't change him. No way. A therapist cannot change him, either. No one can. He may be confused and he may eventually discover he is gay, bisexual or even heterosexual. Being wonderful is not limited to heterosexuals. There are many gay, lesbian and bisexual teenagers who are very nice, decent and interesting. Gays don't all act alike. Neither do heterosexuals. Perhaps you can help your friends celebrate differences.

QUESTION: "I have been in love with my friend for a year. My other friends try to convince me it's just an infatuation, but I am sure it is not. He arouses so many feelings in me, but the bad part is I am a guy also. He is amazing and I love him so much. He is extremely affectionate with me (he fed me cake once!!), but I am sure he is not gay.

"Unfortunately, he is extremely homo-phobic. Lately, he has been talking about girls and how beautiful they are. And it bothers me so much. Should I quit hanging out with him and pursue a more plausible relationship? Should I tell him my feel-ings so he will quit talking to me? We've been friends for so long, and I don't want to lose him. It hurts me so much to hear him talk about girls. What can I do?"

ANSWER: You can be in love with someone who does not feel the same way. If your friend is truly straight, he can love you as a friend, but not sexually. Cherish your friendship. If he reciprocates your attraction, you could consider developing a sexual relationship. Do not come on to him unless you have evidence of his attraction to you, which so far has not occurred.

You can feed someone, hug them and love them without the feel-ing being sexual for both people. You can keep him as a friend and also keep your eyes peeled for a guy who is gay or bisexual. I would not tell him about your attraction without some evidence that the attraction is mutual. He might freak out and withdraw from you. There is no need for you to lose him as a friend.

If he is straight or bisexual, and if he likes girls, you cannot change him. His homophobia may come from confusion about his sexual orientation, or he may be purposefully displaying homophobia to you because he senses you want a gay relationship and he does not. Once again, **most people who are homophobic fear that they themselves are gay, lesbian or bisexual**. They may fear that associating with gays and lesbians will make others think that they are gay or lesbian. This is ridiculous, but destructive rumors can spread. Our society has still not fully accepted those who are not 100% hetero-sexual—this acceptance will come in time.

Most people who are homophobic fear that they themselves are gay, lesbian or bisexual.

QUESTION: "I'm a 21-year-old guy and I'm bi. I've had sex with a guy, but not a girl. I'm totally 'in love' with this guy and he says he has feelings for me, but he doesn't know what they are. What should I do?"

ANSWER: You may have sexual feelings for both sexes, which according to Woody Allen, doubles your chances for a date on Saturday night! Or, you may be gay. Either way, you are in love with a guy who is a bit confused about his feelings for you. This may be because he is not sure whether he is gay or bi. It may also be due to his lack of clarity about his attraction to you. You should relax and let him take his time before you make any definite overtures. Sex and love come in time when both people are ready for it.

QUESTION: "I have this friend who is bisexual, but he doesn't know that I know he is bi. Should I talk to him about it or just let it pass? Would he be offended if I talked to him about it? I know that he is trying to hit on me because he is always touching me and I don't feel comfortable, but I know it would hurt him if I told him that I am not bisexual. What should I do?"

ANSWER: How do you know your friend is bisexual? I would not discuss his sexual orientation unless you get clear cues that he wants to discuss it—or if his touching you makes you uncomfortable. If he really is trying to "hit on" you (what a terrible term—it implies forcing yourself on another!), you may want to mention that you are uncomfortable with the way he touches you. You might tell him that you are straight, but you really like him as a friend.

58

Coming Out, Coping, and "Changing Yourself" in a Homophobic World

QUESTION: "I'm a 17-year-old girl. I've known that I've been bi for at least a year now. I guess I'm not the first to say this, but being a gay/bi teen really sucks. I haven't been able to meet any girls that are the same as me. The only lesbian in our school is also a chronic liar and her presence bothers me. I really don't know what to do. I haven't really told many people because of my fear of rejection.

"Recently I met Jane. She's just as confused as I am and she's gay or has some psychological problems. She has problems with intimacy with her boyfriend. Any physical contact turns her off. That leads me to believe that she's gay. But when I asked her, she said she wasn't. Same thing I always say when people ask me. I want to give her some advice. I am literally her only female friend. I also am developing a slight crush, to make matters worse.

"Do I sound like a teen magazine yet? I don't know anyone to ask about advice on this stuff, because she's only told me this. I also think the intimacy, kissing, sex, etc., was triggered by her parents' negative views on sex. Any help you could send me would be GREATLY appreciated."

ANSWER: Your dilemma is common. Teen magazines sometimes deal with this issue, but you don't need to be afraid of sounding like anyone else. I know that it is not easy being gay or lesbian, especially in a small town. Your friend could have an intimacy problem without being gay. She may be confused about her identity.

59

Unsolicited advice is probably not going to win you brownie points. You could attempt to broach the subject of sex. Mention intimacy and gay issues in passing to see how she reacts, but I definitely would not push advice or conversation.

Rumors are rampant in many high schools, so I would be very careful about discussing your dilemma. Only choose those you really trust to be confidential. Sometimes it is easier and more comfortable to discuss your concerns with those who do not attend your school.

QUESTION: "I am 22 and I am gay, but I am not really comfortable with the lifestyle. Is it logical to spend the rest of my life as a heterosexual, but still have homosexual feelings? I see no future with homosexuality. I am not denying it to myself. I have admitted it to my closest friend and to myself just recently. It's just that I am not a 'flaming queen.' Is it possible for my life to be complete without indulging in homosexual activities? Is this extreme denial?"

ANSWER: You say you are gay, but are not comfortable "with the lifestyle." How do you know you are gay? If you have not had any sexual experiences, it is possible that you don't **know** if you are gay or not. Gays and lesbians have futures just like anyone else. Some gays and lesbians are happy, while others are not. The same can be said of heterosexuals.

Being gay is not "a lifestyle." It is a sexual orientation with several lifestyle choices. Heterosexuals and bisexuals also choose from several lifestyles. **It is a choice to act on your desires in a specific way.** It is also a choice not to experiment sexually. If you are really gay, I doubt you will have a happy and complete life without eventually acting on your same-sex desires with someone you care for and are attracted to. You can learn to be comfortable about who you are and who you become.

It is a choice to act on your desires in a specific way.

QUESTION: "I'm a 21-year-old female and I have known I was lesbian for about two years. I want to come out to my parents. Any hints on how to do it?"

ANSWER: You have a common dilemma—how to come out to parents once you are reasonably sure you are gay, bisexual or lesbian. Some parents are more open about homosexuality than others. If your parents are generally approachable, it will be easier to tell them. You could simply sit them down and tell them and see how they react. Or you could tell the parent you feel closest to first—then tell the other parent, probably with both parents present.

If your parents are not very open, your task is much more delicate. In some cases, it is better not to tell either parent if you are still living at home. Some wait until they are in their mid-twenties or later. It all depends on how you think they might react.

Some teenagers and young adults are pleasantly surprised to find their parents are supportive when they tell them. Others are disappointed or worse. Some parents even reject their son or daughter when they come out to them, but don't expect the worst!

There is no one approach for all people. Sometimes it is easier to come out to a brother, sister or close friend than a parent. Many adults and some teenagers participate in National Coming Out Day on October 11—which is intended to motivate people to exclaim "I am proud of who I am."

QUESTION: "I am 19. I am a recent 'out-of-the-closet' bisexual. I have somewhat of a girlfriend who wants me to answer a question she has been bugging me with. She wants to know if I would ever date a guy and a girl at the same time.

"The way I feel about my relationships with females is that it is an intense friendship where two females share their 'secrets' and are very comfortable being with each other. I can't see myself committing to a girl.

"I have only understood (to an extent) my feelings with someone I met at a club. This girl drew me to her. She had a very open relationship with her girlfriend who was the one to 'hook' me up with her. I fell for her hard, knowing I was setting myself up.

"That is exactly what happened. I did not understand this was strictly a physical relationship, seeing as how they were always on and off, and they were happier separated. I thought I could make her forget about her girlfriend, and be happy with me. I was wrong.

"So, my 'first time' was not a good one. My girlfriend is there when I need her and she doesn't stay mad at me for too long when I'm not completely open about my sexuality in public. I want to be with her, but I don't want to jump into being sexual again like the first time with the other girl.

"My first question is, what can I say to my girlfriend to help her understand how I feel about the commitment 'thing'? She knows about the whole story firsthand. Another thing I want her to understand is that I don't mind if she is with other girls. We have not been physical, and I feel like I am depriving her. I want her to want me, but at the moment I can't satisfy her because I don't feel comfortable starting a relationship with another girl. Please help me."

ANSWER: You say you don't want to commit to a girl and you want to have sexual experiences that are non-exclusive with them. This may or may not work to your satisfaction. It can be confusing to date around when the relationships are all sexual. Some can handle it, others cannot. You have learned not to jump into a sexual experience. It was not a good experience when you did.

Your girlfriend is a friend. She appears to care for you and vice versa. Don't ruin the friendship by rushing into a sexual experience. She may not want to have sex with you—or with any female. If she does want to, I suspect she will let you know. How could you be depriving her of anything? You are friends who do not date.

Remember, another girl has already rejected you. Take your time. Let the flow go naturally—it may be best to be her friend and be a partner with someone else. You might eventually have a girl and a boy as lovers. You may want to commit to a guy someday. Don't worry about it—be honest with yourself and others of either sex.

Don't ruin the friendship by rushing into a sexual experience.

QUESTION: "My brother is gay. He is only 17, but he is sure of it. I can support him because it makes him happy and I'm all for his happiness. But the problem lies with my parents. My brother hasn't told them about it. And they are homophobes. I'm worried about my parents' reaction to him. My brother would be torn to pieces if they couldn't accept who he is. I love my brother and my parents, but I don't want to see any of them hurt. I can't talk with my brother or my parents because they are very uncomfortable with confrontation. Any advice?"

ANSWER: I commend you for your openness and your support for your brother. I'm sure he appreciates it. It doesn't sound like your parents are open to discussing your brother's gayness, but eventually they will have to deal with it. They may already suspect that he is gay and choose not to discuss it. You can encourage your brother to feel good about being gay, but I would not bring it up with your parents.

Only if your brother wants to bring it up—with or without you pres-

ent—should you enter in any discussion. You could bring up the general topic of homosexuality with your parents to see how they react. If they seem more open than you suspect, your brother could later tell them, but timing and approach are important.

It is sometimes better to wait until you are on your own, although some parents are open and nonjudgmental. Your parents may eventually ask you if your brother is gay—or they may say they suspect it. This would make it easier to discuss the issue with your parents—hopefully with your brother present.

 QUESTION: "I am an openly gay student. There is another boy at my high school, a total closet case, and he insists on harassing me. Do you think this has anything to do with his repressed homosexual feelings?"

ANSWER: His harassing you may indicate some confusion and fear on his part, but it does not prove that he is gay. He may have repressed gay feelings, but you cannot be sure. You chose to come out of the closet and I commend you for your choice. I know it can be difficult to be openly gay in our homophobic society.

You need to deal with the harassment. You could tell him that you will not put up with it—that harassment is against the law. Schools are now liable when sexual harassment occurs. If he does not stop the harassment after you ask him to stop, you should report him to the proper authorities at school. Depending on the nature of the harassment, you may eventually have to report him to the police too.

Even though there is far too much homophobia, things are getting better. A lot of heterosexuals support gay, lesbian and bisexual rights. Support shows up in public statements in the media—and by those who march with gays and lesbians during Gay and Lesbian Pride Marches across the country.

It is totally unfair to be unkind to gays and lesbians because they are different, or because AIDS has plagued gays—along with IV-drug users—more than most people. **Regardless of your sexual orien-**

tation, you all can be sexual, responsible and happy by standing together against those who try to censor or repress your sexual desires and behavior!

As you'll see in the next chapter, the first and most basic sexual desires and fantasies can be satisfied through self-pleasuring. Read on!

Regardless of your sexual orientation, you all can be sexual, responsible and happy by standing together against those who try to censor or repress your sexual desires and behavior!

3

MASTURBATION PUTS A SMILE ON YOUR FACE!

"Growing up I felt that masturbation was something women did not do, so I kind of have a negative feeling about it, but I can't do it. I have tried to masturbate and I don't feel anything at all. The second my boyfriend does it I really enjoy it. I can use a vibrator and have an orgasm within a minute. Also, I don't have an orgasm during sex; it feels good and sometimes I come, but never does it feel as awesome as if he was going down or using a vibrator."

Unfortunately, this young woman has depended totally on her boyfriend or her vibrator to stimulate orgasm. She equates sex with intercourse, but oral sex is sex too. So is masturbation—except no one else is involved. Her lack of orgasms from intercourse is partially from her discomfort when exploring her own genitals.

Self-pleasuring would enable her to have an enhanced awareness/understanding of orgasm, so she could have orgasms. Any girl who is not comfortable pleasuring herself is

less likely to have orgasms during intercourse. **If she masturbates to orgasm**, she is much more likely to be fully orgasmic from a variety of forms of sex play.

A word that **sounds** like something you should not do, masturbation is sex with yourself, a hands-on activity—or holding your own. The ultimate do-it-yourself hobby, it is enjoyed by millions, it is safer—and more fun—than bungee jumping, less time consuming, less complicated and cheaper than dating—and you don't have to look your best! The ultimate tension release, masturbation can also help you relax enough to fall asleep.

The word, masturbate, which has Latin roots, carries heavy negative connotations from the past. To masturbate is "to pollute with the hand." "Play with yourself" could be taken as childish. Some more sex-positive terms: "self-love," "self-pleasure," "jollification," "self-stimulation," and "sex with ourselves." Some of the ubiquitous jargon depicting masturbation includes "beating off," "hand job," "jerking off," "jacking off" and "whipping it."

Self-pleasuring should be guilt-free. Sometimes masturbation leads to guilt about pleasure—totally unnecessary, unfortunate and unhealthy. In the Bible, Onanism is linked with sin. The sin of Onan was that he did not impregnate his dead brother's wife as required by Jewish law (to perpetuate his brother's memory through children). Later, Christians wrongly called this masturbation, hence the abomination. Onan did not masturbate—he used withdrawal. **Masturbation is not a sin. It is healthy fun.**

You are your own best—and usually your first—lover. There is no rational reason to feel guilty about private pleasures. Your mental and physical health ben-

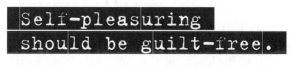
Self-pleasuring should be guilt-free.

efit from awesome self-induced orgasms. Woody Allen aptly states: "Don't knock masturbation—it's sex with someone I love." Even Ann Landers recommended masturbation for all people.

Most people have their first orgasm by themselves. Self-pleasuring is a national pastime—about 95-99% of men and 70-85% of women participate. As women get older, more report pleasuring themselves to orgasm, and they do it more often. If you are female, you can happily contribute to the trend of more women celebrating secluded orgasms.

Masturbation is normal. Don't ever feel guilty about loving yourself. Pleasure and orgasm are essential for a balanced existence. Self-pleasuring is first-rate–not second-rate–sex. It's convenient, it feels good and it's great for your self-esteem. Many start masturbation by age 13 and others are happily masturbating by age 10. Infants have been observed masturbating to orgasm. Some wait longer because they don't know how–or they have been taught negative, inaccurate messages.

Masturbation is a mature activity–not selfish or immature.
The best lovers get into their own pleasure, not just their partners' gratification. Pleasuring yourself is a superb way to literally get in touch with yourself so you can explain to your lovers what it takes to satisfy

you. It helps you become more aware and more sexual so you can become a polished lover. Those who never or rarely pleasure themselves have much less of a chance to realize their erotic potential.

As you experience more sexual relationships, you may find one or two partners who are offended when they find out you masturbate, fearfully claiming you shouldn't **need** to pleasure yourself. This is based on their wrongheaded idea about property rights: that they own your body because they have sex with you. None of this is true.
You own your own body–revel in it!

When you feel really horny–a kind of **sexual emergency**–masturbation is quick, safe and free of hassles. There is nothing wrong with orgasmic release–a wonderful part of your day, your night, or both. As long as you make it to school and work, enjoy.

Don't believe all the negative propaganda about self-pleasuring. Masturbation won't cause hair to grow on your palms or make you go blind. It won't cause you to be stared at by others–unless you do it in public, which I don't recommend! You don't have to look your best. They won't know whether you do it, how much you do it or how you do it. Let them wonder.

Masturbation is an opportunity for private pleasure so you can sensuously explore your body without anyone dictating what you should do. **It is important not to rush to orgasm.** If you come

too quickly when alone, you are more likely to ejaculate too early when you have intercourse. This is called **premature ejaculation**—a common problem for young guys (see Chapter 5).

Imaginative, fantasy-driven jollification often leads to joyous, sensual and orgasmic satisfaction for teenagers and adults of all ages. Some of you enjoy cybersex fantasies. About 70% of online chat rooms are sexually oriented—lots of web sites feature sexual images, talk or information. Some of these sites are erotic and healthy; others are in poor taste and exploitative.

If our society were not so sexually repressed—with adequate comprehensive sex education and a more sex-positive emphasis without sexual censorship—there would not be a virtual obsession with pornography. Much pornography is produced in Denmark, but the Danes don't consume it nearly as much as Americans. This is because they are more balanced; they are open and they encourage sex education and sexual pleasure.

To some misguided politicians, you should not have the right to access explicit sexual images or text on the net. There are constant attempts to pass laws to restrict your access to whatever they think is indecent or obscene. I disagree with judgmental politicians who are sure they know what is best for everyone. Many of them don't even know what is good for adults. No one can censor your erotic imagination; romance novels and television offer plenty of stimulation.

`It is important not to rush to orgasm.`

I offer a few words of caution about chat rooms and meeting those you chat with. Unless you have met the person you are chatting with, you cannot be sure he/she is for real. Some people totally misrepresent themselves in chat rooms and through e-mail. Meeting a stranger from a chat room isn't particularly safe. If you meet, always bring a friend and meet in a safe public place. Your parents may worry about this; their concerns are worth serious consideration. You may be masturbating to erotic overtures from someone you believe to be another teenager or a young adult, but that person could easily be an older adult with a problem.

The media constantly report rape and other violent crimes that occur after communicating on the net. You can't even be certain they are the

sex they say they are, even if they send you a photo. How do you know they are who they say they are? Be careful and use some common sense. Fantasies should safely lead you to orgasm, not to trouble.

Fantasies—whether from the net or your own imagination—make masturbation powerfully erotic. A sampling of tantalizing fantasies follow:

"Lying in deep grass high on a hill—my body naked and the sun splashing down on me—feeling its warmth penetrate me. My lover stands before me blocking out the sun. I look at his beautiful smile and the nakedness of his body. He comes down on me, his body on top of mine—gentleness, kissing, touching like penetrating, our arms and legs entwined in one another, and we roll down the hill together."

"My most common fantasy is of an assertive stranger, the girl that I just meet somewhere, and she initiates sex. It's more direct than anything that usually happens in real life. She unzips my pants, shuts the shades and doors and sucks me off. I keep wishing I'd meet more women like that."

"I love to fantasize about two guys making love with me at the same time. They are both eager to please me in every way imaginable. They do whatever I request—and more. I have multiple orgasms at the same time that they come. Then we collapse into each other's arms, ready to do it again in a short while. A variation of this fantasy is making love with a guy and a girl at the same time."

"I like to fantasize that I'm standing at the top of the globe masturbating next to a master switch. I could produce a current that would go out to thousands of women holding electric vibrators to use on their clitorises and G-spots. They would all get off at the same time, and they would all hear each other and me making sexual comments and noises on the same closed circuit sound system. Simultaneous orgasms would be sent around the world."

These fantasies illustrate the power of imagination to incite desire, arousal and orgasms. **Your mind is your main sex organ.** For your body to be supercharged with ecstatic orgasms, the signals your mind sends through your nerves from your brain down your spine to your genitals need to be potent, pure and overwhelmingly erotic.

Now for your questions.

Who Masturbates? (Who Doesn't?!)

QUESTION: "I am a 17-year-old young woman. I have a question. It is something I just can't talk to anyone else about, including my mother. I know that masturbation is OK, but just how common is it in teenage girls? I have been pleasuring myself since I was 14, and unfortunately I am no longer a technical virgin. I have never actually had sex, but I have masturbated in a way that caused me to lose my virginity. I am afraid that because of my actions I am ruined for guys. I can't tell someone my age why I am not a virgin and actually trust him.

"I also wonder if I am a nymphomaniac. There are times when I masturbate four times a day. I reach orgasm each time and probably would continue but my muscles are worn out (this really is embarrassing). Is this too much? I mean, there are times I have gone without for two weeks, but then my desire overwhelms me.

"I feel that these actions on my part are just more to make me different from my friends. I am already regarded as 'dirty-minded' by them all. I think it may be because I am so much more sexual than they are. I have a collection of 90 so-called trashy romance novels that also put me apart from them. Could you please answer my question?"

ANSWER: Relax. You are totally normal and healthy. You are more sexual than your friends and that is fine. A highly sexual woman is not a nymphomaniac. You appear to feel there is something wrong with not having your hymen—that piece of skin that some girls have in their vaginas when they have not had intercourse.

Why are you so hung up on being a virgin? Most guys aren't searching for virgins. You are **technically** still a virgin, since you apparently have not had intercourse (see Chapter 5). No method of masturbation has any bearing on virginity.

You are a sexual **enthusiast**—a perfectly normal, well-adjusted, healthy person with natural desires who acts on them as often as possible. You are not "dirty-minded." You are normal in your fantasies from reading romance novels. There is nothing wrong with this. It is very common for teenage girls to read erotic passages and masturbate.

Some writers admonish you to masturbate less, contending you are a "sex addict" or a "sex maniac." This is utter nonsense. There is no reason to feel guilty about pleasuring yourself. Every teenager has to discover her/his unique pattern of orgasm. If masturbation were all you did during an entire day, I would recommend some balance so you can also savor other pleasures like a tasty meal, a radiant sunset or gorgeous flowers.

There is nothing wrong with orgasms a few times a day—or once or twice a week if you prefer. I suspect some of your girlfriends are not telling the truth about how much they masturbate. Orgasms release stress; they are good for your mental and physical health.

QUESTION: A 15-year-old guy asks: "No matter what your age, it is OK?"

ANSWER: Yes, it is not only OK, it is extremely healthy and fun to masturbate. Nearly everyone masturbates eventually. Males masturbate more than females, in part because of the easier-to-find-and-play-with penis (joy stick) compared with the less visible and less accessible clitoris (joy button inside the folds and above the vagina). I predict the gap between the sexes will continue to close. Girls who are highly sexual usually masturbate—which makes them more likely to be satisfied with their lovers too.

The gap between the sexes is closing because girls are learning to be sexual at younger ages. Girls are given more permission to be sexual by the media, their friends and by some adult role models. Women who are more educated and career-oriented are more likely to masturbate.

Lots of you wonder how often you should masturbate. Here are some sample questions.

QUESTION: "Is it OK to masturbate daily? Will the urge to do it change after I have sex?"

ANSWER: It is fine to masturbate daily. You will have just as much—and probably more—of an urge to masturbate after you have intercourse. Remember that sex is not limited to intercourse.

Single and married people masturbate, although some keep it a secret. It is absolutely normal to masturbate, whether you have a sexual partner of any kind (making out, petting or more). Those who are sexually active also mastur-

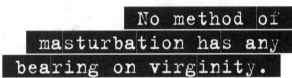

No method of masturbation has any bearing on virginity.

bate more than those who are not sexually active. It is better to get ready for sex acts with others by learning what it takes to give yourself an orgasm.

How Do You Masturbate?

There are lots of ways to masturbate. Men stroke their penis, varying the speed and pressure, with a free hand sometimes used to caress thighs, nipples, stomach and testicles. You can use a lubricant, such as K-Y Jelly or a massage oil or lotion, to enhance languishing sensations and to avoid pain.

Some guys rub against a t-shirt or a pillow while visualizing a willing, sexy girl. Some lie on their backs, while others lie on their stom-

achs or sit up. Still others masturbate while standing in a shower or another inviting place. Many masturbate while viewing a sexy photo or video to fuel their fantasies.

The same is true for girls. Women lie on their backs or their stomachs and stimulate their clitoris and vaginal lips with their hand and/or rub against an object—or they use a vibrator. They often caress their breasts and watch in a mirror. Some

There is more than one way to masturbate.

use a lubricant or saliva to avoid painful friction and to increase pleasurable sensations. They choose to hold their legs apart or tightly together. Others prefer a removable shower massager to stimulate their clitoris to inspire enthralling orgasms from water pressure.

QUESTION: "I am a mature, independent young woman. I am still a virgin (and will be until I am at least 18 or 19), but I am very sexual. This may sound weird, but 'tis very true. My problem is that I don't know how to masturbate. Which, for me, is a bad thing, because I'd like to pleasure myself before anyone else does. Is there any one way? If so, what? If not, what do most women do? I am lost and would like your advice."

ANSWER: There is more than one way to masturbate. Use your imagination. If it feels good, do it. Some girls use their fingers to stimulate their clitoris and the mons area around the clitoris. Some insert a finger or dildo in their vaginas. Others occasionally use a vibrator, either battery-operated or electrical, for clitoral—and sometimes for G-spot—stimulation.

If you have access to sex toys, some vibrators have G-spot attachments, allowing you to simultaneously stimulate your clitoris and your G-spot—two triggers for female orgasm. The G-spot is an

area about the size of a dime about two-thirds up the front wall of the vagina. Properly massaging this welcome spot can inspire female ejaculation and orgasm (see Chapter 5).

If you use a vibrator, it is best that most women not use it all the time; it is so intense that it may numb you out to other forms of stimulation, including your own hands and a shower massager to stimulate your clitoris. Warm water running over the clitoris is a pre-ferred method of self-pleasuring for many girls.

A young woman explains another method of masturbation:

QUESTION: "Ever since I was about 3 years old (I'm 22 now), I have been pleasing myself when I go to bed. I don't know how it started, but it's sometimes the only thing I can do to get myself to go to sleep. I lay flat on my stomach and I make a fist with my right hand and place it on top of my vagina. Then I support that hand with my left, and I make circular motions that rub against my clitoris. I do this while imagining some sort of sexual adventure in my head (usually involving my boyfriend and me in a shower together—it's one of my favorite fantasies), and I do this until my vaginal muscles start to contract, and then shortly after, I fall asleep.

"Now I have a few questions:

1. Can you briefly explain to me what it is I have been doing all these years?
2. Can it cause harm to my reproductive organs by doing it almost every night?
3. Is this a form of masturbation, or Kegel exercises?"

ANSWER: Circular motions with your fist stimulating your clitoris while lying on your stomach is a form of masturbation. You have found a style of self-pleasuring that works for you. You are not causing harm to your genitals by masturbating like you do. Kegel exercises are squeezing your pelvic floor and vaginal muscles. Kegel exercises can bring out your G-spot for stimulation (see Chapter 5), but they are not masturbation.

Whether you use erotic novels or visual images to fantasize—or your own limitless imagination—**fantasies enhance masturbation**. Having erotic fantasies is necessary for male masturbation and it increases arousal and orgasms for female masturbation too. Fantasies about what you'd like to experience arouse you, making it more likely that you will orgasm.

Girls often read romance novels to stimulate their fantasies, while guys typically use visually explicit material like *Playboy*, sexual sites on the Internet (unless you have a computer with censorship filters) and erotic videos.

QUESTION: "I am 15 years old and mastur- bate three to four times a day. The thing is, I have never had a wet dream. I was wondering if the reason was because I masturbate so much, but if it's not, then I was wondering if there was anything that I could do to speed up the process."

ANSWER: You do not say if you are a guy or a girl. But it doesn't matter, because you are a healthy 15-year-old with an above-average libido who enjoys self-pleasuring. Good for you. If you masturbate three or four times a day, you are less likely to have a wet dream. Why worry about it? Try masturbating less and see if you have a wet dream. Relax. Just let it all happen naturally. And as a general note about the frequency of masturbation, unless you are troubled about something and using masturbation only as an escape from a problem, it sounds good. If you feel good about what you do and about yourself, you are fine. If you don't feel good about yourself, then try to figure out if your discomfort is from giving yourself pleasure, or whether

you have some other dilemma that you might be trying to escape by masturbating. Deal with any concerns and continue masturbating.

QUESTION: "How often is too often to masturbate? I am a 20-year-old guy and am just wondering. Also, should you keep masturbating after you ejaculate?"

ANSWER: As long as you fulfill your obligations to your family, friends, school and work, don't worry about how many times a day you play with yourself. A few times a day is just fine. There is little reason to continue stimulation after ejaculation, although you technically can orgasm before and after ejaculation. The most intense orgasms usually occur during ejaculation. You may feel pain if you continue, because the tip of your penis can get sore from continued rubbing.

Multiple orgasms are more likely for younger guys and for guys who do their Kegel exercises—squeezing down on the muscle that starts and stops urination and holding the muscle while taut, and repeating for five minutes twice a day. Your pleasure heals your mind and your body. Do a self-meditation on your pleasure when you masturbate.

QUESTION: "When I masturbate, I don't usually insert anything. I just rub my vagina. Is that OK, or is it better if I insert fingers?"

ANSWER: Do whatever feels best. You need to stimulate your clitoris and the surrounding mons area, not just the outer lips of your vagina—your inner and outer lips should feel good too. Stimulate your G-spot by inserting a finger or fingers to massage the front wall about two-thirds up—especially if you do your Kegel exercises. Kegels bring the G-spot out for easier stimulation.

QUESTION: "I am an 18-year-old female and I have been masturbating for quite a few years now, but I can't seem to get an orgasm. Can you tell me some techniques that I can try?"

ANSWER: You can't "get an orgasm"? Where do you think you will "find an orgasm"—under the covers, in the shower, while sitting on a car seat or by a creek? If you can afford one, buy an electrical or battery-operated vibrator. It is best to use a vibrator that can be inserted for G-spot stimulation **that also has a clitoral stimulator**. If you have a credit card and aren't freaked out that your parents will open the box (no one can tell what is in the box!), you can call one of the sex toy mail order companies and ask for their catalogue. You can also check out their web sites—see The Yellow Pages for Sex.

I recommend the Hitachi Magic Wand vibrator along with the curved G-spot attachment. The Hitachi is the **Mercedes** of vibrators **and** it can also be used for general body massage. It is somewhat expensive; not all young women can afford one. It is over a foot long, and it has two speeds. Start with low speed. For most women, it is advisable not to use the vibrator exclusively. It will probably stimulate you to one or more orgasms—perhaps your first orgasms—but it is **intense**. Put it away and use your fingers too.

QUESTION: "I'm a 21-year-old guy. It has been taking me longer and longer to mas-turbate. What could be my problem?"

ANSWER: I suspect it is primarily mental. You could be bored and thinking of other things, which makes orgasm less likely. You need to concentrate and imagine erotic fantasies. Surely there must be some girls who really arouse you. Some fantasize about movie stars, but most also have fantasies about those who turn them on that they know, used to date, are dating—or wish they were!

Fantasize thoughts that supercharge your desire to masturbate. If you have access to a computer not censored by filters, check out some of the more tasteful sexual sites. Also, you may not be exercising and sleeping enough and/or eating fatty foods that clog blood flow.

QUESTION: "I'm a 19-year-old girl. I don't masturbate. I just don't feel like I need to. It's kind of embarrassing to say, but whenever I try to with my fingers it's like they just aren't big enough or something, because I don't like whatever I try. The only thing that felt good was when someone ate me out a LONG time ago back in my slut phase. And I just think that fantasies are enough for me. Is that abnormal or something?"

ANSWER: Try some objects that are clean and safe which are larger than your fingers for vaginal stimulation and use your fingers to stimulate your clitoris. Fantasies without orgasm are fun, but acting on arousing fantasies is more fun. You aren't abnormal. You are simply seeking your own gratification.

Slut phase? You aren't a slut. No girl is—neither are guys. The term has been a put-down to those who are recreational about pleasure. If you insist on using the term, let's redefine a slut: How about a Sensual, Liberal, Unbelievable Temptress (SLUT)? A slut is a naturally erotic female who is put down for her lust for more than one lover by those having less sex than she.

Some wild women even wear "slut" t-shirts cut off above a sexy navel. More power to sluts! Unless someone is being exploited or hurt, why would you be negative about sex for the fun of it?

What Are the Side Effects and Benefits?

Masturbation is an intense sexual activity that can cause some to simultaneously be anxious, fearful and curious. As the following letter illustrates, masturbation can also affect lovemaking.

QUESTION: "I know you get this a lot, but I'm still not sure what to do. Thanks to your consistent urging of masturbation, I've found my new favorite hobby at age 18. Not until I started did I have an orgasm. Now I find having sex with the guy I'm with not so great. We have tried different positions except the ones I'm uncomfortable with. We have oral sex and still no orgasm. I find myself ready to go, but within minutes I'm no closer to a climax than when we started. I almost could fall asleep or reach for the remote. Any advice would be helpful."

ANSWER: I am glad that you had your first orgasm after I encouraged you to masturbate. Self-pleasuring is a superb stress-reducer; you've discovered orgasm from fantasizing and experimenting. Good for you.

Something is wrong with your relationship for you to be so sexually bored. **You may not have chemistry**, and/or you may not be with the right person in terms of interests, values and needs. Find some new partners who are adventurous and active who want to do something besides watch TV with you. It could also be something in your head—possibly a fear about connecting on an intimate level. You may fear what sex implies or means, and this could keep you from enjoying it.

QUESTION: "I was wondering if masturbation stunts your growth. I'm 15 and my penis is six inches when erect. Will I grow any more? Please respond because there is no one else I can talk to about this."

ANSWER: I know how hard it is to find an adult who is willing and able to help you with sexual problems—that's one reason I did this book.

You won't affect the size of your penis by masturbating; your

penis is probably as large as it will get. Why are you worried? Six inches is average to slightly above average. You are putting too much emphasis on size. How about what kind of person you are—which will affect what kind of lover you become? Why don't you focus on this and forget your penis size fears?

QUESTION: "I am a 16-year-old female who has recently started masturbating. I feel bad for religious reasons when I do it. I am trying to keep my virginity until I am married because I feel that is something special that you can only give once. My question is I can never find my G-spot and I want some other ways to 'get off.' This all started when I found I couldn't get play from guys right now. I am a very pretty girl. I do not understand why I cannot get a boyfriend. This is another problem that I have. Please help me."

ANSWER: You can find your G-spot two-thirds up the front wall of the vagina. Doing your Kegel exercises should help you find it. Try stimulating your G-spot with your fingers or a vibrator. If you simultaneously massage your clitoris, you should "get off" nicely.

It is totally unhealthy and unreasonable to feel guilty about masturbation. Masturbation is normal—there is nothing to feel bad about. Maybe you need to reconsider your interpretation of your religion.

As a sex therapist, I don't view virginity as a prize like the toys in Cracker Jack boxes. Sex is not a pie in the sky to wait for (see Chapter 5). I recommend that you wait until you are 18 or 19 to have intercourse, but it might be a mistake not to have intercourse before marriage. **Making love before marriage allows couples to truly discover if they are sexually compatible, so that they can be sure that they have sexual chemistry.** Sadly, far too often I meet with couples who discover after marriage that they share no chemistry. There is nothing any therapist or doctor can do to help a couple be sexual when they don't have chemistry.

I don't know why you don't find guys who want to date you. You may be looking in the wrong places or you may be doing something that puts guys off. Maybe they think you are too conservative. Ask your friends for some feedback. They may have some ideas about what you might be doing to make yourself less appealing than you could be. Use your sense of humor and be playful! You will find some dates. Ask out a guy who interests you.

 QUESTION: "Would early masturbation as a child have any effect later in life?"

ANSWER: Relax. Early masturbation has a positive effect on you now and later. It gets you in touch with your mental, emotional and physical self and it enhances your self-esteem. It gives you pleasure and relieves stress. Early stimulation to orgasm helps assure that you will be sexually satiated throughout your life. It has no negative effects unless you allow yourself to feel guilty about giving yourself awesome orgasms.

QUESTION: "I have a serious problem. I am just 16 and it would mean so much to me if you could help me. I don't have any money to pay a sex therapist. I have been dating this girl for three months. She is my first girlfriend. However, in that three-month span I have not ejaculated with her from intercourse or in any other way. We have done everything. I don't like to masturbate because I feel guilty, but since I realized my problem, I thought I should. A couple of years ago I did watch pornography, but now I don't. Now it takes me about fifteen minutes masturbating to ejaculate. Can you help me?"

ANSWER: Your guilt is probably the main reason you aren't ejaculating with your girlfriend. Guilt makes it hard to ejaculate when you are alone too. You need to let go of any negative thoughts (see Chapter 9) so you can accept sex with yourself and with others as normal. As long as you are sincere, responsible and sensitive, you should not feel guilty.

I do not think it is wise for you to be having intercourse at age 16. I would wait until you are at least 18—you will be more informed and more able to handle the responsibility of such an intimate connection. You can learn to have orgasm—perhaps by dry humping and by hand-to-penis stimulation from your girlfriend (her hand, your penis). Finally, I don't recommend that you limit yourself to one girl. She is your first, probably not your last.

QUESTION: "Is it unhealthy to masturbate to Internet porn?"

ANSWER: It depends on whether you occasionally view sexy images and cheerfully act on your fantasies or whether you are so obsessed with porn that you are too desensitized to be normally sexual and emotional with a real girl. There is nothing wrong with getting turned on to visual images, but you need **balance**. Don't compare real live girls with porn stars—it's usually an unfair comparison. It's easier to fantasize to an image than to relate to real girls, but porn doesn't come close to the thrill of in-the-flesh sex. Why not enjoy both?

QUESTION: "Can masturbation cause any deformation of the penis if done about once a day?"

ANSWER: A thousand times no! If you don't masturbate, you might have problems with erections and ejaculations from leaving your sexual equipment in cold storage. Your penis will be happier if you regularly give it pleasure.

QUESTION: "Is masturbation for a 15-year-old guy abnormal? Could doing it four times a week or so have any bad side effects?"

ANSWER: It is totally normal for a 15-year-old guy or girl to masturbate four times a week or so.

QUESTION: "Whenever I masturbate in the shower and I ejaculate, I become very tired and I do not have the urge to have sex anymore, or to have more fantasies. Is this normal, and what is this caused by?"

ANSWER: You may be tired after you ejaculate; it takes energy to get to that point. It is normal to feel more relaxed and tired after orgasm. You may not want to fantasize or have more orgasms right away, but after a while you will rekindle your desire through fantasies, and you'll gladly masturbate again.

It is normal to feel more relaxed and tired after orgasm.

QUESTION: "Sometimes when I masturbate I don't spurt as far as I should, and my entire groin aches for twenty to thirty minutes. Usually this happens when I masturbate sitting down. Is something being pinched off? Also, how long is the average recovery time between orgasms for males?"

84

ANSWER: Your groin may ache because you prolong arousal too long without an ejaculation to release the tension. If the pain only occurs while in one position, you may be cutting off some blood circulation. The shorter spurt may be your perception. I doubt it is a consistently shorter spurt. For you, the sitting position may not be as arousing as other positions that encourage longer ejaculatory spurts.

Try masturbating on your stomach, back or side. You don't have to measure how far you shoot. **This is not the Sexual Olympics.** The average time after ejaculation to get erect again—the refractory period—is about fifteen to forty-five minutes for a healthy young guy. Some take an hour or more; don't worry about it.

QUESTION: "I am only 15 years old, and I am trying to ejaculate a long way when I masturbate, but it just drips out. How do I get it to shoot a couple of feet so when I am with my woman she won't laugh?"

ANSWER: You are 15. Don't get too involved or obsessed or you will drive yourself crazy. Don't be too concerned about all of this before you and your female friends are ready to deal with it. If you do your Kegel exercises, your ejaculation will be more forceful and more pleasurable (see Chapter 5). Only as a result of fake camerawork in porn movies will you see a man who can "shoot" two feet. Ejaculation distance has very little to do with sexual satisfaction or performance. Don't worry yourself. Relax.

Enough about sex with yourself for now. I recommend a balance between pleasuring yourself and safely giving and receiving sensual gratification with your lovers. In the next chapter, we'll explore dating, hooking up and sexual friendships.

4

DATING, HOOKING UP AND FRIENDS-WITH-BENEFITS

It's Saturday night with a full moon overlooking a tempestuous river. A warm breeze and approving stars illuminate Tove and Mike's hot date. They enjoy a portable radio with soothing music, a soft blanket and a tasty picnic dinner. Though they are not exclusive, they are friends who are very fond of each other.

Mike is excited by her outgoing personality and her sexy appearance. She has enjoyed satisfying intercourse with several guys. Mike is a technical virgin, but he has made out and petted to orgasm with many girls.

Unlike Tove, Mike has had very little sex education from his parents or from school. Some of his friends have already had the misfortune of unwanted pregnancies and STDs. He is 17 and he has chosen to wait until he is out of high school to enjoy intercourse. He is proud to be cautious and smart. Tove allows him time to sort out his feelings so he can emotionally handle whatever happens.

Her red flowing hair brushes his face as they laugh, playfully French kiss and pet with escalating arousal. They relish numerous orgasms from hand stimulation, intense French kissing and exploring each other's bodies.

Tove and Mike date others too. Some of you limit yourselves to one boy or girlfriend, while others date around. Some of you hook up for casual or stranger sex without dating, and others develop friends-with-benefits relationships where you are sexual with a **friend**, but don't **formally** date them. This chapter is devoted to distinguishing—and making some suggestions about—all four choices.

Only you can decide which choice is best suited to you today. You may make a different choice tomorrow. Some of you date one person, break up and hook up for a while. Others date and hook up or develop sexual friendships at the same time, sometimes trading one choice for another.

Your friends and parents may argue for very different choices, which may result in confusion, anxiety and anger. Most parents prefer that you date one or more people, with the hope that you will limit or avoid sexual expression. Your friends probably are more split between recommending hooking up, friends-with-benefits and some form of dating—which may or may not be recognized as dating by your parents.

No matter where you live or which choice you make, you may not be on the same pleasure team with your lovers. You may assume a relationship is non-exclusive and your partner may assume it is exclusive. Different assumptions, dishonesty and playing games cause hurt feelings, anger and disconnections.

Most negative emotions and experiences could be minimized by having a Pre-Sex Discussion and continued open talks about what a given arrangement or relationship means and what each person expects and wants (see Chapter 6).

Let's take your sexual choices in order: dating one or more, hooking up and sexual friendships.

Commonsense Dating

Some view a date as companionship and sharing common interests with little or no sex. Others view a date as a potential sexual adventure.

Some questions for you to answer: What is a date? **Is dating a dated concept?** Is dating as your parents practiced it (hopefully they still date each other!) passé and archaic? In your era of frivolous hook-ups, is dating too difficult and tedious to bother with? Is a date going steady, going steadily but still dating others, or is it a casual, non-exclusive social/sexual arrangement?

Do you date? If so, do you enjoy it? What do you expect and desire

from dating? Are there accepted guidelines or rules? What are they? Do you often have a different definition of a date than those you date?

Dating is a tempestuous dance with fuzzy guidelines, especially when it comes to sexual etiquette. Dating usually includes some flirting, kissing and more. If the guy pays, does he expect sex in return? In America, sex is still partly a pleasure for guys to seek and for girls to control. **In the process of controlling sex, girls often fail to enjoy it.**

Twenty-four years ago sex educator Dr. Carol Cassell argued that **women feel they must be swept away by romance and love to justify sex.** She stated: "It is a tactic, employed unconsciously by women to get what they want—a man, sexual pleasure—without having to pay the price of being wanton or promiscuous" (*Swept Away*, 1984). Her analysis still applies, but young women have become more liberal about sex without as much fear about being put down for their erotic interest and experience.

In the process of controlling sex, girls often fail to enjoy it.

This doesn't mean that girls aren't still force-fed the destructive idea that high drama and romance are normal. Romantic obsessions propel girls, and some guys, to define their self-worth by whether they are loved by a specific person. If you find yourself trying to make someone jealous and conclude you can't live without him/her, you are obsessed— you are in love with love, not with the person you obsess about.

There is more than one possible guy or girl for you to eventually love in a mature way. Don't jump to the conclusion that there is only one person you could ever really love and be happy with. It is normal to be affectionate, but not to cling to someone or to continually obsess about where they are, what they are doing and how much they think about you. Seek enjoyment and adventure—not a needy obsession in the name of love.

If a date is a negotiation for a future commitment rather than a fun evening, it's fraught with uneasy tension. When one person counts the minutes—let alone the number of dates—for sex to occur and the other is obsessed with falling in love and going steady, there is a problem. This is not just a difference between the sexes. Some women are more flexible than men and vice versa.

Dating should be fun. It should be based on friendship, common

sense and pleasure. It's sensible, healthy and responsible to be aroused, to be emotional and to express your sexuality in ways that don't get you in trouble. Balance your sexual needs and rights with your responsibility to be considerate of others' needs and rights.

A date can be great fun if both have similar needs and desires. Open dialogue and common sense help ensure that dating is mutually satisfying. Dating needs to be redefined so you can date without seeing it as too much to handle along with school, work, your friends, family and other activities.

You've come a long way from your parents where a goodnight kiss was often the high point of a date. Those with little or no experience often put down girls who enjoyed sex beyond heavy kissing and garment groping. The double standard was much stronger when your parents were in high school, but it still is a barrier to intimacy and mutual fun.

I offer three guidelines to improve dating, friendships and sex. Regardless of my use of he/she, these guidelines apply equally to gays, lesbians and bisexuals.

Guideline #1:
Become friends, be honest and fair and treat each other as equals.

You don't lie and break up with real friends—you are honest, caring and sensitive. Guys don't deserve more attention, sexual or otherwise. If you treat each other as equals, you'll enjoy dating and sex more than the old rules allowed. This is simple common sense.

There is no reason that guys should hold all the power by doing all the initiating, always calling and picking the girl up and paying for every date. Why not be more spontaneous and flexible?

The guy asking out the girl and paying for the date sometimes sets the stage for him to expect sex. The old view of male-initiated dating may discourage unique, creative adventure. It is more balanced if girls have equal freedom to suggest a date, especially if the guy is shy.

It's polite and sincere to return phone calls promptly, rather than playing games by leading someone on or rejecting him/her by not responding. Honesty and caring promote exciting dating relationships based on friendship; no one likes to be used.

Guideline #2:

Do not become possessive with those you date, hook up with or are friends-with-benefits with.

When you date, you either date as a single person, or as half of a couple. Some of you have a boy or girlfriend that you care for or love. There is nothing wrong with love, but falling in love doesn't always mean you will stay together forever. Breaking up is a common outcome when you date one person at a time.

Some of you prefer a girl or boyfriend. This choice suits some, but I don't want you to look back wishing you had dated a variety of sexy people. **This doesn't mean you have to be lovers with everyone you date.**

It's difficult to get a balanced perspective on what you want by having one boy or girlfriend. Unfortunately, it's too easy to put most of your energy into a relationship instead of yourself. If a boy or girlfriend is demanding and possessive, it's hard to focus enough on yourself; you end up concentrating on his/her needs more than your own. Why not please yourself and focus on your personal growth as your first priority?

Early coupling is more likely to lead to early marriage and divorce, sometimes after children are born. If you date a variety of people, you are more likely to make an appropriate partner choice later on. Some claim they've dated around and are ready to date one person at age 15. Most of you aren't emotionally mature and experienced enough to know whom you will spend your life with. You need more time to get to know yourself better first.

Some teenagers pair off and marry within a few years after high school graduation. A few of these marriages are successful, but the odds are against them. Everyone thinks they'll be an exception, but divorce statistics don't lie; almost all of you are better off waiting until your mid-twenties or beyond to consider marriage. This doesn't mean you can't date—and care for—one person more than others.

Your worries and confusion about dating reflect a lack of clear and realistic guidelines. Some of you define a friendship as a platonic relationship ("Oh, he's just a friend"). A friendship **is** a relationship, whether or not sex is part of the friendship.

You've inherited a dysfunctional version of dating that encourages possessiveness from unhealthy jealousy and insecurity. Lying, cheating, manipulation and painful breakups often result. Why make every-

day life into a roller coaster of high soap opera-like drama?

Your generation is changing some outmoded dating traditions, but most of them are still around. Forget the rigid, moralistic rules that Dr. Laura Schlessinger and other moralists try to impose on you. Have some fun, be careful and be honest. Never allow yourself to be pressured into another person's values by giving in to her/his demands in the name of love or duty.

Guideline #3:

Whether you date, hook up or have a sex buddy or two, wait until you are at least 18 to experience intercourse.
This does not mean you aren't sexual in the meantime. Sex—and sexual **stopping points**—include kissing, making out, petting, outercourse and oral pleasure. All are less risky than intercourse and lots of fun.

I know many of you have already had, or are having, intercourse. I want you to pay special attention to the rest of this book so you'll be knowledgeable and wise about STDs, birth control and what facilitates healthy and safe erotic experiences and relationships.

Depending on your age and level of sex education, you are much better off waiting for intercourse until you are emotionally ready and fully informed about sexual dangers. This doesn't usually happen until your late teens or early twenties. For some, 21 is too young.

People vary because of their family backgrounds and their level of knowledge and experience. I realize many of you feel you are ready for intercourse at 16 or 17, but most people are not truly ready for the responsibilities and possible consequences—including emotional wellness—until at least 18 or 19.

You are sexual. This doesn't mean intercourse and oral sex are the only exciting sex acts. **Many of your parents inaccurately equate sex with intercourse.** Sex also includes other arousing acts: French kissing, making out, outercourse (erotic friction without penetration, usually over clothing), hand stimulation of nipples and genitals and oral sex, which can happily lead to healthy, stress-reducing orgasms.

As you'll see in Chapter 5, most sexual problems could be avoided by exercising a little common sense based on accurate sexual knowledge.

91

Remember that realistic stopping points utilize common sense. Sex should be awesome, whether you make out for hours or slowly experiment with other intense sexual behaviors. Age, maturity and the availability of a person you trust should define healthy and reasonable stopping points.

Jumping into a heavy relationship by going too far too quick is a mistake. Errors in judgment sometimes result in unwanted pregnancies, STDs and emotional hurt. All of these can be avoided; see the rest of this book. Whether you hook up, date or have sex buddies, resist the temptation to go beyond your level of emotional readiness, sexual knowledge and physical intimacy.

Now we'll explore hooking up.

Hooking Up for Lust

Boy: What are you doing other than not talking to me?
Melissa: Nothing at all.

Boy: Wow, you're as bored as I am?
Melissa: Booooooooored.

Boy: Lol. Yup. Life is good. Lol.
Melissa: Freakin' fantastic. Lemme tell ya.

Boy: I wish you lived like next door. It would be so much easier. Like I don't know about you, but I wanna [expletive].
Melissa: U always wanna [expletive].

Boy: True.
Melissa: Haha.

Boy: But that's cuz we've been talking about it and haven't done it. It's built up.
Melissa:That's bc u haven't picked me up yet silly. Well I'm gonna go lay down. U know my number and where I live if things work out soon.

Boy: Hey wait. If I can do you wanna come over?
Melissa: Sure. So just call me.

Boy: Do you have condoms?
Melissa: Yes dear.

Boy: Hold on.
Melissa: I'm holding.

Boy: I can come get you right now if you want.
Melissa: Um gimme a sec.

Boy: O.K.? I'll come get you now if you're ready.
Melissa: But I'm gonna be boring tonite…and I'm just telling u I'm not in the mood for nothing but str8-up sex (*New York Times*, 2004).

In this dialogue between strangers, instant messaging led to instant sex. Melissa saw her hook-up again and wanted to continue seeing him, but he broke it off. She was depressed about the breakup: "'It's really stupid, I know…It's kind of ironic, isn't it? I try to set up a situation where I won't get hurt, and I still manage to get hurt'" (*New York Times*, 2004).

In the image of Samantha Jones in *Sex and the City*, Melissa thought she could be emotional with her friends and not with her hook-ups, but she was wrong. **Sex often propels you to become emotionally attached. It's easy to confuse lust with love–or with being in love.**

When sex is awesome, it sometimes makes you feel you've found the only person you could ever love. Most of you will fall in lust–and in love–with more than one person in your lifetime.

Hooking up refers to casual sex, not necessarily intercourse, without much, if any, of a relationship, including one-night stands. Hooking up often includes oral sex and/or intercourse, but other intense sex acts are also common.

Christina Aguilera says she loves casual sex and views it as part of being a strong woman, while Angelina Jolie enjoys friends-with-

benefits who are truly close friends (Sherman and Tocantins, 2004). This doesn't mean that Christina Aguilera doesn't or wouldn't enjoy sex with a friend. As of this writing she is engaged, but it is hard to accurately predict the sex lives of celebrities.

Sexual friendships usually are open relationships where either lover is free to see others too. Some cannot or do not choose to be so vulnerable to rejection. These nuances of sexual meanings easily get lost if two potential or actual lovers don't communicate effectively in pre-sex and between-sex discussions.

College students pioneered hooking up with strangers or acquaintances for casual sex. Hooking up has filtered down from college to high school. This trend has given dating some real competition; fewer teenagers and young adults date and more hook up and have sexual friendships. Depending on the college, 40-90% have hooked up at least once. Partly because of combined college-high school dating, some of you have hooked up for the lure of easy, no-strings-attached sex.

Cell phones, instant messages and photos from Internet sites facilitate hook-ups. Gays, lesbians and bisexuals use meeting sites with personal ads, and so do straights. This is usually done without parents knowing about it. Once again, if you decide to meet anyone from the net, which can be risky business, I strongly advise you to bring a friend and meet in a safe public place.

Many gay teenagers interviewed for a *New York Times Magazine* article (2004) claimed they met dates from the net, but did not favor hook-ups. Straights often hook up and date from the net. Several teenage and young adult sites are used to meet dates, hook-ups or just to chat.

Some of the sites include rating systems where you evaluate others according to their sex appeal and overall attractiveness. The ratings can affect your self-esteem—if you get a high rating, you get an ego boost, but if you get a low rating you may feel poorly about yourself. It's unfortunate that so many of you obsess about how strangers rate your looks. When I was a guest on Oprah Winfrey's show, I stated that **being sexy is strongly affected by how we feel about ourselves–not just by how we look.**

When you hook up, you look for quick sex. Some of you may want to be friends and date some of your hook-ups too. The problem is the other person may not feel the same way. Hooking up requires

an unrealistic detachment from your emotions and any inkling of romance, which is not always possible or particularly healthy.

The most passionate and exciting sex occurs as part of an ongoing relationship—whether it be dating or a sexual friendship. Mutual affection supercharges desire, arousal and orgasm. There is nothing wrong with being horny, but hook-ups focus exclusively on lust without any emphasis on becoming real friends and getting to know the hook-up in other ways.

Some of you who hook up are deeply concerned that those you date or would like to date won't find out that you also hook up, which they define as "dirty." I wouldn't call hooking up dirty, but it is extremely limiting.

When your emotions pop out, it isn't you who is the problem—it's your

> Hook-ups focus exclusively on lust without any emphasis on becoming real friends and getting to know the hook-up in other ways.

assumption that you can hook up without having feelings for the hook-up. If you have to hide your hook-ups and your emotions, hook-ups aren't a good choice. Like Melissa, many of you have been hurt when you wanted to continue seeing a hook-up, but the hook-up said "no thanks" or didn't call you or return your calls.

Hook-ups may work better for some guys, but many girls, including Melissa, do not find much joy. She still concluded that hook-ups were fair: "'Everyone is using each other. That's fair.'"

Girls can also be used when they date and think they are in love with a guy who is primarily interested in his own orgasm. More than half of 10,000 teenage girls surveyed by *Seventeen* magazine ("The Hook-Up Report" by Sunny Sea Gold, December, 2004) said guys pressure girls to hook up. No one should give in to pressures or expectations to be sexual.

Guys are sometimes adversely affected by hook-ups too. They may focus entirely on girls as sex objects, leaving them unprepared to be naturally emotional. Some guys and girls become emotional with dates and lead secret lives by simultaneously hooking up with others.

Instant disconnects can leave you sad and empty; it's normal to want a fun connection to continue. Some do. Most hook-ups are temporary, while a few develop into friendships-with-benefits (FWBs). Even if you use condoms (sometimes they break), you put yourself at some risk for STDs, unwanted pregnancies and hurt feelings (see chapters 6, 7, 8 and 9). You don't have to fall in love to have satisfying sexual relationships, but some caring for your lovers is healthier and more rewarding than a sexual connection quickly followed by a potentially hurtful disconnection.

How can you develop emotional and sexual intelligence? You are more likely to be smart about your emotions and your sexual feelings if you date and/or develop sex buddy relationships. **Abstinence from all sex acts isn't healthy–neither is an exclusive focus on hooking up.** If you are horny, you can masturbate without the risks of hooking up.

Sexual Friendships (Friends-with-Benefits)

Simone and Randy meet at a high school dance. Simone is an 18-year-old from France, and Randy is a 17-year-old from Canada. Both speak French and English. Tonight they speak the same language. Simone noticed Randy talking with his friends and she asked him to dance. Their sexual chemistry is instant. They laugh as they touch. During a slow dance, their bodies undulate and fit tightly together. They quickly become aroused by each other's smells and their sexual chemistry is overwhelming. Everyone notices.

Neither Simone nor Randy hook up with strangers, but both feel a powerful urge to get together to become friends-with-benefits. Neither is enthralled with the primrose path of dating and courtship. Some of their friends date. Many have a boy or girlfriend with no freedom to see others.

They briefly discuss their interest in each other, quickly exchanging their cell

phone numbers and their e-mail addresses. Randy walks Simone to her car, and they electrify the night with a lingering good-night kiss.

With eager anticipation for more, Simone e-mails Randy a "How about this weekend?" message when she gets home. Randy is just as excited as Simone. He replies, "Sure, I'd love to. How about Friday night?" Her response: "Great! Do you want to become friends and lovers?" His answer: "Yes, but it is important that we talk and get to know each other first so we do more than hook up." She agrees.

It's obvious that this is the beginning of a fun sexual friendship. They meet at a local teenage club on Friday night. They again dance and laugh and after a while they sit down to talk. Some would call this a date, but to them it isn't. There are no formalities or rigid expectations for an exclusive relationship.

They discuss what being a friend-with-benefits means. They agree that this will be a friendship without destructive games or possessiveness. They feel affectionate and erotic. Their Pre-Sex Discussion provides a foundation for an honest friendship with adventurous sex play.

They talk about how far they should go sexually without getting in over their heads. They agree to make out, pet and give and receive oral sex both ways as a definite stopping point. They acknowledge that they might eventually have intercourse when they are both emotionally ready and effective birth control and STD prevention are in place.

They leave the dance early to go to her parents' home. Her parents are on a

date and won't be home for quite a while.
Simone laughs as she leads him to her bed-
room. They continue their conversation
about each other's lives and their mutual
attraction and they again become aroused
by each other's pheromones.

They continue to kiss and fondle as
they slowly remove each other's clothes.
They saturate each other's bodies with
languishing kisses and sensual, caring
strokes and they playfully give each other
oral sex. Their orgasms are easy and full.
They continue to caress and kiss, but
resist the temptation to go beyond oral
sex to intercourse.

They later agree to have intercourse
when they graduate, and they do. It is a
year later and they still have a solid sex
buddy relationship. Both have recently had
other lovers, but they still prefer each
other. They have scintillating chemistry,
their friendship blossoms with plenty of
common interests besides sex and they have
similar values. Eventually they go on
trips and some would say they date, but
they never use the word.

It's too early to tell whether Simone
and Randy will eventually live their lives
together. They go to the same college.
They have fun as good friends who confide
in each other and share movies and comedy
shows—and as sublime lovers. Both live in
the pleasure of the moment without worry-
ing about the future.

This story is a wonderful example of a sexual friendship that is car-
ing, respectful, trustworthy and lusty. Simone and Randy both fit this
choice because they were mature enough at 17 to deal with their
emotions and their magnetic attraction. Not all of you are ready for

this choice yet. Others have already made this choice; still others will eventually choose one or more sex buddies.

Non-exclusive dating and sexual friendships are healthy and fun if you are emotionally stable. You can become friends when you date too. Depending on how you define dating, these choices are similar and complementary; you may go back and forth between them. In a study from the National Institutes of Child Health and Human Development in 2004, 40% of 12th graders have had sex outside a romantic relationship, which includes both hooking up and friends-with-benefits (Weill, 2005). When asked how many partners they had in a previous year, women 18 to 19 and men 20 to 24 have the most lovers (National Center for Health Statistics, 2005).

Many dating relationships end because one person smothers the other. I like the idea of a friendship where you share a lot—sex and more—without getting overly possessive and jealous. Jealousy doesn't mean you love someone; it stems from insecurity and low self-esteem.

Unlike hooking up, sexual friendships don't exclusively focus on sex. You are friends. When sexual friendships change—let's say you eventually become enamored with someone else—the friendship may continue. It depends on how good your friendship is to begin with. If the friendship took a definite second place to the sex, the friendship may end when the sex ends. Sexual friendships can continue in spite of one or both dating others, but it is crucial that you are honest with all of your partners.

Some label a casual hook-up as friends-with-benefits to avoid being labeled a slut or a ho. Women sometimes blame men for wanting hook-ups because they aren't interested or able to commit to an exclusive dating relationship, but women can be equally fearful of commitment—and equally horny too. Some hook-ups become more.

All of these distinctions should be discussed in a Pre-Sex Discussion and again when you hook up, are sexual friends or casually date. Some try to hook up or have a friend-with-benefits, but they feel guilty because they aren't in love. Their unease may be due to prudishness or a strong need for an emotional connection.

Hurt feelings, STDs and unwanted pregnancies are less likely with respectful and honest dating or sexual friendships than with hook-ups for sex without a relationship. Sometimes one or both hook-ups desire to move on to an ongoing sexual friendship or a more serious dating relationship.

Melissa thought she had a friend-with-benefits, but it was all in her head. Her hook-up had no intention of developing a friendship with her. Instead, he jumped to someone else and left her feeling hurt and rejected.

Real friends don't break up with you. They might change the relationship, or drift apart for a while or forever, but they usually remain friends. Some who date and have sex later decide to be friends-with-benefits even though they are no longer as emotionally involved as they once were. Non-sexual friendships also come and go to some extent, although it is wonderful to have best friends and lifelong friends whether they were or are sexual or not. Sometimes your interests and priorities change and your friendships change accordingly.

Simone and Randy never hooked up. They started with a sex-buddy relationship and it lasted. The advantage of genuine friendship based on non-possessive caring and love is obvious. I know you will discuss all of this with your non-sexual and your sexual friends, and with your dates and perhaps with your hook-ups. I hope you are comfortable enough to bring the subject up with your parents too. You can learn from each other about the sexual realities of your respective eras.

Your e-mail and calls to me are full of worries about how you can ask someone out, what to expect on a date, whether to call someone back, how far you should go sexually and whether it is OK to date someone who is older or younger. You also wonder whether you should date a friend's friend or a brother or sister's friend and you want to know how to emotionally connect with those you have feelings for.

Why worry? Celebrate pleasure by being honest, open, creative and caring with those you like and are attracted to.

Your Dating Questions

Honesty and Trust with Dates, Sex Buddies, Hook-ups (and Parents!)

QUESTION: "I am 16 years old and I feel as though I am old enough to mess around, i.e., oral sex. My boyfriend's

parents were snooping through his room when he was over to my house yesterday, and they found a note we had written back and forth during class about a blowjob. He mentioned how he liked it and wanted to know if I was willing to do it again.

"Well, his parents weren't happy, so they called my parents. Now I am banned from seeing him for a month, possibly even longer. What have I done that was so wrong to deserve this severe punishment? My mother claims that she has lost all trust in me and I will only get to see him again if I can regain her trust. My father isn't bothered by it.

"I am so upset, to the point where I can't eat, sleep or do anything without crying, because I feel as though this is my fault. I can't call him, e-mail him or anything, absolutely NO contact whatsoever. How is this going to keep us from doing anything again? I only gave him a blowjob ONCE, I swear, and my mother doesn't seem to believe me. I've wanted to talk to her about things like this for a long time, but she's not an easy person to talk to. What should I do? Was I wrong to experiment with my boyfriend?"

ANSWER: You and your boyfriend are not at fault. Your father is more balanced than your mother, but unfortunately your father did not negate the inappropriate punishment from your irrational mother. I suspect your mother has her own inhibitions and they've been imposed on you. It's totally unreasonable for your mother to expect you not to communicate with and see your boyfriend.

You need to get your father and mother together so you can attempt to reason with them. Tell them you've wanted to be able to openly discuss sex and relationships. Maybe they will take baby steps toward being helpful parents with this fiasco. This is the only way for you to regain **your trust in your mother**—and for her to

learn to **trust you and to trust herself**. She needs to lighten up and enter the twenty-first century of teenage sexual reality.

QUESTION: "I am 16 and I've liked this girl for about a year and a half, and she likes me as a FRIEND. Anyway, she 'loves' a 19-year-old guy and she is only 15. He never calls her and he doesn't treat her as well as I do. I've been taking her out a lot more and I do everything for her, but she just wants to be friends."

ANSWER: Chill out. She has to go with her feelings. You can't shape them. Be her friend. Maybe someday she will want more, but she might not. Go out with other girls. She has to learn what she wants and whom she wants it with. You are both young. As for the older guy, if she enjoys him, you can't change her mind. Your honesty and sensitivity may eventually make a difference, but she may not be sexually attracted to you. Not everyone is attracted to you just because they like you.

QUESTION: "I'm a nice guy, or so I'm told. The girl I'm pursuing has been playing games. We recently went to a movie with some friends and she said she didn't have any money. So, being a gentleman, I paid for her. I think we were hitting it off, but she didn't even want to sit with me in the movie. I don't know if I was used. What should I do?"

ANSWER: You're kidding yourself. You don't have to pay for a girl to see a movie to be a gentleman. In this case, she sounds like she was using you. It wasn't even a date. There may be something I don't know, but I don't see how she has shown great interest in you. I would not put all of your eggs in her basket.

Go out with some other girls and, if you wish, ask her for some clarification about what she would like from you. You need mutual honesty and open communication. You may end up as platonic friends who hang out, but do not date.

QUESTION: "I would like to ask you a question about a guy that I am dating. I am 17 and he is 18. We go to different schools, so maybe that has something to do with it, but he just doesn't have any idea of how things are supposed to be in a relationship. He thinks that LOVE is when your boyfriend says he is going to go mess around with another girl and you are not supposed to get mad or upset, and you are supposed to love him the same. And I just don't think that is right.

"Should I try to work with him and see if that is what he truly thinks, or should I believe him and just stay back for a while? The way that me and him got together is that he cheated on his girlfriend so he could be with me, but I didn't know he was doing that until she found out and called me. Should I go with the 'once a cheat always a cheat' saying here? He gets really jealous of my guy friends and always wants to know where I am all the time. Is that a bad sign? I don't want to keep putting all of my effort into something that is not healthy for me."

ANSWER: Forget him. He's dishonest, insecure and possessive—not a good recipe for a healthy relationship. I agree with him that dating others does not mean you don't care, but when you are dishonest about it, it comes

Relationships don't last without honesty, compassion and openness.

103

back to bite you. It's bad karma to be dishonest and selfish—it means you aren't sincere or trustworthy.

Relationships don't last without honesty, compassion and openness. He lacks all of these qualities. It's a fantasy of a relationship. You are not married. You act as if you are some big couple; this is untrue and it is unhealthy for you.

QUESTION: "I'm 21. Before my boyfriend and I had sex, we discussed how many partners we had. He told me that he had slept with two other people and they were both virgins. That eliminated any concern about diseases. Well, four months into the relationship we had some problems and he e-mailed me and told me I was 'number nine, not number three.' I was devastated! At that point I had already had sex with him. We discussed the matter, and he said that he was pissed at me when he wrote it, and regretted telling me the truth because he was ashamed of it."

ANSWER: He lied to you. His dishonesty does not make for a trusting friendship. It's hard to trust someone who lies and later regrets telling the truth. Move on to more honest guys. Avoid getting sexually involved until you know someone well enough to nurture a solid friendship. In the meantime, you should be tested for STDs at a local Planned Parenthood clinic or a doctor's office (see Chapter 7).

QUESTION: "I'm 16. I had sex with my ex's best friend, and he isn't sure if he broke up with his girlfriend because he hadn't talked to her about it and he's scared that my ex will find out and hate him. I'm sorry, but if my ex didn't want me to be with other guys, he shouldn't have broke it off with me. So my ex shouldn't even care. My question is how

can I reassure the guy I slept with that
we should be in a relationship?"

ANSWER: None of this makes any sense. You're a teenager having
intercourse in an ill-defined "relationship." You're confusing fantasy
with reality when you think you have an "ex" to begin with. All of this
breaking up is just plain craziness. You can't possess people. Your
"ex" is insecure and jealous. Move on to some new guys and avoid
friends of his. There are plenty of guys out there. Enjoy them.

QUESTION: "I've been going out with this
girl for a little longer than two months.
One month ago she went away for camp. We had
some arguments from the beginning of the
relationship. We decided to 'take a break'
from each other while she was gone. Which is
a way of saying that we were still together,
but we just didn't say that we were. We both
promised not to see other people though.
 "While she was at camp I received a
letter from my friend saying that she was
'doing stuff' with other guys. She returned
home yesterday and I confronted her about
it, and she blew up saying that I should
have written her a letter and asked if it
was true. We are now back together, but I'm
not sure if it was a good decision. My
friends have told me that I should get out
of the relationship, but my heart is
telling me that I shouldn't. I'm so lost on
what to do. Please give me some advice."

ANSWER: You have been dating a girl for two months who dates
others. So what? You should be dating others too. It's normal and
healthy to date more than one. You are not a couple. You could date
her and date others too. I hope she is dating others too. Why can't
you have fun with several girls? Honest fun should be a major goal—
not being possessive and serious.

105

QUESTION: "My best friend, who will be 17 in July, is always in the mood for sex these days. He doesn't have a girlfriend, but he's got a long-distance relationship with another girl that he met on a trip. He has repeatedly told me that he wants his first time to be special, and he says he would love it if it were me. He says I'm that special to him. BUT, like I said, he's my best friend, NOT my boyfriend. I'm not quite sure what to do about this one. I'm not ready for sex yet, and I told him it'd be a while before I even got interested in having any with him or anyone.

"Do I need to talk to him more about this, or leave him alone for a while, or what? I love being around him and don't want to quit hanging out with him, but he gets so close to me and is practically suffocating me at times. I sometimes am a flirt with him and wonder if I need to cut that out too. I only flirt for fun."

ANSWER: You may be leading him on by flirting with him. He's horny and he believes he's ready for sex, and you aren't. He probably isn't ready emotionally, but he thinks he is. I would cool it with him. I would be his friend, but not in a sexual way. If that doesn't work, move on. You sure do not want to be suffocated by him or anyone else. He sounds too needy.

QUESTION: "I am still in high school and old enough to do it (almost). And I agree with you, it's best to date more than one person, but when you're going steady with one person, it's not always a great idea to be dating another at the same time."

ANSWER: If you go steady, you should be **honest** and keep your commitment to the steady. You don't have to go steady. Do you feel pressured into this? You could date **steadily** with a main squeeze and still date others too.

QUESTION: "I am a 20-year-old college student who has a small problem. I went out with a girl for five years and we broke up because she had sex with some guy who was supposed to be her best friend. I hated her for that, but the funny thing is I still love her. I live with it because I let the hate dominate. I tried to go out with other people and get her out of my head. I still have strong feelings for her, but I know there could never be anything between us again. Please help me."

ANSWER: Your problem is common. You got involved exclusively at much too young an age and you apparently had intercourse before you were ready. Too early sex can easily confuse you into thinking you love someone. **Sex is sex, and love is love. Sometimes they go together and sometimes they don't.**

In your case, you think you love her, but I suspect it's mostly an ego need. Although it isn't the norm, best friends are sometimes sexual with each other—it isn't just boyfriends and girlfriends who have sex. Let go of the past and get into more productive dating relationships. Live in the pleasure of the moment; those who dwell on the past aren't happy campers.

> Sex is sex, and love is love. Sometimes they go together and sometimes they don't.

QUESTION: "My friends are seniors in high school, and they go to different schools. They are with each other every

waking moment—after school, on weekends and every night. I was talking to him and he said that he and his girlfriend are considering marriage after they graduate.

"I have tried to tell him some of the things that you discuss on the show, but I can't get through to him that it is a bad idea. They have been going out for one year, and he has told me that the only reason that he has not already asked her to marry him is because of their parents. Is there anything I can do to tell him that this is not a good idea? This is his first love."

ANSWER: Your friend has to come to his own conclusions. Point out that **the younger you marry, the greater the chance that you will divorce**. They need each other in an obsessive, insecure way. This will lead to nothing but mutual misery—misery loves company. I'm sure their parents will discourage early marriage. They also should discourage such an all-encompassing dating relationship at such young ages.

The younger you marry, the greater the chance that you will divorce.

QUESTION: "I am 20 and currently battling depression. I recently broke up with my 19-year-old girlfriend who lives quite a commute from my home. We had an awesome relationship for a year and a half. Her reasons for breaking up were because of the transportation problem and a new guy friend she met at work. Up until a few weeks ago our relationship and sex left no doubt in my mind that she loved me too.

"I am devastated that she would let me down so hard. I am familiar with your

views on serious love at such a young age, but my question is how do I deal with this overwhelming depression? I don't want to eat, sleep or exert any constructive energy. What should I do?"

ANSWER: Your depression might not have occurred had you taken my advice not to be so serious at your age. You became attached, in part because of the sex. The distance you had to travel took its toll on your relationship. You need to pour yourself into your career plans, your friends and your family. You'll find other women who are closer by to date. It will take a little time to let go of the past, but you will do it. Someday you will look back on this as a misguided choice that led to a breakup.

QUESTION: "OK, there is this guy that I really like, but we are good friends. He knows that I like him and he likes me, but the problem is that he's afraid if we go out, we could break up and not be friends. So I guess that's what's keeping us apart. How can I get him to believe even if we do go out and break up we can still be friends?"

ANSWER: You need to relax and talk with him. Don't pressure him to go out with you. Take your time to see what happens naturally. You could reassure him about your friendship and you could tell him dating him is what you'd like and you'll always be his friend. Then it's his choice. Respect and honor his choice. See others too.

QUESTION: "I have a real problem falling in love too easily. I have been through a lot of bad experiences with girls. About two weeks ago I went up to this girl who I had been admiring for some time and used some stupid line that worked. We met after class and talked for about two hours. She gave me

109

her number and we talked on the phone and over the Internet before our date.

"Her boyfriend of two months cut off all contact with her, and when she went clubbing she ran into him and danced. Then she went out with me, but she only wanted to be with the other guy. Should I lay low and be her friend until things die down or should I talk to her about our relationship? Is it possible for this girl to like me, see this other guy and then lose all feeling she had for me?"

ANSWER: You don't **have** a relationship with her; it's pure fantasy. You had some interaction and one mild date. She is tied up with someone from her past. Move on to some girls who are more together and available. You are much too wound up with her. This is not healthy. You need to be more playful and light—you take yourself far too seriously.

QUESTION: "I have a problem with obsession. I'm 20, and a little over a year ago I met my first love. It was an on-and-off relationship for nearly eight months. We never had intercourse, but I spent many weekends with him and slept in the same bed. My relationship with Josh has pretty much ended, but when I am not with him, I feel empty. I cannot date anyone else. I cry almost every day."

ANSWER: You need to see a professional counselor or therapist. You're dwelling on a relationship that never got off the ground. You need to get beyond your depression and live in the present rather than the past.

Date and Be Sexual with People Close to Your Age

I get lots of e-mail and questions about whether it's OK to date someone who is quite a bit younger or older. As I stated in Chapter 1, you are much better off with someone close to your age while you are teenagers and young adults, but age makes little or no difference as you get into your mid-twenties and beyond. Now let's take a look at your questions.

QUESTION: "Hi. I've been going out with this girl who's three years younger than I am. And the problem is that when we're alone, the only thing I can do is try and sleep with her. She always says no though. Other than that, we fight all the time. She's really attractive, and I don't know what to do."

ANSWER: If you fight all the time and all you want to do is sleep with her, it doesn't matter how attractive she is because it's a total mismatch. She has made her answer clear—honor and respect her answer. Find someone who has some common interests with you, and don't just focus on sex.

Making out and petting will come in time with a girl who has mutual feelings and chemistry with you. Most girls do not want to spend all of their time being sexual with you. A more balanced relationship is more fun and it will last longer. Date different girls and become their friends.

> A more balanced relationship is more fun and it will last longer.

QUESTION: "I was wondering what you thought about relationships with large age gaps. I am 17 and I have been seeing this guy for a while now. He is 30. Yes I said 30. I feel very close to him and he has given me all of my sexual experiences.

111

I know something is not right because we never go out. We always stay home and 'fool around.' I love to do this, but I do wish for the normal things girls my age get. You know, like holding hands in public and stuff like that.

"My parents know about him. And I have to sneak around to see him. I have betrayed my parents (who trust me greatly), friends, and others that I love. I am a strong Catholic and I have trouble dealing with my choices. I do not plan on waiting until marriage for sex, but I do plan on waiting until I graduate from high school. I am 'the good girl.' Top 10% of my class, Beta club, band, National Honors Society, debate. No one would ever expect this behavior from me. But I guess that when it comes to love and lust everyone can be caught."

ANSWER: You know in your heart that a 30-year-old who only wants to "fool around" with a 17-year-old is exploiting her. He might not be too old for you when you are several years older, say 25 or so, but he is too old for you now. Depending on the state you live in, the age difference might even land him in jail for statutory rape.

You are not behaving in a way that is reasonable, honorable and sincere. You need to make a clean break from him. I would tell your parents and friends the truth and live a more honest life. You are much better off dating guys closer to your age—within a few years either way. If you try to grow up too fast, you will continue to miss out on the experiences you already miss. .

QUESTION: "My boyfriend is 27 and I am 16, but he thinks I am really 18. We have been going out for almost six months and I love him more than anything. He treats me so well and I really don't want

to lose him. Also, his friend is 25 or 26 and he is married and we have all been talking online lately. And he has been hitting on me lately. He is really cute, and I love him like a brother, but I don't want to lose my boyfriend. What can I do?"

ANSWER: Your boyfriend is too old for you at your age. If you had intercourse with him, he could be charged with statutory rape in many states. The married guy is dishonest and is too old for you too. Forget both of them. You can get involved with the wrong guys online, so be careful about meeting online. It's easy to confuse fantasy with reality and it's hard to tell when someone is honest online. Face-to-face meetings are best.

QUESTION: "I'm currently dating a guy a few years younger than I. I feel that our relationship as boyfriend/girlfriend doesn't really 'click.' I want to break off the relationship, even though he loves me a lot. I'll still be his friend. We've been dating for about six to seven weeks. He is 15 years old.

"I've always believed that age shouldn't matter in a relationship, but I realize that I have to draw the line. I'll be 19 in a little less than six months, which would make me an adult and him still a child. I want to give him a few good reasons why our relationship just won't work (besides age differences). My question is, what are the major factors that are important for relationships? I can only think of two: mutual love and physical attraction."

ANSWER: You need more than mutual love and chemistry. You have to have common values and interests, and none of this is feasible with a 15-year-old boy. You need to see guys a little older than him. Try 18 to 22 or so, and in a few years you can go older than that.

113

QUESTION: "I have a question concerning a girl I like. You see, I like her, but I don't know if she likes me. And I have to know, or else I can't take the next step and ask her out. What signs should I look for to know if she likes me? And if one of the answers is flirting, please describe flirting."

ANSWER: You need to take a deep breath and relax. Flirting is innate behavior. Some are more polished than others at expressing their flirtatious feelings. It's in the eyes and what your body language expresses. If you are open and not closed off with your body and if you are playful in a light and humorous way—with a touch of erotic anticipation—you are a flirt.

Some flirt just to flirt, and others mean it—they are sincere about wanting to go out with you. Liking can also be expressed by a glance or a comment. Listen to words and notice body language and what the eyes and facial expressions have to say. All flirtation is not blatant. Some of it is subtle. Enjoy.

QUESTION: "My boyfriend has his tongue pierced and it's awesome. Everything is great except that I am 16 and he's 21 and in college. I really like him, and he's the one that I lost my virginity to. I'm afraid that he might get caught and sent to jail. He's perfect for me. He's just like me, preppy and nice. I don't know what to do. I love having sex with him and he's perfect."

ANSWER: Let him go for now. Five years is not too much of an age difference when you are 18 and he's 23. You're too young to be sexual with a 21-year-old. Depending on the state you live in, you may be below the legal age of consent; he could be charged with statutory rape.

Avoid more intercourse until you are at least 18. You can get yourself into big trouble with your parents and with yourself and others emotionally, and you might have to hassle with a possible

unwanted pregnancy and/or STDs. Date some high school guys. You are vulnerable to making a mistake that you will regret.

QUESTION: "I am 17. I want to tell this guy who is 23 that I want to get closer to him, but he has said that nothing more than a friendship can happen. But I feel as though he is holding back, maybe because of his sister who is my friend, or because our age difference might bother him.

"You're a man. Would you know why he would say that but not act like it when we are alone together? And I have asked him but he always avoids the question. We were on his couch and we started tickling each other, and before I knew it he was pulling me on top of him, and I was pulling back so all of a sudden he ended up on me."

ANSWER: Relax and realize that the guy is saying he doesn't want to get involved. He may be interested in sex with you, but no more. I would avoid being alone with him. He doesn't sound totally honest. Your relationship with his sister could be damaged too. Just a few years can be a huge difference when you are in high school. Age doesn't usually matter when you are older.

The complexities of your sexual choices are worth some new knowledge and fun times experimenting with caring sex. You've been inundated with erotic images from Abercrombie & Fitch catalogs, MTV, *Sex and the City* and porn on the net. There's little wonder that you are curious about and interested in sex, dating and affection; your fantasies are in overdrive from sexual saturation all around you.

Whether you date, hook up or have sex buddies, sex is an important part of your life. The next chapter challenges what it means to be a virgin. It covers the pleasures of making out, petting, outercourse, oral sex and intercourse, and how to enhance sex and sexual health and solve sexual problems.

5

FROM PARKED CARS TO EMPTY HOMES:

Will the Real "Virgins" Please Stand Up? (and Make Out!)

> "I am 16. I've always believed that sex was a magical thing. I've told myself I was going to wait until marriage to have sex. This weekend I had a convention with my youth group. I 'hooked up' with a girl there. The second night we did something that I will always regret. I put my penis in her for a total of one second. I freaked right after it happened. Being a virgin was something that I was extremely proud of. I don't know why this happened, but it did. I have an incredible amount of guilt. I guess the question I have is am I still a virgin? It was only in for one second, if that. I'm really scared."

Is this guy still a virgin? To be or not to be…a virgin. But who is a virgin? Why is being a virgin defined by some to be a prize or a gift? Most books, including a book about younger teenagers, *The Real Truth About Teens and Sex* (2005) by Sabrina Weill, claim that intercourse instantly transforms you from being a virgin to a non-virgin.

To many, virginity is "lost" in a few strokes. Why is intercourse the only sex act that results in a "loss" of virginity or innocence? Why is this fearful 16-year-old guy obsessed with being a **technical virgin**— a meaningless term? It's like saying you're a little bit pregnant.

Focusing on intercourse as the sexual rite of passage allows you to rationalize experiencing orgasms in other ways. An orgasm is an orgasm is an orgasm. To some, you don't lose your prized status as a virgin if you don't have intercourse. They apparently view themselves as **penetration virgins**!

Are you a virgin if you've had oral sex to orgasm, but not yet had intercourse? Blindly accepting irrational abstinence propaganda, a few call themselves "**secondary virgins**." They mistakenly believe they can start anew by repenting and pledging not to do it again until marriage. Are you a virgin if you haven't had intercourse in a while? If so, how long is a while?

Virginity is a state of mind more than a physical condition.
The traditional definition of virginity focused on a girl's hymen, a thin membrane inside the vagina that is broken by intercourse or by riding a horse or other physical activity. In the past, virginity was a way to control female sexual pleasure to assure that girls were "protected" or pressured to refrain from intercourse until they were prepared to reproduce in marriage.

In the modern era, the only thing the vast majority of brides and grooms lose on their honeymoon is their baggage. In spite of the government's emphasis on abstinence, there is no empirically verifiable trend toward fewer people having intercourse before marriage.

The median age of marriage has gone up to 25.1 for women and 26.7 for men, and the rate of those 30 to 34 years old who have never married has almost quadrupled since 1970 (Vanessa Ho, 2004; Associated Press, MSNBC, October 13, 2005). It isn't surprising that very few wait until marriage to experience intercourse. **Large studies indicate that about 80% have intercourse by age 20–and a reasonable estimate is that 10% or less are technical virgins at marriage** (Dr. Ira Reiss, phone call, July 27, 2004).

Sexual pleasure, whether it be intercourse, oral sex, outercourse, making out or petting is a **gain in freedom** rather than a loss of anything. In his famous seventeenth century poem, "To the Virgins, To Make Much of Time," Robert Herrick advises young people to "Gather ye rosebuds while ye may..." Why feel guilty about intercourse more

117

than other orgasmic sex acts? Only you can determine what is moral, sensible, responsible and appropriate.

Why take all of this so seriously? When a guy asks if he was "the first," girls often reply, "Why do all you guys ask that?" Can you imagine public announcements—similar to a wedding announcement—applauding a person's official introduction to intercourse?

When I was a teenager, most of us made out, petted and groped in parked cars, but few of us had oral sex or intercourse until we graduated from high school.

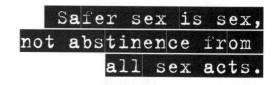

Fear-based health education was useless. We learned by trial and error; the lack of openness about sex made it confusing and frustrating.

The high school dance was symbolic of the uncertainty and inadequacies we felt about sex and dating. This is still true. The lack of an agreed-upon sexual etiquette makes it difficult to communicate and satisfy your desires. You still have a clumsy dating dance; some of you are unsure about the proper steps toward mutual pleasure and affection.

Your sexual journey is even more perplexing than it was for your parents. Most of you prematurely rush intercourse while schools fail to offer anything resembling objective, comprehensive sex education. Because of abstinence funding from Congress, "sex education" is almost always the fear-based, ineffective, abstinence/sex-is-a-problem approach.

Safer sex is sex, not abstinence from all sex acts. Abstinence is not a **sexual** choice; it's a choice **not** to give and receive erotic sensations. The abstinence movement demands "Just-Say-No" pledges not to have intercourse before marriage, but the tone of this sex-negative movement discourages other healthy non-marital sex acts too.

When you "have sex," it usually means you have intercourse. To many, nothing short of penetration counts as **real sex**. This is preposterous. **Oral sex is sex.** The same motives and meanings are behind petting, oral sex and intercourse. Why should intercourse be morally wrong, while petting to orgasm and oral sex are acceptable? Oral sex has all but replaced the goodnight kiss, it's just embarrassing to do on a doorstep.

Moral distinctions between oral sex, intercourse and other sex acts can be traced to some, but not all, religions. Each of you can

find peace in yourself with your own code of morality and your inter-pretation of your chosen religion.

Why should sex, primarily intercourse, be viewed as sinful or bad? Even some who are not devout use these distinctions to justify sex: "It was only a blowjob" and "he only went down on me" are rationali-zations for orgasms that don't make you feel guilty. Unless you are coercing or forcing sex, why feel guilty about it?

If the same motives and meanings are attached to intercourse as oral sex, what is the difference? If you are horny and/or need an emotional connection, how is oral sex more moral than intercourse? How about if you've had anal intercourse, but not vaginal intercourse? In the *Seventeen* magazine survey of 10,000 teenage girls (2004), a whopping 38% believe you are still a virgin if you've had anal sex. This makes no sense.

Definitions of what sex is and which sex acts are moral and immoral are like giant weights on your shoulders. Even the most lib-eral young adults can be pulled down by these unnecessary, illogical burdens in your present and future lives.

How would you determine if a lesbian or a gay is a virgin? Does engaging in oral and/or anal sex mean you are no longer a virgin only if you are not heterosexual? As teenage web publisher Heather Corinna astutely observes, "Defining sex by male-to-female inter-course would make a lesbian who has had over one hundred part-ners, but no male partners, a virgin" (Scarleteen.com, 2004).

As long as you are with someone who cares for you, it's natural and normal to experiment with sex. You can experience orgasms from mak-ing out, outercourse, mutual hand stimulation and oral sex. Once you are emotionally ready for intercourse, you will be a better lover **because** you were **smart** enough to learn about sex **gradually**, rather than rushing sex acts that you were not able to **sensibly** deal with.

Some of you use the baseball analogy for sexual bases. First base is usually intense kissing and light fondling. Second base is typ-ically heavy petting and perhaps outercourse. Oral sex is often defined as third base and intercourse as a home run. These bases can be reasonable "stopping points" that are agreed on during a Pre-Sex Discussion (see the next chapter).

This book takes a Just-Say-Yes approach by suggesting responsible sex acts you can enjoy with relative safety. You don't have to rationalize that it's OK to be sexual as long as you are

swept away by uncontrollable lust or love or if someone else gives you permission.

It's better to "lose" your virginity than to lose your integrity. Be honest with yourself and your partners. I hope you will honestly discuss this book with friends, dates, parents and other adults.

Affirm Pleasure Through Your Senses

Dr. Lionel Tiger states, "The sexual spasm is the most physically pleasurable human event" (*The Pursuit of Pleasure*, 1992). Orgasm involves involuntary muscle contractions that release sexual tension from escalating arousal. Not surprisingly, few willingly abstain from orgasmic pleasure.

Orgasms are healthy and relaxing; your mental and physical health is enhanced by intense orgasms. Research shows that you live longer when you experience frequent orgasms. The mind is critical for orgasm; a mind free of anxiety and guilt is more likely to send signals through your nerves to your genitals to stimulate orgasm.

Erotic fantasies and dreams encourage orgasm. Eroticism in romance novels, *Playboy*, chat rooms and on web sites sparks arousal and orgasm. Unfortunately, pleasure is often defined as a scarce resource. Attempts to censor explicit lust by the government and conservative groups are motivated by an unhealthy, obsessive need to control your fantasies and sex acts. As citizens, **you are entitled to pleasure** and to your own choices. You aren't young children—**you are adventurous teenagers and young adults**.

Pleasure is often put down as an impediment to work. Why isn't there a sense of balance between work and play? If hard work is so terrific, why are so many too busy and stressed out to delight in playful pleasure? Why not encourage less work and more play—including sex play from the welcome collaboration of your eager senses?

Come to your senses. Your senses are your excitable pleasure receptors. When you French kiss, make out and fondle each other, your seven enlivened senses are in overdrive. Celebrate the richness of smell, taste, sight, touch and sound, and gladly use your sixth and seventh senses: your intuition and your sense of humor.

You know when you are aroused. Your brain functions by remote control full speed to your genitals, telling you how to savor your senses to celebrate your sexuality. What a heady experience arousal is. You are totally free to let

your senses and your emotions saturate every sensation. The endless fantasizing capacity of your brain amplifies your willing surrender to pleasure.

Each of your senses combines to arouse you. It's wonderful to immerse yourself in the depths of your sensuous senses. Whether it's lust at first smell (pheromones), or at first sight, touch, taste or sound, fully engage your senses to give and receive pleasure.

Erotic desire is embellished by your ecstatic senses in cooperation with your brain and your heart. Let's look at what each sense has to offer your pleasure.

It's popular to ascribe initial attraction to looks and personality, but your most visceral sense is **smell**. Girls are more aware of their sense of smell. According to Diane Ackerman, "For those of exquisite sensuality, there is nothing headier than the musky smell of a loved one moist with sweat" (*A Natural History of the Senses*, 1990). For both sexes, natural pheromone odors in body hair stimulate arousal more than perfumes.

Your skin is your largest sex organ, essential to a sophisticated appreciation of arousal and orgasms. **Touching** is usually intimate; it arouses and heals. Some touch is sensual, like a soothing massage, while other touch is pleasingly sexual, like an erotic massage.

The first kiss is often your first touch with a new

> The mind is critical for orgasm; a mind free of anxiety and guilt is more likely to send signals through your nerves to your genitals to stimulate orgasm.

lover. During a kiss you touch, smell, taste and hear sensations. Emotions are expressed through a loving touch or a firm movement toward engorged arousal. The closeness you feel after orgasm is encouraged by **afterplay**—prolonged gentle touching and caring cuddling.

As soon as you touch with your lips and tongues, you **taste** the sweetness of unleashed desire. Pungent smells and tastes magnify the effect of each sense; your taste buds and salivary glands are two of pleasure's allies.

If smell doesn't immediately engage you when you meet a sexy person, **sight** often enlivens early desire and arousal. Eye contact can be extremely exciting. Your eyes love novelty.

Guys are more visually aroused than girls, but more girls are revealing their interest too. A guy's muscle tone and the shape of his buttocks are a focus for girls' approving eyes—and hands. Flirtation depends on brief eye contact. Prolonged eye contact is staring—not polite or arousing.

Sensual music and soothing words contribute to eroticism. A sultry voice can relax and/or excite you. **Sound** is the basis for flirtatious overtures and a potent signal for arousal and orgasm. Moans, groans and screams communicate and embellish pleasure.

Your sixth sense is your **intuition**, that almost indescribable gut feeling that you should or shouldn't be sexual with someone. Intuition involves knowing yourself well. You could have a lust for someone without feeling comfortable with her/him. Intuition depends on your other senses to give you clear clues about what is appropriate. **A Pre-Sex Discussion** allows you to intuit and make sensible choices (see the next chapter).

Your **sense of humor** is your seventh sense. It's a lot easier to be with a person you can laugh with; it's more fun to be sexual with a playful, witty and imaginative lover. Humor facilitates orgasms by freeing up your mind. Humor provides a **balanced** view of yourself and your partners. Share some laughs on a date—watch the comedy channel or a romantic comedy together.

Pleasure and pleasure receptors are basic for your sexual health.

Fine-Tune Your Sexual Health

Your sexual health is essential for your wellness. If you don't take care of your health, your sexual health suffers too. Pleasure and orgasms are as valuable as exercising, eating a healthy diet, satisfying sleep, laughter and taking your daily vitamins.

Those who eat junk food aren't as sexual as those who eat a diet low in animal fat and high in fresh vegetables, fruit, healthy protein like fish, and grains. Exercise is essential to fine-tune your sex life; healthy blood flow and vital hormones are heightened by frequent aerobic exercise. Swimming, biking, running, hiking and tennis are examples of healthy exercise.

In addition to exercise and foods, herbs can positively affect your sexual wellness. Damiana, *Tribulus terrestris* and muira puama are examples of natural substances that may enhance desire and arousal.

As I mentioned in Chapter 1, alcohol and nicotine are negatives for sex.

Alcohol numbs your main sex organ—your brain—and nicotine restricts blood flow needed for maximum arousal. Tobacco and alcohol also dull your sense of smell, which makes you less than fully sexual. If you want to say an unqualified yes to sex, you need to say no to alcohol and nicotine.

You live in an overly medicated society. Prescription drugs, including many antidepressant drugs, especially selective serotonin reuptake inhibitors (SSRIs), such as Zoloft® and Paxil®, restrict desire, arousal and orgasm. If you are on an antidepressant or another drug, ask your doctor about negative sexual side effects. If you are on drugs that work against your sexual health, request a sex-positive drug from a medical professional.

Drugs aren't the only answer for negative emotional states. Counseling, self-help books and exercise help lower depression and anxiety. As a cognitive therapist, I know you can learn to let go of fearful, irrational, negative thoughts to become happier and more sexual (see Chapter 9).

Your relationships are important for your sexual health too. Relationships are more intimate and fun if they are based on equality, openness, honesty, sensitivity and adventurousness. If your relation-ships drain you emotionally, you need to improve them or move on to more positive relationships. Healthy relationships, whether they involve dates or sexual friends, need support from honest communi-cation, shared values and experiences and mutual concern.

Once you are sexually healthy, you can focus on being an awe-some lover. You will profit by understanding the fun-filled intricacies of kissing and making out, fondling, outercourse, oral sex and intercourse.

Delight in Thrilling Sex Acts

Let's begin with **kissing and making out**. Mouth-to-mouth resuscita-tion is the most underrated, exciting pleasure this side of heavy pet-ting. Deep, wet and hot kissing is a long-lost art. Intertwined tongues are so exciting. Whether wet or dry or long or short, kissing is a pas-sionate sex act.

You can tell whether your chemistry is strong by the way you kiss. Kissing is a marvelous way to tease out what arouses a new lover. Practice makes perfect—each lover desires to be kissed in a unique way. A great lover is a great kisser. You can tell a lot by the way you kiss. Try some deep, wet French kissing and have some fun.

Making out is heavy kissing with fondling and garment groping. Petting is a popular American—and European—pastime. Some pet

above the waist, while others enjoy stroking genitals to orgasm. You may believe you invented heavy petting, but everyone started as a teenager, including your parents.

Sensual strokes of easily aroused body parts will fly any enthusiast to sexual heaven. If you take off each other's clothes, explore giving and receiving an erotic massage with a soothing lotion or oil.

Outercourse is another **stopping point** before oral sex and intercourse. With or without clothing, outercourse wakes up genitals by simulating intercourse without penetration.

Guys should be careful not to ejaculate near the vagina—it's possible for sperm to swim into and up the vagina, possibly resulting in a pregnancy **without penetration** (see Chapter 8). Also, genital skin-to-skin touching could transmit herpes or genital warts if either of you has one of these STDs (see Chapter 7).

Depending on your previously agreed on "stopping point" (see the next chapter), some of you may give and receive oral sex. Oral sex is nearly universal with older teenagers and young adults.

Girls often

> Guys should be careful not to ejaculate near the vagina—it's possible for sperm to swim into and up the vagina, possibly resulting in a pregnancy without penetration.

enjoy **fellatio**—sucking and licking a guy's penis, usually culminating in ejaculation and orgasm. **Cunnilingus**—gentle licking and sucking of a girl's clitoris—activates full-blown erections for a guy and intense pleasure for a girl. A girl's G-spot can simultaneously be massaged by finger(s) while receiving oral sex, often resulting in powerful orgasms. Simultaneous giving and receiving of oral pleasure is known as the "69" position—a bit athletic, but fun.

A word of caution about oral sex: If you aren't certain about the STD status of your partner, use a latex or polyurethane condom for fellatio (see Chapter 7). For additional STD protection, some girls and guys use Saran Wrap or a dental dam to cover the vulva and vagina during cunnilingus. If you use barrier protection, you can

increase the girl's pleasure by using a few drops of a water-based lubricant on the side of the barrier touching her.

Intercourse, vaginal and anal, is a source of much pleasure, but there is a greater risk of STDs than from other sex acts. Always use a latex or polyurethane condom and a water-soluble lubricant like Astroglide or K-Y Liquid to protect you from breaking a condom and contracting an STD or causing an unwanted pregnancy (see chapters 7 and 8). If you are at least 18 or 19 and have confidence in a **Pre-Sex Discussion**, intercourse may be an appropriate choice.

Use your imagination to experiment with a variety of sexual positions. No one position is best for all. Some prefer the man on top—the missionary position—while others enjoy the girl on top, vaginal rear-entry or side-by-side intercourse. There are many more positions that you can discover with an imaginative lover. There are several books devoted to photos and drawings of basic and more exotic lovemaking positions; see The Yellow Pages for Sex.

Be playful and laugh together. The Eskimos call making love "laughing time." When you consider the positions you get into during foreplay, oral sex and intercourse, sex can be really funny. Can you imagine telling a lover you want to try the double angel ankle lock position—and the lolly plop flop and the bull hog grind positions? These frivolous labels should make you laugh and experiment with several pleasurable positions.

Discussing preferences before, during and after intercourse increases mutual gratification. Sex talk during intercourse and other sex acts can be arousing and fun. Use active verbs.

Intercourse is better if both sexes faithfully do Kegel exercises. Kegels bring out the G-spot for enhanced stimulation for the girl, which can result in gushing G-spot ejaculations and orgasms. Similar exercises for the guy improve the quality of an erection and prolong intercourse before ejaculation.

How do you do Kegels? Locate the pelvic floor (pubococcygeus, or PC) muscle by stopping the flow of urine. Once you find the muscle, breathe in deeply from your abdomen without holding your breath. While you breathe in, contract the PC muscle for a few seconds, then release the muscle as you exhale. Repeat for five minutes twice a day. Do your Kegels while sitting in the library, in class or while doing any other routine activity.

Like any other muscle, your PC muscle will become sore if you

overdo the exercises at first. After a week, you can hold the muscle for ten seconds as you breathe in and out. Girls: Insert a finger or two in your vagina to be sure you are contracting the correct muscle; you should feel the vaginal muscle tighten around your finger(s).

For guys, the PC muscle is at the base of your penis. You can improve the strength of your PC muscle by doing the routine described above and by adding a series of rapid on-and-off PC muscle contractions to your "work out." After about eight weeks of twice-a-day Kegels, you should notice improved arousal and orgasms.

Sex is a welcome joy, but sexual problems are important to deal with too.

Solve Sexual Problems

Sexual problems often have more than one cause; there are physical/medical, mental and relationship issues to deal with. You can usually solve problems by talking about them with a lover, doctor or sex therapist. Sometimes a parent or another adult can help too.

If you have **low or inhibited desire**, there are usually several pieces needed to solve your puzzle. You need to discuss your lack of desire with current and potential lovers. Communicating openly about any problem is crucial to solving it. If you have anxieties or you don't feel close to a lover, talk about your feelings; discuss what is bothering you and how it affects your relationship.

Many prescription drugs, fatigue, poor diet and a lack of frequent exercise result in low desire. If you are overweight, lose some pounds and you'll have

> **Many prescription drugs, fatigue, poor diet and a lack of frequent exercise result in low desire.**

more energy—and a more robust libido. You will desire sex a lot more if you have a positive and sexy body image.

Either sex could have a hormone imbalance, mainly low testosterone, but hormones don't lag for most of you. Your hormones are probably raging. If hormones could talk, they would exclaim "I want sex now!" This is one reason why hooking up has become a pop phenomenon.

Birth control pills can lower desire for **some** girls, but Depo-Provera shots can really do a number on a girl's desire (see Chapter

8). A blood or saliva test from a doctor can inform you about your hormones, but unless you have good health insurance, the tests could cost more than you can afford.

Anxious, depressed and angry thoughts lower your desire too. If you obsess about anything—not just sex—your thoughts aren't **pure** enough to provoke desire. If something in your relationship makes you unhappy, it's normal not to feel much desire. Your lover might be short-tempered or have bad breath. Figure out what is bothering you and bring it up so you can be more relaxed, comfortable and motivated to give and receive pleasure.

Low desire can also be caused by a lack of sexual chemistry; if your smell/pheromone attraction isn't there, you are probably with the wrong person for a sexual relationship. You don't have strong chemistry with everyone. No doctor or sex therapist can create chemistry—it's there or it's not there.

> Guys and girls who don't feel or express affection aren't as sexual as those with positive emotions.

Inhibitions are negative thoughts that should be exchanged for positive thoughts and fantasies. Unlike low desire, **inhibited desire** can result from parents or others who shame you into feeling guilty about sex. You need to rid your brain of any distorted thoughts that view being sexual as a bad thing.

Inhibitions are also caused by being mentally, physically or sexually abused. If you've been abused, see a counselor or therapist who specializes in abuse so you can put it all behind you (see Chapter 9 and The Yellow Pages for Sex).

Both low and inhibited desire can also be caused by a lack of positive emotions, which are based on your thoughts. Affection makes sex more passionate and more satisfying. Guys and girls who don't feel or express affection aren't as sexual as those with positive emotions.

You can learn to become more emotional by changing your thoughts. Sometimes a counselor or therapist is necessary to help you become more emotional and improve your self-esteem. **Healthy self-esteem encourages sexual confidence.** If you feel good about yourself, it is easier for others to be around you. If you don't

have positive feelings about yourself, **choose friends who support and love you**. Negative people can bring you down. Stay up!

In addition to low and inhibited desire, some girls experience **painful intercourse**. All girls do not feel pain the first time, but some do. Some girls bleed if they still have their hymen. Gently stretching the vagina with clean fingers can help prepare the vagina for intercourse as can a water-soluble lubricant applied to a condom.

It's important to have lots of foreplay—hand and mouth stimulation of all hot spots—before intercourse. **Foreplay helps a girl lubricate well. As a result, pain is less likely, and orgasm is more probable.**

If a girl is anxious about pain, she is more likely to tense her vaginal muscles. Tense muscles can cause pain, partially from a lack of natural lubrication. Sometimes a girl is too tense to admit the erect penis—**vaginismus**—a clue that something is not quite right. It may mean she is not comfortable trying intercourse yet, at least not with the guy she is with. Girls need to listen to their bodies. A mind/body connection is essential; be sure both your mind and your body cooperate to bring you pleasure.

A vaginal infection or an STD can also cause pain (see Chapter 7). Do not have intercourse if you believe either of you have a vaginal infection or an STD; you could transmit the infection or STD to your partner and you could feel pain. See a medical professional if you continue to have pain; you might have a medical condition requiring treatment.

Some girls and guys don't get **fully aroused** from intercourse and other sex acts. Lack of arousal is affected by anxious thoughts and a lack of attention to each other's comfort and preferences. To become thoroughly aroused, you need to relax and breathe deeply from your abdomen.

A yoga class helps you breathe deeply to relax and expand your arousal. Your instructor might not talk about the relationship between breathing and sex, but it's there. This should help the quality of your arousal, with better lubrication for girls and harder erections for guys.

128

If you are worried about someone discovering you in the heat of passion, pick a place and time that is private and quiet. If one or both of you aren't aroused, take more time, or agree to put off intercourse until you are clearly ready and aren't rushed or anxious.

Some of you who have had intercourse don't feel much pleasure yet. You have to be with a lover you really **want** to be with. And your timing should be just right.

More foreplay and becoming more imaginative, playful and skilled should increase your pleasure. If intercourse isn't immediately delightful, don't assume that it won't get better. The first time isn't always as thrilling as subsequent erotic episodes, but some first times are fabulous.

Orgasm can be a problem too. Some of you worry that you aren't having orgasms or you're not having them when you want them. For girls, the lack of orgasm is called **anorgasma**. For boys, it is typically ejaculating too quickly—**premature ejaculation**.

Some girls have never had an orgasm. As you learned in Chapter 3, masturbation typically results in a girl's first orgasm. Using a vibrator in the clitoral and G-spot areas increases a girl's chances for orgasm. Oral sex and hand stimulation often are orgasmic. The emphasis should be on sensual clitoral stimulation, but nipples and the G-spot are important orgasm hot spots too.

Since orgasm is largely a mental event—your brain is your main sex organ—a girl needs to free up her mind so she doesn't have distorted thoughts that negate orgasm. If a girl thinks, "I know it will never happen," it probably won't. Visualizing orgasm during erotic fantasies helps you experience one or more orgasms. Obsessing about it decreases your chances. If you don't take orgasms too seriously, you are more likely to experience them.

Getting beyond embarrassment and inhibition by changing thoughts and choosing sensitive lovers encourages orgasm. It's a good thing to talk about your feelings, fears and fantasies. This includes talking about what feels good during sex play. If you want a different touch manually or orally, express your preference.

> Visualizing orgasm during erotic fantasies helps you experience one or more orgasms.

Experiment with different positions with oral sex and intercourse. Don't fret if you don't have an orgasm; you probably will in time. Don't fake orgasm; those who fake it have a hard time getting it right. All lovers need honest feedback on what feels good and what doesn't feel so grand.

It's not just girls who fake orgasm; some guys fake it too. Why fake pleasure—to get it over with or to make your lover feel that she/he is great? You don't give another person an orgasm; he/she gives it to him or herself. It is your mind that induces orgasm; your mind has to be free and focused enough to inspire your body to orgasm.

The mind is central to a guy lasting long enough to be satisfied and to fulfill his lover. If a guy is anxious about pleasing his lover, he is more likely to ejaculate quickly—premature ejaculation. This is a very common problem, especially with young guys. To relax and last longer, the guy needs to let go of his anxious thoughts. Slowing down physical stimulation from his lover also helps him put off his ejaculation.

If you ejaculate before you and your lover prefer, you can slow your ejaculation by doing some simple exercises. Kegel exercises help by strengthening your PC muscle. After doing Kegels for eight weeks, you should be able to squeeze your PC muscle when you feel like ejaculating, allowing you to slow your ejaculation.

> All lovers need honest feedback on what feels good—and what doesn't feel so grand.

If you masturbate slowly and visualize lasting longer, you can put off ejaculation. Lightly pressing your urethra under the tip of your erect penis for ten seconds when you are about to ejaculate—the **squeeze technique**—helps the mind cooperate with the body. Restart stimulation—the **stop and start technique**—and repeat the squeeze technique several times. A lover can do the start and stop and squeeze techniques with you too. If the problem persists, consult a sex therapist—see The Yellow Pages for Sex.

Ejaculation of semen and prostate fluid and orgasm are not the same phenomenon, but a guy's most pleasurable orgasms usually occur during ejaculation. Similarly, a girl who has G-spot ejaculations usually has her most exquisite orgasms while she is gushing a clear fluid—not urine—from her vagina (the proverbial wet spot or puddle).

A few guys have trouble ejaculating—**retarded ejaculation**. The opposite of premature ejaculation, some guys can't ejaculate during intercourse and/or oral sex but can during hand stimulation and masturbation. A few fake orgasm—a bad idea.

Retarded ejaculation is usually related to a guy holding his emotions inside rather than freely expressing them. If he doesn't feel connected to his lover, he is less likely to ejaculate. Guys who are controlling in general—control freaks—fear being out of control, which is what you are when you orgasm. The fear of being open and letting go makes ejaculation and orgasm unlikely without seeing a certified sex therapist.

Sexual problems are often caused by relationship dilemmas. Sexual satisfaction is a commentary on the state of your relationship. If you aren't comfortable in your relationship, you need to openly discuss your concerns.

If you are angry or otherwise unhappy, sex suffers. Relationships require openness, sensitivity and caring. Chapter 6 discusses the importance of ongoing conversation to solve relationship/sexual problems and to help you make good sexual and relationship choices. Don't overlook your parents, friends and other adults to discuss your relationship concerns.

Questions About Virginity, Sex Acts and Sexual Problems

Your confusion about whether or not you are a certified virgin (certified by whom—parents, teachers, your dates or yourself?) reflects your confusion about sex. This is clear in the following question.

QUESTION: "I want to know whether I've lost my virginity or not. I read in Seventeen magazine that even if a finger goes into your vagina, you still have your virginity. Yet when a guy called in about his girlfriend not wanting to have intercourse and she was doing everything else with him, you said she wasn't necessarily a virgin.

"A few years ago, at age 6, I per-

formed oral sex on my cousin, who was a few months older. I had no idea what I was getting into because I didn't know any better. From then on, it seemed like every time I saw him we made out and did oral sex with each other. His penis was in contact with my **vagina**, and at times they even touched, but we never had intercourse. We did just about everything else. I also want to know whether what we've been doing comes close to being called sex."

ANSWER: Sex acts at age 6 aren't imbued with the same meaning at age 16 or 17. *Seventeen* magazine may claim you are a virgin until you have intercourse, but I challenge their logic. You are a technical virgin (penetration virgin), but you certainly have had sex; intercourse is not the only sex act.

You should not focus exclusively on how far you go sexually without considering why you are doing whatever you are doing—and with whom. Is the sex an act of genuine caring or is it a way to build your ego and have an orgasm while being dishonest and hurting another? The motivation for any sex act—whether there is real trust, honesty and caring—is more relevant to what is moral and good than which sex act you enjoy.

Anyone who gets aroused is not innocent. Why should pleasure be viewed as something you shouldn't experience? Too early sex acts are not smart, but it is not the acts that are wrong—it is the timing. Why don't we worry whether kissing is right or wrong? As the following letter implies, what is it about intercourse that makes it **real sex**, when it is just one of several thrilling sex acts?

> Too early sex acts are not smart, but it is not the acts that are wrong–it is the timing.

QUESTION: "I think what you said on your show about kissing being very sexual is true! French kissing and just touching always

gets my boyfriend and me very aroused. I don't think many people know how great tongue kissing (and tongue sucking) is, and I think you're right on the subject of oral sex—that men will give it as freely to a woman as a woman would give it to a man."

ANSWER: Kissing is a very enthusiastic sex act. Arousal builds when tongues and mouths search for each other in utter abandon. Sucking tongues—and lower lips—escalates arousal to a high pleasure pitch. For many, kissing is the most appropriate and safest sex act. Practice makes perfect. When you are with someone who turns you on that you are comfortable with, enjoy kissing, petting—and **perhaps** oral sex kisses too.

QUESTION: "I am an 18-year-old virgin. This is not because of my religion. I just haven't found a guy that I feel like losing, or gaining freedom, as you would say, with. But now every time I meet a guy I am interested in, they don't want to have a relationship with me when they know that it won't be sexual. And if they do have a relationship with me, they will basically look for sex elsewhere. This is frustrating me, and I would like your advice on what I should do."

ANSWER: If a guy wants sex and you are not interested, it isn't surprising that he would seek other girls. This doesn't mean you should be sexual to date him—sex is not a duty. You may also be experiencing the outmoded double standard where some guys see you as the "good girl" whom they do not have sex with—and "bad girls" whom they do have sex with.

I would look around for a more mature guy who believes you can be both good and "bad" (meaning sexual, which is good, not bad!). I would not go for just any guy, but it doesn't have to be the guy you plan to marry. Take your time to get to know the guy in other ways.

When you find a guy you have chemistry and affection with, you will probably make love with him.

QUESTION: "Hey, I'm 12. Most of my friends are Christian and go to church and everything. I go to Fellowship of Christian Athletes. The last time I went they talked about sex and they said we should wait until we are married, and my friends got mad when I didn't say I wouldn't have sex until I was married. That day we got a card that said that I wouldn't have sex until I was married, and a friend signed it. I wasn't about to get more of my friends mad at me because of it, and so I turned it in.

"I know that I can't really promise to myself and God that I wouldn't, and it's not like I want to do it tomorrow, but I feel that I will do it and I know I will do it before marriage. So why did I sign this pledge? I learn a lot about relationships and my body from your show. My mom doesn't have the guts to explain all of this to me."

ANSWER: Your friends have been duped into thinking there is something wrong with sex before marriage. You have been inappropriately pressured by your peers to promise not to have intercourse before you marry, at age 12! Peer pressure does not help you find what you want—you have to decide this for yourself when you are older.

Signing a meaningless pledge under pressure does not amount to a hill of beans. Don't succumb to pressure to avoid pleasure again. Pleasure is healthy; those who restrain themselves from pleasure are unhealthy. This does not mean you should have intercourse until you are definitely ready. You will be ready before you think about marriage and you will enjoy kissing and other sex acts when you are older too.

Peer pressure does not help you find what you want—you have to decide this for yourself when you are older.

QUESTION: "My problem, if you can call it that, is that I want to start having sex with my boyfriend. We've been together for a little over a month and I love him with all my heart. I'm a virgin (he's not), and I desperately want him to be my first. One of the problems, though, is my parents are VERY religious. They would kill both of us if they ever found out we were having sex. But I don't intend to let this stop me.

"I want to let him know how I feel. I think he kind of knows, but I haven't really told him face-to-face yet. That is what I want to know. I don't know how to bring something like this up. Help! We have a very close relationship and it's not that I'm afraid he won't want to. I just want it to be romantic and special (we can do it on the kitchen table and other kinky stuff after we make love for the first time)."

ANSWER: You do not mention your ages. If you are 18 or 19, you are more likely to be ready for your first intercourse than if you are younger. It is better to wait until you are out of your parents' home to have intercourse; I do not recommend sneaking around behind your parents' backs.

When you decide to go ahead, you need to have some **Pre-Sex Discussions**. Clarify what sex will mean if you have it and make your intentions clear. If you expect each other to be exclusive, you need to make this obvious beforehand. Sometimes your expectations change, so be prepared for this. One month is not very long to get to know someone. Relax. Take your time. Enjoy him in other ways. There is plenty of time to make love with him.

QUESTION: "I'm 15 with a 19-year-old boyfriend, whom I only see once a month. We've gotten pretty intimate (for my age), and we've had some pretty serious conversations. He says it's stupid for teenagers to have sex because they're not likely to spend the rest of their lives together, and I completely agree. But he tends to give in to his emotions when it comes to love, and I'm afraid we'll go farther than what I'm comfortable with. I have to admit that a couple of times in the past he's gone a little farther than I'd like, but in the intimacy of the moment, I didn't say anything.

"In one of our discussions, I made him promise to respect my decision if I told him that I was uncomfortable with what we were doing, and he did stop without hesitation. I made it clear that love wasn't all about making love—it was also about respect and trust, and he agreed. I guess I'm just worried that if we ever do go too far, I won't have the courage to tell him that I'm uncomfortable. I want us to have a healthy relationship that lasts a long time—one that ends in friendship, not in anger. How can I be more sure of myself and discuss with him how I feel?"

ANSWER: My major concern is your age difference. You are both smart to hold off on intense sexual contact until you are older. At your age, you are less prepared for intimacy than when you are older. Four years' difference is no big deal when you are both older, but right now it is a bit of a gap. Go slow and be open to seeing others as you mature. If he is right for you, it will all happen in time.

I am impressed with your discussing things, and I am in full agreement that it is best not to do anything you are uncomfortable with. **You are super-smart in your observation that you wish**

to have a healthy relationship that lasts and "ends in friendship, not in anger." Some people are able to maintain a friendship even if the intimate part of their relationship ends. This is far better than breaking up and not being friends.

QUESTION: "I am 18. What can I do to please my 19-year-old boyfriend more? He does everything imaginable to me and I barely do anything to him. My boyfriend and I are considering cunnilingus and fellatio. He thinks that performing oral sex on him is degrading, but if I don't mind, he doesn't mind either. But I'm not too crazy about it. I would really like him to perform oral sex on me and he would really love to do it to me, but I'm stuck on the hygiene thing. Him kissing me afterward would be like me licking myself. What can I do to make myself taste sweet?"

ANSWER: Both of you need to discuss oral sex. Take a shower together and wash each other, and get over the idea that there is something dirty about oral sex. After experimenting and discussing what you like and don't like, you will probably both enjoy it.

You have some common concerns about oral sex. You will get over your uptightness. The vagina and penis are clean; the smells and tastes are a turn-on as long as you genuinely like each other's smells and tastes. Pineapple and other sweet fruit and vegetables may make you taste sweeter. Animal fat, such as hamburgers and fries, may make you taste a bit bitter.

> Pineapple and other sweet fruit and vegetables may make you taste sweeter. Animal fat, such as hamburgers and fries, may make you taste a bit bitter.

137

QUESTION: "My girlfriend and I have been fooling around a lot more lately and I've noticed that my tolerance and stamina regarding sexual activity is very low. It seems like the more we fool around, the more aroused I become (obviously). We are not having intercourse, but we are doing everything else. I have asked her to hold off on oral sex for now (mainly so I could write you!), because I am afraid that it will last fifteen seconds and that's it. I don't want that.

"I want to know if there is anything I can do to increase my stamina. Are there exercises, medicines or foods or anything? Anything you tell me will be very much appreciated. Also, are there any tips you can give me that will enhance oral sex to my girlfriend?"

ANSWER: You are anxious about coming too soon from oral and manual stimulation. Slow her down. If you ease into arousal rather than rushing it from too much stimulation, you will take longer to ejaculate.

If you do your Kegel exercises, you should be able to squeeze down on the PC muscle prior to the feeling that you are close to ejaculating; this is called ejaculatory inevitability. You will then be able to prolong sexual arousal before ejaculating. There are prescription drugs that put off ejaculation, but if you do your Kegels, I doubt you will need them. Also, if you use a condom during oral sex, you probably won't ejaculate as quickly.

As for giving your girlfriend oral sex, you need to gently lick and suck her clitoris and the mons area around her clitoris while you insert one or two fingers to lightly massage the front wall of her vagina about two-thirds up. Your fingers may help her ejaculate from her G-spot. You can also massage her nipples with your free hand.

QUESTION: "I am 21, and my girlfriend of one week is 18. She loves it when I go down on her, but she has yet to come. She has had oral sex and intercourse with four guys so far, but she's only had one orgasm. I love having sex with her and want her to be satisfied too. She is concerned that I don't ejaculate when she gives me oral sex. What do you say about these issues?"

ANSWER: You've had a "girlfriend" for one week. You are just getting started! If you relax and experiment without obsessing about orgasm, you both will probably have orgasms. If she doesn't already, she needs to masturbate to orgasm. This will help her know her body better so she can let you know what kind of stimulation she needs. She can fantasize and visualize orgasms with you.

You will learn to let go and ejaculate if you focus on your pleasure. If you only think about her satisfaction, you won't let go enough to ejaculate. Once you ejaculate, pay more attention to her pleasure and she may orgasm too. Discuss all of this with her.

I am sure that some of your parents will sigh in relief that you are learning about sexual pleasure from a sex expert. I am equally certain that other parents will be aghast at my candor and my support of your pleasure. You will get beyond all of this. You will learn to celebrate affectionate sex acts without serious problems.

In the next chapter, I advocate a Pre-Sex Discussion and other commonsense steps toward safer sex so you can avoid STDs, unwanted pregnancies and emotional pain.

6

THE PRE-SEX DISCUSSION:
A Gigantic Step Toward Consensual Safer Sex

"Sex. I think about it all day long. I love to talk about it too. It's what keeps me going. I love it. Sex just gives me a new vitality, every time, and a newfound purpose in life. After I have sex, I feel that I can face anything that life has to offer. I have a renewed sense of enthusiasm after hot sex. It gives me such a high on life."

This exuberant 22-year-old woman's endorsement of sex is refreshing and healthy. She is one of many teenagers and young adults who frequently celebrate erotic pleasure through talk and action.

There is no valid reason to play down arousing fantasies and adventures. Most of you appreciate discussion about sex and affection; face-to-face conversations enhance your intimate life. Communication about sex is absolutely necessary for a healthy exchange of pleasure.

A shared vision and open communication don't just happen. It's smart to talk about sex acts and what they would mean

before you agree to be sexual. Don't decide whether to continue sex play while in the heat of lust and passion. The agreement should be made by the time you eagerly unsnap bra snaps and unzip zippers!

Although public discourse about sex is ubiquitous, some of you are uncomfortable with open discussion in private. At best, you are frank and humorous as you converse about sexual risks and preferences with a prospective lover. At worst, such essential discussion is so embarrassing that it is totally avoided.

Even though most of you are sexual, not all of you openly discuss sex before you start a new relationship or encounter. A 17-year-old told me he discusses sex with women, but he doesn't talk **specifically** about what sex would mean. He states:

"I worry about the emotional responsibilities attached to sex, but I still don't discuss my feelings ahead of time. I wish I could be more open about what I like sexually, and what my lover prefers. It's just hard for me to be specific about oral sex and other things that arouse me."

Some of you are shocked by the idea of candidly discussing STDs and the meaning of sex prior to sex play with a new or old lover. In a survey of 56,000 Americans, MSNBC/Zogby International found that for those 18 to 24 years of age, 31% of males and 45% of females always discuss HIV or other STDs beforehand, while 26% of males and 23% of females only discuss STDs with partners they don't know very well, and a resounding 36% of males and 25% of females **never** discuss STDs with a potential partner. How can you be safe without knowing each other's vulnerability to STDs?

The Zogby survey revealed that 60-61% of both sexes have had unprotected sex while under the influence of alcohol, which is not safe! Since 42% of males and 44% of females have had from 6 to more than 25 partners, and **only .5% of never-married women and 1% of never-married men said they had not had sexual relations**, these findings underscore the critical importance of conducting Pre-Sex Discussions (MSNBC/Zogby Survey, October 10, 2005).

Trust and emotional honesty flow from honest communication. Your sexual health depends on accurate information about STDs, contraception and what sex would mean. Even if you are physically safe from STDs and unwanted pregnancies, your mental health requires that you share similar expectations and goals **beforehand**. If one of you prefers a sexual friend or a hook-up, and the other

wants a girl or boyfriend, a mutually satisfying experience is unlikely.

The agreement should be made by the time you eagerly unsnap bra snaps and unzip zippers!

A PSD is an intimate and entertaining conversation that informs prospective lovers about each other's feelings, desires, expectations, fantasies and her/his sexual knowledge and sophistication. It's an introduction to the possibility of a sexual relationship or encounter–**a preview of what sex would be like**.

A PSD is much more than "do you have a condom?" A properly conducted PSD minimizes dangers and maximizes pleasures. A PSD includes the meaning of sex, assessing the risks and preventing STDs and unwanted pregnancy, and agreeing (or not) to celebrate sex together. A PSD encourages mutual honesty; sex without honesty is not meaningful, long lasting or fun.

When you are sexual, sometimes you share your hearts. Sex should not be expressed in a way that hurts yourself or another. A PSD lessens the chance you will be hurt or exploited, but it is not foolproof. Any real adventure–including sex–entails some risk.

For too long, safer sex has been narrowly defined as using a condom. One goal of this book is to expand safer sex in a more realistic and effective way beyond the sole focus on condoms. Although condoms are a critical precaution, intercourse and oral sex are less problematic if you utilize these additional preventive strategies:

1. Pre-Sex STD Tests, including–but not limited to–HIV tests (see Chapter 7).
2. A Thorough Pre-Sex Discussion, including dialogue about what sex would mean, preventing and assessing the risk of STDs, using effective contraception and coming to a mutual agreement to be sexual or not–and if so, which stopping point both agree to beforehand.

New microbicide gels intended to kill STDs on contact are being developed. When the FDA approves them, these new products will be a third step toward safer sex (see Chapter 7).

This all sounds good, but how do you suggest a PSD to potential lovers?

Breaking the Ice

"To be a good seducer, you have to appeal to a woman's romantic side. It isn't romantic to discuss safe sex before you have sex. But I use a condom. It's the man's responsibility to wear a condom on a date. I don't like to bring up sex, because that opens the possibility of rejection."

This 21-year-old guy is an example of **romantic seduction**. This is the old dysfunctional **game** featuring romantic lines to seduce a girl (or sometimes a guy) without discussing what's **really** happening. He even "wears a condom on a date." Imagine the guy futilely trying to put a condom on his soft penis before a date!

There hasn't been an understood etiquette for pre-sex conversations—a gap filled by the PSD. If you use your imagination, there are many ways to bring it up. It doesn't have to make you nervous, although it might. Reasons for not discussing sex prior to doing it vary. Fear of rejection, embarrassment and lack of self-esteem contribute to virtual silence before the first time—and before and after the second, third and fourth times.

It's obvious that many of you sense another person's character and your sexual safety by **intuition** alone. Some of you believe that a nice guy or girl wouldn't have an STD. Not everyone knows when he/she has an STD. **It's dangerous to be naive.**

One way to introduce the possibility of having sex is to pop out this book. Use humor when you propose a PSD by following the guidelines in this chapter.

You'll have a lot of fun getting to know him/her by interviewing each other while you share this book. You'll also make each other more comfortable about the prospect of a mutual decision.

Look for opportunities to bring up sex when you are with friends. Use a magazine article or a TV show to discuss behaviors that promote consensual safer sex. You'll be more informed and more comfortable when you talk with a potential or current lover.

It's common to discuss sex in general ways while watching a love scene in a movie or with a larger group. One girl used a lead-in sentence like: "In the movie we just saw, the couple went to bed without any discussion of what it would mean to them. They weren't responsible."

Replacing Romantic Seduction with Mutual Seduction

"As a progressive guy, I am not overly aggressive unless the girl clearly wants me to be. I don't play the approach-avoidance game of kissing and then petting and the girl pushing my hands away and me trying again until she relents, which is much too common.

"I make it clear in early conversations that I am attuned to their nonverbal responses and I respect whatever they seem to want. If we are making out, I put my hand down the front of her pants, and if she pulls my hand out, I continue kissing and petting outside her clothes, but I don't attempt to put my hand into her pants again during that make-out session.

"Many women feel they have to be modest and pull a guy's hand away, but they expect guys to try again and again. They act like they are relenting, but they are just playing the game. I found this out through cause and effect. My hand would get pulled away and I would continue to make out and not try again. Later the girl would say to me, 'Why didn't you keep trying to get into my pants?' and I would answer, 'You didn't want me to.' Girls need to let go of this need to be swept away by a guy to enjoy sex. They would enjoy it more too. It is time to get beyond this brain-dead, nearly automatic game."

This is a get-real observation by a 22-year-old senior in college. He is honest and sensitive, he treats women as equals and he respects their wishes. He hopes women will realize they are playing a game that limits pleasure for both partners. His emphasis on conversation before sex play is a Pre-Sex Discussion.

You can't escape flirtation and sexual overtures. The only alternative to a PSD is to fumble your way through uncomfortable and often risky seduction games. The unhealthy emphasis on danger doesn't usually stop you from indulging in sex; it just makes you more paranoid when you do.

Sexual Attraction and Affection Are Hindered by Silence and Embarrassment.

Using the trappings of romance to manipulate another flourishes in a climate of silent fear where one person, usually the guy, is more powerful, more experienced and more exploitive than the other person, usually the girl.

If romantic love is the only legitimate reason to suggest—let alone experience—sex on a date, true caring, friendship and equality suffer. Talking about sex doesn't appeal to those, usually girls, who obsess about being swept away like a romance novel character.

A girl doesn't have to be out of control with romance to enjoy sex. Both sexes play nonsensical games that inhibit open discussion about expectations, risks, protection and what turns you both on. Some—like a girl making out and playing games with the progressive guy—insist on a perfect setting and great-sounding, though insincere, "lines" so they can avoid an explicit **Pleasure Pact**. Unlike the progressive guy, the seducer doesn't want his game to be revealed and the seduced needs justification—an excuse—to avoid admitting that she/he desired and was satiated by sex play.

Romance encourages the **illusion** that you are safe and secure. By accepting this myth as a fact, you reject rational thinking and proceed without any common sense. Practical concerns about STDs, unwanted pregnancy and the meaning of sex evaporate in the addictive steam of **compulsory romance**.

Exploitive seduction games promise nothing but ego-stroking and hurt feelings with excitement, followed by emptiness and desperation. The seducer often hurts him/herself as much as he/she harms a lover.

145

The painful and senseless truth is that our society expects you to be lost in a hazy romantic cloud so you will succumb to romantic seduction with rose-colored glasses. Pretending you are in love with every person you desire can set you up for hurt feelings, STDs and unwanted pregnancies. It can also lead you into a committed relationship that you, perhaps, don't want.

Honest romance in balance can contribute to some dating relationships, but friendship and erotic attraction suffer from an overemphasis on romance. As pioneer sexologist Dr. Albert Ellis contended in his classic book, *The American Sexual Tragedy* (1962), romantic lovers are antisexual, demanding, jealous and changeable. Romance often includes putting a lover on a pedestal—a difficult position in which to celebrate erotic pleasure!

Mutual seduction after a PSD is more fun than the exploitive game of selfish seduction. A thorough PSD encourages sexual adventure and sometimes romance without phony lines, if you are on the same page.

Treating each other as equals encourages genuine intimacy, and awesome sex, a lot more than catering to and protecting a lover and possessing her/him in the name of love. If she/he has to feel swept away by romance and the illusion of love to have sex, she/he won't be fully immersed in her/his own pleasure—a real loss and a real shame.

The best way to demonstrate caring between equals is to conduct a PSD. If media entertainment and comprehensive sex education in schools featured the PSD, consensual, responsible sex might become the norm.

Since there isn't an accepted sexual etiquette for anything other than romantic seduction, it's time to develop more caring manners based on pre-sex as well as between-sex conversations. A PSD that becomes a series of discussions is a more accurate predictor of mutual trust and joy than a brief one-time talk.

A second or third discussion might begin with "I have thought about our last talk, and I have a few more questions. What if I wanted to have another lover too? Could you deal with it?"

If you are easily intimidated, get to know potential lovers to see if you really want to be sexual with them. Explore his/her character and values so sex is more likely to be safe, meaningful and exciting enough to repeat. It's best to make an emotional connection that will nurture your self-esteem. Otherwise, you could succumb to the usually unsatisfying quick fix of premature sex without any preparation or discussion.

When you agree to a PSD, you are allies on the same **Pleasure Team**. A PSD should include questions, answers and conversation in equal proportions from both prospective lovers. Starting the PSD should be fun, funny and enlightening; it makes you look sophisticated and full of common sense.

Overcoming Obstacles to a Pre-Sex Discussion

Fear of rejection stops many from dating, let alone from discussing sex. This is one reason why many, if not most, sexual experiences occur without discussion, sometimes under the unfortunate influence of alcohol. It's easier to handle the fear of rejection if you are not fully alert and responsible; you can rationalize and avoid looking at your problems, needs and emotions.

Some of you have been taught to fear a loss of romance and spontaneity if you **plan sex**. You have been told not to share your scandalous past or your lack of sexual experience. Such advice can be a barrier to a PSD if you don't emphasize why it's critical that both of you be totally honest. How else can you decide if you want to be sexual? Providing a brief overview of your past can be fun and informative without being overly voyeuristic or intimidating. You don't have to reveal every torrid detail.

If a potential lover can't accept you because you've enjoyed sex with others, she/he shouldn't become your next lover. The world is full of prospective lovers. You can find others who aren't so rigid and uptight.

Your rule should be: **No sex until we talk, then we'll see how we both feel and we'll make an intelligent decision together.** When there is powerful attraction, it's not too early to suggest a PSD, even if you've just met. This doesn't mean you'll necessarily agree to be sexual after your first conversation. If you don't start the discus-

sion, your potential lover may. It doesn't matter who begins a PSD, just be sure someone does.

In spite of sexual dangers, many of you are embarrassed

> **If a potential lover can't accept you because you've enjoyed sex with others, she/he shouldn't become your next lover.**

when or if you approach a potential partner to talk. Pioneer sex educator Dr. Jessie Potter captures the essence of embarrassment: "If you always do what you've always done, you'll always get what you've always gotten." This is true for lots of habitual behaviors that don't serve you well.

In order to change your behavior, you have to first get rid of distorted thoughts. It's easy to repeat mistakes when you fail to look within yourself (see Chapter 9). Question habits that don't support personal and relationship growth. To break out of unworkable habits, get to know yourself better. Your friends are your mirrors for who you are—and who you wish to become.

Conducting a Pre-Sex Discussion

"The idea of a discussion about sex before doing it appeals to me. I insist on a series of conversations before I agree to start a new sexual relationship. Most people don't talk much before they have sex, and a lot of them don't talk much afterwards either. I want to know why a guy likes me, and why he wants to have a sexual relationship with me. I need to know about his sexual history, whether he's been tested for HIV and other STDs, and whether he is going to be around for a while."

This intelligent 18-year-old woman controls sexual dangers and affirms trouble-free pleasure by talking before agreeing to be sexual. You don't all have to make the same choices to be healthy and normal, but everyone should discuss sex beforehand.

You must calculate your own sexual risks. How well do you know the person? Do you trust him/her? What makes you think you can trust him/her? How much do you know about their sexual history? Knowing someone well does not preclude their having sex with others—even if you aren't aware of it. This makes you ponder when you are really safe. Since the polygraph is not used to certify sexual honesty, a PSD is your best gauge.

When you get in touch with your feelings, you learn to be reasonable about your expectations, wants and needs. Talk candidly about your desires and fantasies. Once again, it's best to discuss sex **before** you are in a sexual situation—not after you reach the point of no return.

Some of you don't have the idea and meaning of sex clearly formulated in your mind. Since there is no standardized way all of you learn about sex, you are faced with conflicting messages from your parents, friends, movies/TV, pornography, previous sexual experience and, lastly, from school "sex education." Because of different messages for women and men, you may not speak the same language when you try to talk about specific sex acts, what they mean to you and what you are comfortable doing and not doing.

It may sound awkward, but you first need to define what you mean by words that express what any sex would mean to you ("When I say I'd like to be your sexual friend, I mean…"). If you are comfortable that you are clearly communicating and not mind reading or jumping to conclusions, the PSD will flow much more smoothly.

Guys and girls should share equal responsibility for being honest about their expectations, and about birth control and STD prevention. It's smart to look into each other's eyes to see if his/her eyes waver when you ask what sex would mean and what you would expect from each other, and about STDs and birth control.

Other questions: How serious would it be? Could you still date or get together with others? Has the man had sex with other men? If

149

so, has he been tested for HIV and other STDs? To what extent has each person practiced safer sex? And, of course, what are his/her fantasies about you?

One function of a PSD is to help you become more conscious—and more cautious—about sex and affection. If a possible lover refuses to candidly answer your questions, you've saved yourself a lot of misery by not being sexual. Look for lovers who are in touch and at ease with themselves and with you.

A person may have an STD and not know it—or he/she may lie. You can sense whether a person is lying when you ask the right questions while noting their nervousness, their body language and their eye movements. A PSD is an efficient way to ascertain a person's sincerity. **Honesty is a real turn-on.**

The more thorough you are, the better a PSD will serve you. **Every PSD doesn't—and shouldn't—result in instant sex.** Sex may occur later or not at all. You may discover that sex would not be comfortable because you are not in sync on one or more issues. Sometimes one or both want a serious relationship first, but the reverse can be true too. Sometimes one or both don't want anything serious.

Responsible and comfortable sexual choices require agreeing **about the meaning of sex**. When you make a **commitment**, some of you mean **sexual exclusivity**. There is nothing wrong with this meaning, but it's improper to **assume** this is the **only** acceptable meaning.

Not everyone defines commitment with her/his genitals. Some view sex as fun to be indulged in with one or more playmates. The motto for some pleasure-oriented people is "if it feels good, do it."

The last part of a PSD is deciding whether or not to celebrate sex. **The most critical part of any decision to be sexual is the agreement itself; you both must clearly consent.** This decision should always be made together. Date rape and other sexual aggression aren't as likely if you are on the same Pleasure Team (see Chapter 9).

Sexual conversations should continue after the PSD. Sex will be safer and more fun if you talk openly throughout a sexual relationship.

Asking Yourself Questions About Sex

Before you try to conduct a PSD, ask yourself similar questions. You can't expect another person to answer your questions if you haven't answered them for yourself. Go over your answers with a few close friends; form a focus group about a PSD.

The following questions for self-reflection guided my interviews for this book:

1. **Do I discuss sex before I decide whether or not to enjoy a new lover? If not, why don't I talk first?**
2. **How does open conversation affect my sex life?**
3. **How would I start a PSD?**
4. **What do I (and could I) ask about?**
5. **What would I like to ask about?**
6. **Am I scared about having sex? What are my fears?**
7. **What does sex mean to me? What do I expect if I have sex?**
8. **How can I tell if a prospective lover is honest with me and with him/herself? How can I increase the probability that a lover will be candid?**
9. **Will I discuss my sexual likes and dislikes and those of my potential lover before having sex? Why or why not?**
10. **How do I define safer sex? Is it using a condom? Is it other methods of prevention in addition to a condom?**
11. **How consistently do I practice safer sex?**
12. **Have I been tested for HIV and other STDs? If not, why not?**
13. **Will I continue to talk about my feelings after the first time? Why or why not?**

Your potential lover probably will be relieved and delighted that you have initiated a sex talk. He/she will feel more comfortable because you are open and responsible.

Use the following PSD to start a dialogue. Be forthright and look into each other's eyes. You will be vulnerable, but so will he/she. Remember that you both want to lower risks and heighten pleasures.

Playing fairly by these guidelines increases mutual pleasure and happiness. There may be moments of tension and apprehension—all part of being honest.

Never try to manipulate a potential lover. Consider each other's goals and desires. **Be a good listener.** Be open to humorous moments that release tension and make it all fun and worthwhile.

Even though the following version of a PSD requires verbal communication, it's essential that you be aware of nonverbal cues and gestures. Eye contact, body language and the energy between two people make up 65-70% of communication. You need to compare what is said with what you "read" nonverbally and see if they match.

Asking Each Other Pre-Sex Questions

1. **What are your feelings for me?**

2. **If we become lovers, what would it mean to you? What expectations would you have? Would you expect an exclusive relationship or would we both be free to see others?**

3. **Have you had any STDs? If so, which STDs have you had? Do you have any reason to think you currently have an STD? Please elaborate.**

4. **Have you ever had anal intercourse? Did you use a condom? Was a bisexual or gay man involved?**

5. **Have you been tested for HIV? What were the results? When was the test taken?**

6. **Have you been tested for other STDs? Which STDs have you been tested for and when were the tests done?**

7. **Have you had unprotected intercourse since the tests? Please elaborate.**

8. **How often do you use a condom? Do you use latex or polyurethane condoms?**

9. **Have you ever used IV drugs? To your knowledge, have you ever had sex with an IV-drug user?**

10. **How have you selected your lovers?**

11. **Would you tell anyone if we have sex? Whom and why?**

12. **If we have intercourse, what methods of STD and pregnancy prevention are you prepared to use?**

13. **If it looks like sex may occur: Do you want to be sexual with me? Why or why not? What are your sexual likes and dislikes? If we are sexual, which sex acts are you comfortable doing at this point?**

14. **Should we have sex now, later or not at all? Why?**

You can modify the above PSD to suit your needs and goals. I advise using some humor—be the eternal optimist with playfulness. If you both agree to sex play, a **Pleasure Pact** is official.

Oral pacts are splendid. You can even seal your mutual consent with a deep French kiss! There is no need for written contracts or a notary public, but erotic letters are appropriate. Explore each other's minds, bodies and spirits.

If in doubt, don't. Otherwise, do and enjoy.

What Is Mutual Consent?

Seventeen magazine and www.Sexetc.org conducted a study of 10,000 younger teens. They found that 81% of the girls and 72% of the guys "feel pressure to do more than they're ready to" (*Seventeen*, 2005). The opposite of mutual consent, this finding indicates that both sexes are sometimes pressured into sex.

Mutual consent is a nice-sounding concept, but what does it mean? It requires careful listening so you are sure you **both** 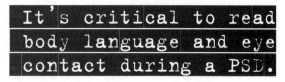 want the same thing. Don't be pushy; be patient and respect each other's feelings, wants and needs. If your goals match after a thorough conversation, a mutual choice is more likely.

Once again, it's critical to **read body language and eye contact** during a PSD. If your potential lover folds his/her arms, crosses legs and leans or looks away, he/she may not be fully open, and he/she may be less than truthful and comfortable. Direct eye contact and intimate body language and touching mean there is more potential for honest affection and sex.

Sexual honesty is a must. Some of you were introduced to *The Velveteen Rabbit* when you were children. In this classic story, the Skin Horse explains what it means to be real to the Rabbit: "When you are Real you don't mind being hurt….once you are Real you can't be ugly, except to people who don't understand" (Margery Williams, 1922).

To be **real** like the character in *The Velveteen Rabbit*, you need to be in touch with your inner self—that still, small voice within you that cries out to be expressed. When you are honest, you don't exploit or manipulate; never promote sex under false pretenses. If you need to be deceitful to have—or not have—sex, there's something missing inside you. Not revealing something is as dishonest as blatant distortion. Don't look for false excuses to avoid or to relish sex.

Awesome sex happens when there is an **honest connection**. Dishonest sex is lousy sex. Why have shallow sex based on cold-hearted deception when you can revel in imaginative, caring sex based on warm-hearted honesty? Guys who lie to go to bed with a girl—or another guy if they are gay or bisexual—sometimes lose their erections or prematurely ejaculate because of their anxious dishonesty. Girls who lie about their motives for sex are also less aroused and less satisfied.

Most of you could be a lot more honest. You've been taught to play hard to get, not to be easy. Some of you use big come-on lines to lure another into your arms. In short, you've been taught to be dishonest to either put off or rush sex. It's more sensible and fun to be honest about your desires and to act on them when they are clearly mutual.

Mutual consent without mutual candor is worthless. Once again, it's safer and more responsible to have **more than one discussion prior to sex.** You will be confident and comfortable if you trust a prospective lover. Consent should be active and clear rather than passive and nebulous. **It's not consent to merely give in to another person's desires.**

Being honest is not enough. **Be fair and treat each other as equals.** It isn't easy to treat each other as equals when women are unfairly paid less than men, but you can still behave as equals. You can't be as intimate, or as erotic, unless you treat each other as equals. Being equal means either person is free to initiate, and pay any expenses, for a sexy, playful ren-

dezvous or a hot date. You decide what you are comfortable with.

Be responsible and sensible. It's impossible to be responsible unless you are honest, fair and fully informed. It isn't sensible or personally responsible to avoid playful fun. Your mental and physical health are enhanced by caring pleasure. Being responsible isn't just practicing safer sex. It's being sensitive to each other's feelings, being a good sexual citizen in a social sense and a caring lover in a personal sense.

Be sensitive and caring. Part of being a good listener is being sensitive and caring—which doesn't mean you have to be in love to be sexual. To really connect, you must open yourself to what he/she feels. Loving compassion is sensing what she/he wants and enjoys and what hurts her/him. By giving yourself to another with an open heart—and if appropriate, an open body—you experience their joy as your own.

One goal of a PSD is to become friends—and to become better friends. If you are friends and friendly, any mutual choice will nurture the relationship. As long as sex is mutual and responsible, it has the capacity to convey caring and the respect that caring requires.

In order to justify mutual consent, it's crucial that you learn to trust each other. Sharing a variety of non-sexual experiences is a superb way to learn whether you can count on each other. Sexual discussion should not be like the art of a business deal. Sexual choices should occur in a loving, rather than a competitive, atmosphere.

You are expected to understand what consent means, but the same overture or sex act may be perceived by one to be making love and by the other to be forced sex or date rape (see Chapter 9). It's better to err in the direction of admitting you don't fully understand each other, or you aren't sure sex is appropriate quite yet. Once again, **if in doubt, don't**.

Consent should be verbal, clear and mutual. Mutual consent applies proper manners to your sex life. Don't ask a series of questions as you heavily kiss a new lover. Asking if you can touch a breast or take off clothing is unnecessary if you have conducted a thorough PSD with an agreed-upon stopping point. You should have a clear mutual agreement about sex prior to anything beyond kissing and light petting.

Some lose a friendship when it becomes sexual. If this is your fear, why not be sure the friendship is solid before sexualizing it? A

strong friendship should endure with or without sex as long as mutual consent and ongoing discussion occur. Sex doesn't have to ruin a friendship. It can enhance a friendship as long as neither person becomes possessive or demanding.

If you feel that sex negatively affects a friendship, you can converse about it and decide together whether it would be best for the friendship to remain friends without further sex. Changing a friendship or dating relationship is far better than breaking up and not staying friends.

A PSD is the first step toward caring and safer sex. Now for your questions about sexual conversations before potential and actual sex.

Your Questions About Sex Talk Before Sex Play

QUESTION: "I've heard you talk about a PSD on your show. It sounds like a great idea, but I'm scared the guy might think I am weird or presumptuous or something. I am a 19-year-old woman, and I've had lots of lovers—some good and some not so great. So far, no one has asked for a PSD. I admit some of the sex I've had should not have happened. I got genital warts from one of my mistakes. My friends and I are waiting for your response."

ANSWER: Any guy or girl who resists talking about sex before doing it is not fully responsible. Unless they are manipulators, most of your potential lovers will appreciate your offer to talk first. I can't promise a PSD would have filtered out all of your mistakes, but I suspect you would have been more cautious, resulting in fewer mistakes.

One goal of a PSD is to become friends—and to become better friends.

If you had used latex condoms, you would have been less likely to contract genital warts, but condoms don't always prevent warts (see chapters 7 and 8 for discussions of the female and the male condom). A PSD makes the use of condoms more likely.

You also would probably have made fewer miscalculations in your choice of fellow pleasure-seekers. Not talking first leaves you vulnerable to being sexual with someone you aren't certain you can trust. Talking about what concerns you and interviewing each other cuts down on errors in judgment. Discuss this with your friends.

QUESTION: "I'm an 18-year-old guy. I agree with your idea of interviewing each other before sex, but I still wonder how you bring up the subject. I feel awkward asking a date to discuss sex with me. She might think I am propositioning her and expecting sex. She might assume I am sex crazed. Any advice?"

ANSWER: You aren't alone in feeling uneasy about asking a date to discuss having sex with you. Don't suggest a PSD unless you are reasonably sure the potential lover is attracted to you and likes you. Look for clues that she is interested before you ask her to talk about sex. If she asks if you are propositioning her, tell her you aren't yet— that you always discuss sex before suggesting it. Be sure to let her know that sex is not a duty or an expectation.

As long as you don't come on too strong, she won't see you as out of line even if she has no sexual interest in you. I doubt she will see you as sex crazed unless you only talk about sex. Use some humor to break the ice. Spoofing yourself is safe; laugh at yourself and maybe she'll laugh with you. It's better to laugh at yourself before someone laughs at you. Being playful is essential to having fun, including a sex talk on a date.

Being playful is essential to having fun, including a sex talk on a date.

157

QUESTION: "Your PSD works. I interviewed a new lover first and now we have a lot of fun. I attribute our mutual success to two thorough discussions beforehand. We talked for hours both times. There was almost no room for mistakes. We are both 17 and we chose to use oral sex (both ways) as our current stopping point.

"When we graduate from high school in nine months, we both feel we will probably hit a home run (intercourse) with each other. We like your idea of taking it a little slow and allowing our friendship to mature so we can handle it emotionally. So far, we are sex buddies who are free to see others. We don't date, but we are discussing adding dating to the sex. What do you think?"

ANSWER: I commend you for having a Pre-Sex Discussion! Your stopping point of mutual oral sex sounds like a good choice for now. If you enjoy each other in other ways, by all means date each other too. I recommend that you continue to define your friendship as non-exclusive. There is plenty of time for a more serious relationship when you are older. In the meantime, enjoy each other, and continue your discussions about your friendship, dating and sex.

QUESTION: "My friends and I all listen to your show. We realize you are humorous and we all wonder, how do you use humor during a PSD? We are all freshmen in college."

ANSWER: When you break the ice and ask someone if he/she would like to talk about the possibility of some kind of sex with you, you can laugh at your forthrightness. It's safer to spoof yourself than to be sarcastic or caustic with humor. Feel free to be teasing and flirtatious before and during a PSD.

For example, if you both mutually consent to sex acts, you can use your humor by "reading" each other erotic Miranda Rights—a spoof on what policemen do when they make an arrest. List your future lover's rights, expectations, desires and responsibilities as they define them prior to your first sexual experience. You might pro-

Feel free to be teasing and flirtatious before and during a PSD.

claim: "You have the right to remain silent, although I'd rather you moan, groan and scream from intense pleasure. You may graphically detail which forms of stimulation you prefer, how you would like them administered and the cadence that fits your mood!" Then give your new lover the opportunity to hear your erotic preferences.

You might try a variation of this. The point is to have fun and use your creativity. Consider this oral agreement your **Pleasure Pact**.

QUESTION: "I wish your PSD were required before sex. Maybe if sex education included something besides abstinence we'd all be informed enough to be selectively sexual. All we ever get from teachers is the tired, irrelevant 'Just Say No' motto. I believe the PSD would contribute to more suitable decisions about sex for teenagers and college students. About the only PSD most of my friends practice is 'Do you have a condom?' This is especially true of hook-ups. How can we influence adults to be more real?"

ANSWER: I agree with your sentiments about the lack of getting real by saying no to sex. Hook-ups depend on a lack of personal and sexual information. A thorough PSD isn't as likely to precede hooking up. This is why STDs and unwanted pregnancies are probably more common with hook-ups than with dating or ongoing sexual friendships; when you hardly know the person, how can you be safe?

Your emotions aren't supposed to enter a hook-up, but how can you always keep them in check? If you see the hook-up repeatedly without discussion about what is really going on, one lover often gets more emotional than the other, potentially resulting in hurtful rejection.

QUESTION: "I know that sexual problems are usually considered adult issues, but don't you think having a PSD and subsequent discussions would lessen any problems for teenagers and college students?"

ANSWER: Absolutely. Not talking about sex means you can't be as aware of a lover's preferences and desires. If you aren't aware, you fumble around wondering if the new partner likes the same things an old lover preferred.

If lovers communicated more about sex and feelings, they would be more satisfied and less plagued by lack of orgasm, premature ejaculation, low arousal and low desire—to name a few common problems. If any of these problems affect a relationship, talking usually helps solve them (see Chapter 5). If all else fails, see a qualified sex therapist.

QUESTION: "As I understand it, a PSD doesn't always end up with sex happening. How do you handle a PSD if one person wants sex and the other doesn't? Isn't this awkward?"

ANSWER: You have to live what life brings. Live in the pleasure or displeasure of the moment. A PSD doesn't always end up with an agreement to be sexual. Both have to be graceful and accept reality if one wants sex and the other isn't sure and/or wants more time and more conversation first, or doesn't want a sexual encounter or relationship.

It's better not to be sexual than to force the issue with a person who isn't comfortable or who isn't turned on. It's uncomfortable when people aren't on the same page, but who said that all of life—including sex—is smooth and comfortable?

QUESTION: "I'm a 20-year-old gay guy at a very liberal university. I've hooked up, dated and I've had a few sexual friendships. I find that each of these choices can quickly change into one or two of the other options. It's so confusing. I love sex and I love sexual variety, but some of the guys I've been with try to convince me to be exclusive with them. Sometimes they use HIV and other STDs as their reason, but I doubt this is all there is to it. Do you think a PSD and ongoing discussion would help these more serious guys back off from pushing sexual exclusivity?"

ANSWER: Your concerns are identical to those of heterosexuals. Talking about sex before and after the first encounter helps both lovers realize whom the other is—and what they need and want. A PSD would probably help serious guys realize you aren't as serious about sex as they are. This would either back them off from their apparent expectation of mandatory monogamy or make them realize they would probably be emotionally hurt if they had sex with you.

It is critical that you insist on pre-sex testing for HIV and other STDs and that you always use latex or polyurethane condoms with a lubricant without nonoxynol-9 for anal intercourse. Since you aren't in an exclusive relationship, condoms for oral sex would also protect you against HIV. Since HIV is more common among gays, using a condom for oral sex is a good idea (see Chapter 7).

QUESTION: "I can't always tell if there is mutual consent. How can I be sure that neither person is giving in to the other's desires or manipulations? I have been burned by this, but I have to admit that I have never had as thorough a PSD as you advise."

ANSWER: If you follow the guidelines in this chapter, you are less likely to be exploited or succumb to pressure. You have to be in touch with yourself to realize when you are giving in and when you both feel the same way. If you doubt that the consent is real, don't agree to sex. Sometimes you aren't sure after one discussion; you can say you aren't certain and suggest that you have more dates and conversations before deciding.

It's important that you learn to read body language and eyes. Manipulators usually aren't good at lying with their bodies, their eye contact and their verbal communication. Listen carefully and ask a lot of questions. A comprehensive PSD followed by a follow-up discussion or two should make you more confident about

> A comprehensive PSD followed by a follow-up discussion or two should make you more confident about mutual consent.

mutual consent. If you think you are giving in, don't have sex. It helps to get to know the potential lover in other ways; spend more time with the person before deciding to be sexual.

QUESTION: "I'm a 19-year-old woman with a roving eye. I prefer sex buddies to hook-ups or dates. I adore guys who are enthusiastic about sex. I am popular, but worry a little about getting a bad reputation for being into sex so much. I doubt I will ever be totally monogamous. For me, variety is exciting. Can a woman live this way without negative consequences? By the way, I always insist on a series of pre-sex discussions—and more conversations after I am sexual with a guy."

ANSWER: I like your honesty and your enthusiasm. You are smart to converse about sex with new and old lovers. Your interest in sexual variety is probably best served by sexual friendships, although I would not rule out dates too.

There may be some guys—and girls—who put you down for being a highly sexual woman, but I bet there aren't that many. When you are liberal you run the risk of a few negative comments. I doubt you will be heavily rejected because you are more open and non-exclusive. If you find that you are the subject of rumors, develop some of your sexual friendships with guys who don't know those in your social group.

Your satisfaction with your choice of sex buddies makes it all worth the risk of a negative comment or two. The double standard is still with us, but it's not very strong with most people your age and a few years older. It is dying a slow but certain death.

QUESTION: "Even though I have never had an STD, some of my friends have—mostly from supposedly monogamous relationships. Some of them discussed sex and commitment, but they didn't all use condoms. How does this happen?"

ANSWER: What passes as safe monogamy is often serial monogamy. Given the incubation period and frequent lack of symptoms of some STDs, serial monogamy often lulls people into a false sense of security about unprotected intercourse, leaving them vulnerable to STDs—a solid reason to get tested for STDs (see Chapter 7).

Besides serial monogamy, some who claim to be exclusive aren't; they lie or simply don't mention that they are having sex with someone else too. It's safer to use a condom and to continue discussion about sex and relationships. That's why it's called "safer sex."

QUESTION: "You discourage casual hook-ups. I'm a 16-year-old guy who has a lot of fun hooking up for oral sex and sometimes intercourse over the net and from running into hotties at the mall. Why are you opposed?"

ANSWER: Hook-ups usually don't include much—if any—discussion about sex and what is happening prior to sex. They are usually one-night or two-night stands. You run a high risk of STDs, unwanted pregnancy and hurt feelings when you hook up. What will you do if a condom breaks and you get a girl pregnant that you barely know? This could spell **t-r-o-u-b-l-e**!

Besides these problems, you usually don't learn to develop friendships or dating relationships with hook-ups. Some claim they date and hook up, but why not date and/or be sexual friends? You'll incur fewer risks and you'll be more likely to develop healthy emotions for girls.

Hotties at the mall may be put down for being so quick with strangers like you. Do you care about the effect hooking up has on them? Hook-ups sometimes focus more on a guy's pleasure than a girl's satisfaction—hardly fair or balanced. Why couldn't you date or be friends with them? Are you only concerned with your satisfaction? If so, your approach is selfish and shallow.

In the next chapter, testing, symptoms, risk assessment and treatment for HIV and other STDs will be thoroughly explained.

7

SAFER SEX:
How to Prevent, Diagnose and Treat STDs

Yvonne and Mike are two college freshmen who have been dating for a few weeks. They are affectionate and attracted—playful and funny. Their arousal builds as they make out and fondle each other.

They look into each other's dancing eyes as they realize they need to slow down and talk. They acknowledge that they need to discuss how far they will go, and how they can practice safer sex to greatly decrease the chances of transmitting an STD or incurring an unwanted pregnancy.

Yvonne suggests that they enjoy oral sex, but agree not to have intercourse yet. Mike read some teenage web sites and he discovered that careful use of Saran Wrap offers good oral sex protection against STDs, such as herpes and gonorrhea. He tells Yvonne what he learned. They agree to use Saran Wrap on her and he will use a dry condom for relatively safe oral pleasures.

After their Pre-Sex Discussion, our new lovers agree to use common sense about STDs and their emotional health. They escalate their feelings and the intimacy of their sex acts—far more realistic than abstaining from healthy pleasure. Their honesty and caring make them smart and responsible.

After several more weeks, they agree to lift the oral sex stopping point. They choose to experience intercourse with a dry latex condom, adding water-soluble lubricant to lessen the odds of a broken condom and to enhance their pleasure. They discuss condom-use guidelines too, so they can feel reasonably confident that condoms will protect against most (though probably not all) STDs.

They are at his apartment on a romantic Saturday night. His roommate is not home. Yvonne and Mike forgot to agree on which of them would supply condoms and a lubricant, so they both bring them! They laugh as they take off each other's clothes. They enjoy exploring each other sexually through oral pleasure and intercourse, practiced safely.

Yvonne and Mike were informed and responsible enough to play it safe so they wouldn't worry about possible STDs. They were aware that there is some risk to being more and more sexual, that making out is safer than oral sex or intercourse.

They weren't out to manipulate or exploit each other; they were friends before they dated. Being trustworthy friends who respect each other enough to be honest and reliable is an important ingredient of safer sex. Having a Pre-Sex Discussion is another safer-sex step. So is using a condom and being tested for STDs, including HIV.

All these steps toward safer sex are critical to your health. You've learned about discussing sex first. Now you can master proper condom use. Condoms offer considerable protection against STDs, but safer sex is not a total guarantee. You can choose to commit to long-term abstinence (unrealistic for most) or to enjoy exciting safer sex.

Have you considered that it's risky not to be sexual?
Being sensual and having orgasms is essential for your health and joy. Long-term abstinence from sexual expression is not mentally or physically healthy. The long-term practice of this form of self-denial is unnecessary. It's important to remember that sex, in itself, is not bad.

Those who advocate abstinence ("Just Say No") reveal a sex-negative attitude; almost none of them recommend masturbation, vibrators, outercourse or other sources of safe sexual enjoyment as an alternative. There are important benefits to being sexual that must not be overlooked. You have to consider how much risk you are willing to take to be sexual. Your sensate and emotional needs should be considered along with STD and unwanted pregnancy risks.

STDs have been around for a long time. You need to prevent STDs and deal rationally with any that you contract. STDs are too often viewed through a judgmental lens because they are **sexually** transmitted; moralists view them as pay-if-you-play punishment for non-marital sex. We ought to be mature enough to deal with STDs like we deal with other serious diseases.

Some of you are shocked when you contract an STD from someone you love and admire, but STDs don't discriminate; you don't have to appear dirty or sleazy to sexually transmit infections. When you get a cold or the flu you don't moralize about how you got it. You have to be **careful** when you are sexually intimate; STDs can affect all sexually active people. Play it safe.

Fear has never been an effective motivator for responsible sex, or a legitimate reason to avoid eroticism. Repressed people continue to hammer away at the immense power of diseases to ruin your lives, but they have been mostly unsuccessful in their attempt to restrain pleasure by defining it as an extreme danger or a sin. Sex, practiced safely, is not a huge danger or a sin.

Nothing will turn the clock back to abstinence. **Teenagers and college students are very sexual.** Nearly 50% of 9th through 12th graders, 65-70% of 18-year-olds, 80% of 20-year-olds and 90% of 22-year-olds have intercourse. The problem is that 84% of parents don't believe their teenager is sexually active, even though most parents discuss STDs and AIDS (Society for Adolescent Medicine, reported by Reuters, 2004). It's time for parents, educators and government to **get real**.

Why **pretend** that our society is returning to Victorian shame and sexual repression? The abstinence movement won't stem the tide toward more teenage and young adult intercourse—especially with later ages at marriage. Nothing will. Anyone who doesn't believe this should go to almost any mall or campus social event on a weekend night—sexual desire permeates the air.

Intercourse and oral sex are not without risk. In the U.S., those 15 to 24 years old represent 25% of the sexually experienced population. An analysis of several large studies in 2000 concluded that 48% of new cases of STDs occurred in this age group. Genital warts, trichomoniasis and chlamydia account for 88% of all new cases of STDs among 15- to 24-year-olds (The Alan Guttmacher Institute, 2004).

If those who made up these statistics had been tested for STDs, conducted Pre-Sex Discussions, consistently and correctly used condoms and facilitated medical treatments for themselves and their past and current lovers, these and other STDs would not be so prevalent. These preventative strategies would be more likely if our government would fund comprehensive sex education instead of abstinence-only "education."

Nearly 50% of 9th through 12th graders, 70% of 18-year-olds, 80% of 20-year-olds and 90% of 22-year-olds have intercourse.

Instead, the government is "in bed" with right-wing religious groups preaching abstinence. Because separation of church and state is more imagined than real, your sexual choices are threatened by a lack of accurate sex education, including how to safely celebrate healthy pleasure.

Your sexual rights are not always respected or even acknowledged. Schools, government and some teachers, parents and clergy censor your access to accurate education and advice, wrongly concluding that comprehensive sex education leads to irresponsible behavior. Unfortunately, high school students have more limited access to complete and objective information about STDs and other sexual issues than college students.

Sex isn't a privilege; it is part of your American and human **right** to happiness through private pleasure. As long as you are responsible to yourself and your lovers, you have a right to erotic delights. This **doesn't** mean all of you are ready for intercourse.

The remainder of this chapter covers safer sex with a focus on condoms, and the symptoms, testing and treatment for STDs, including HIV. First, I offer a rationale for using condoms and common-sense guidelines for proper use.

Condoms Are Essential for Safer Sex

According to Planned Parenthood (2004), "The truth about condoms is that they offer the best protection for the sexually active..." Condoms don't offer 100% protection from STDs and unwanted pregnancies, but most condoms don't break or slip off.

The typical failure rate is 15%, but if you consistently and correctly use a latex condom during vaginal intercourse–perfect use–2% are likely to fail (Hatcher, 2004). In a study by a medical student at the Mustang Ranch in Nevada, STDs, including HIV, and condom breakage were very rare—.6%—with prostitutes who correctly used condoms (Alexa Albert, *Brothel*, 2002). This shows that proper use of condoms results in almost no condom failures.

Failure rates for anal intercourse are higher; the exact rate is unknown. Condoms are effective against most STDs because they prevent the exchange of semen, genital discharge and infectious secretions, the main modes of STD transmission.

Studies show that for most of you over age 16 or 17, condoms are a much more likely choice than abstinence. According to a 2002 government study, 66% of teenagers said they used a condom at their most recent intercourse (National Center for Health Statistics, 2005). Use them if you plan to have or are already having intercourse. **When condoms are added to pre-sex STD tests and Pre-Sex Discussions, safer sex is quite safe.**

In CDC Fact Sheets, abstinence and then monogamy are emphasized far more than using a condom, but sociologists Ira Reiss and Robert Leik's computer model of risk proba-

Do not use lambskin condoms.

bilities concluded "the risk of HIV infection was increased far more by not using condoms than by having multiple partners." This is a strong argument for using condoms to prevent other STDs too.

If you are allergic to latex (about 2-4% are), use a polyurethane condom. These plastic condoms transmit heat better, making them more pleasurable than latex. The actual breakage rate is not known from widespread studies, but condom distributors don't get many complaints, so they may be as safe as latex condoms. Be sure to use a lubricant (preferably water-soluble) inside and outside polyurethane condoms to lessen breakage and increase pleasure.

Do not use lambskin condoms; they have tiny imperfections that allow HIV and hepatitis viruses to pass through the condom and possibly infect a sexual partner.

Avoid lubricants and other products with nonoxynol-9. The World Health Organization and Centers for Disease Control and Prevention recommend that you not use nonoxynol-9. As a detergent, it can potentially irritate the vagina, the urethra and the anus enough to increase some STD transmission, including HIV (Planned Parenthood Fact Sheet, 2004).

Spermicidal condoms cost more and they are no more effective than condoms without nonoxynol-9. The taste is also terrible for oral sex. Never use nonoxynol-9 lubricants for anal intercourse; they could make HIV transmission more likely. Some condom manufacturers are discontinuing the use of nonoxynol-9, and I predict that more companies will do so.

> The typical failure rate is 15%, but if you consistently and correctly use a latex condom during vaginal intercourse—perfect use— 2% are likely to fail.

Instead, add a **water-soluble lubricant**, such as K-Y Jelly or Astroglide, to the inside and outside of a dry latex or polyurethane condom; this decreases breakage and increases pleasurable sensations. **Do not use an oil-based lubricant** like Vaseline. Latex condoms may also deteriorate and break from mineral oil in some body lotions and lubricants. Oil-based lubricants also clog and irritate the vaginal lining, and they may cause an occlusion in the fallopian tubes, potentially leading to long-term infertility.

The **female condom** is also made with polyurethane. It is inserted in the vagina, with an inner ring that loosely fits over the cervix at the innermost part of the vagina, and an outer ring that covers the labia (outer lips of the vagina). A silicone lubricant inside the condom increases pleasure and decreases breakage.

The female condom typically fails about 21% of the time, but the perfect-use failure rate is about 5% (Hatcher, 2004). Polyurethane is stronger than latex and it is not as likely to tear or break (Cates and

171

Stewart, 2004). Only a small minority dislikes the female condom. In addition to increased sensitivity, a woman can choose to use and insert the condom, making her less dependent on a man to consistently and properly use condoms.

In order to enjoy relatively safe intercourse without unnecessary worries, **there is no excuse for not using a condom**. Drugstores carry condoms at a reasonable price and Planned Parenthood and some health clinics offer free condoms. Both girls and guys should carry condoms—it's better to be safe than sorry. Some conservative congressmen have been pressuring the FDA to use more restrictive warning labels on condoms. Such labels would unwisely lead some to conclude that condoms don't offer significant protection from STDs, leaving them more prone to unprotected sex, which greatly increases the probability of STD transmission.

Proper care and correct and consistent use of condoms increase your chances for enthusiastic, safer-sex encounters.

Guidelines for Correct Condom Use

Proper condom care is a must. Store condoms away from sunlight in a cool, dry place. Be careful not to puncture condoms with sharp fingernails, jewelry or teeth. Do not overheat condoms by keeping them in a wallet or glove compartment.

Check the expiration date on condoms, because aging condoms are not as safe as new ones. If the condom is past the expiration date, or if it's brittle, discolored or sticky, discard it. When you open the packaging, be careful not to tear the condom. If there is a dotted line, use it.

If you aren't sure how to use a condom, buy a few. Drugstore clerks sell thousands of condoms. Guys can practice using a condom while masturbating. Both girls and guys can rehearse on a cucumber or zucchini in private. It may sound funny, but rehearsing makes it more likely that you will properly use the condom in a real situation.

Be sure to apply a condom before penetration. Both sexes are more vulnerable to possible STDs if you allow any penetration before you roll on a condom. Although the risk of pregnancy is not totally clear from studies, waiting may also expose women to sperm in pre-ejaculatory fluids, especially if the guy has already ejaculated and intercourse is repeated. Don't take any unnecessary chances.

A critical issue is the correct unfolding of the condom.
Figure out which direction is up. Hold the tip as you unroll the con-
dom on a fully erect penis, with the condom emerging from inside
the ring at the base of the penis, which means the rolled ring should
be on the outside. Don't put it on inside out, as it will not unroll. If
you put it on wrong, discard it and use a new condom correctly. Use
a drop of lubricant inside the tip before unrolling the condom as the
condom might slip off if you use too much lubrication.

Leave a half-inch space at the top of the penis so the con-
dom won't have air bubbles, making breakage less likely. Pinch the
reservoir tip (or twist the end if there is no reservoir) as you unroll the
condom. There should be a space of extra rubber at the top of the
penis after it is unrolled to the base. If the guy is not circumcised, pull
the foreskin back as you unroll the condom, leaving plenty of space at
the top, preferably with a reservoir tip to catch the ejaculate.

Use additional water-soluble lubricant in the vagina (or
anus for anal intercourse) and/or on the outside of the condom to
avoid breakage and increase pleasure. Check the condom during
intercourse, and add more lubrication as needed.

**After the guy ejaculates, he should firmly hold on to the
ring of the condom and slowly withdraw while still erect.** This
will avoid the condom slipping into the vagina or anus. After inter-
course, check the condom for holes or damage and wrap it in tissue
paper and discard. Don't flush condoms down the toilet and don't
reuse them. Never switch from the anus to the vagina with the same
condom—this could cause a vaginal infection.

There are similar cautions with the **female condom**, except
polyurethane used for the male or female condom does not deteriorate
from sunlight or from oil-based lubricants. The female condom covers
the woman's labia and the man's scrotum (testicles), and it probably
protects against herpes and genital warts more than the male condom.

The female condom can also be used for anal intercourse
between men and women or between men and men. Remove the
inner ring for anal intercourse, and don't use a lubricant with
nonoxynol-9. See www.sexuality.org for more suggestions about anal
sex with the female condom.

Polyurethane is thinner than latex, it does not have a smell or taste,
and it's transparent. Some don't like the large size and the squishy

noise the female condom makes, but the advantages outweigh minor annoyances.

Be sure the penis is inserted **inside** the condom, **not** between the condom and the vaginal wall. An advantage is it can be inserted up to eight hours before intercourse, encouraging spontaneity. As with the male condom, discard after use.

Now that you understand proper condom use to prevent STDs and unwanted pregnancy, let's focus more on prevention, and on symptoms, complications and treatment for specific STDs. I will start with the four most prevalent STDs: genital warts (HPV), trichomoniasis, chlamydia and genital herpes.

Genital Warts (HPV)

Genital warts are usually soft, moist pink or flesh-colored cauliflower-appearing bumps on or in the genitals or anus that are caused by the human papillomavirus (HPV). Some are dry and hard and yellow or gray. Not all bumps are warts—you could have harmless skin tags.

From available data, warts are the most common STD in the U.S., with an estimated 6.5 million cases a year; 74% of infections occur among 15- to 24-year-olds (Weinstock, Berman and Cates, 2004). The actual prevalence of HPV is unknown; the CDC needs funding and government encouragement to determine the true extent of HPV. Health clinics are often overwhelmed by HPV.

Intercourse is not necessary to infect a lover, but vaginal and anal intercourse can transmit HPV. The virus is also highly infectious from outercourse and other skin-to-skin contact. The incubation time from exposure to the appearance of warts ranges from a few weeks to eight months, with an average of three months. If there are symptoms, they usually are manageable. HPV infections are often asymptomatic; many don't know they have the virus even though it may be transmitted.

If smokers need another reason to quit, current tobacco smokers are five times more likely to develop warts than non-smokers (Clinical Practice in Sexually Transmissible Infections, 2002). The reason for the association of cigarette smoking and HPV is probably a tobacco-weakened immune system.

Condoms cut down on transmission. But if warts and asymptomatic shedding of the HPV virus are not completely covered, trans-

mission can still occur. Female condoms probably protect against HPV more than male condoms because they cover more of female and male genitals. According to *New York Times* health columnist Jane E. Brody, "In most cases...the body's immune system knocks out the virus over a period of months or years. When this happens, genital warts clear up and cervical cells harboring the virus do not gradually turn malignant" (Jane E. Brody, 2004). Washing with soap and water after sex may decrease HPV transmission, but it does not extinguish all risk.

HPV can cause dysplasia (pre-cancer) or invasive cervical cancer. Although "only one out of 1,000 women with HPV develops invasive cervical cancer" (Planned Parenthood Fact Sheet, 2004), 50% will develop abnormal pap smears, and over half of these will need cervical biopsy and/or cutting away or freezing pre-cancer cells off the cervix.

On an extremely positive note, a cervical cancer vaccine has been shown to be 100% effective in blocking infection with HPV 16 and 18, which are responsible for about 70% of cervical cancers. When approved by the FDA, girls will need to be vaccinated **before** they become sexually active (Associated Press, MSNBC, October 6, 2005). A second vaccine is also under development. When the FDA approves them, the vaccines would be given to girls and boys 9 to 15. According to Jane E. Brody, research indicates that any parental objections would be overcome by doctors emphasizing the high rate of HPV among older teenagers (Jane E. Brody, 2005).

In addition to HPV, other risk factors for developing cervical cancer include smoking, diet, hormonal imbalance and the presence of other STDs, such as HIV, chlamydia and/or genital herpes.

Sexually active girls, including those experiencing skin-to-skin outercourse and/or intercourse, should get yearly pap smears to help diagnose HPV. Regular pap smears often identify women with HPV infections. Treatment of pre-cancerous cervical conditions detected by pap smears greatly reduces invasive cervical cancer.

Visual inspection of the penis and scrotum is the main way to identify genital warts on guys. Acetowhite testing is performed to detect warts that are not readily apparent on guys and girls; a dilute vinegar solution is applied so any warts are visible with a magnifying glass.

HPV often goes into remission. Most cases are temporary and clear themselves without medical intervention, especially if you take

care of your immune system by eating vegetables with beta-carotene and folic acid. There is no cure for the infection, but several promising vaccines are being tested.

If you notice warts, go to a doctor or a health clinic, such as Planned Parenthood. Treatments for visible genital warts are intended to control outbreaks and decrease sexual transmission. Two common treatments are freezing warts with liquid nitrogen in a doctor's or clinic office, or topically applying trichloroacetic acid or podofilox. Warts can recur after initial treatment, so keep a watchful eye on treated areas. Be sure to inform your past and current lovers so they too can be examined and treated, if necessary.

Trichomoniasis (Trich)

Trichomoniasis (trich) is a single-celled parasite found in the vagina, urethra and bladder. The incubation period is 4 to 28 days.

About 70% of women notice a frothy, creamy white, yellow or green vaginal discharge with an unpleasant odor; some also experience itching, redness, abdominal pain and/or frequent urination—but 30% of women and 50% of men are asymptomatic. When a man has symptoms, he may have a discharge from urethritis or prostatitis.

Trich can be passed back and forth between men and women. About 70% of men who have had sexual contact with an infected woman test positive within two days of exposure. Women who have sex with other women can transmit trich through vaginal fluid exchange. It is uncommon but possible to get trich from toilet seats, washcloths and other moist objects.

Twenty-five percent of those with infections in 2000 were 15 to 24 years old.

After being diagnosed by a medical professional (usually by examining vaginal discharge under a microscope) inform recent lovers so they too can be treated with Flagyl®, an oral prescription drug. Untreated, trich can damage cervical cells, which may increase the vulnerability to HPV, which in turn increases the risk of cervical cancer—another reason to get regular pap smears, and to consistently use condoms.

There are about 7 to 8 million cases a year. Trich is most common between the ages of 16 and 35; 25% of those with infections in 2000 were 15 to 24 years old (Weinstock, Berman and Cates, 2004).

Chlamydia

Chlamydia is transmitted during vaginal, anal and—much less frequently—oral sex, and from fingers from one body to another. It sounds like a flower, but it's extremely common and it's often asymptomatic; 75-85% of women and 40-50% of men would not know they had chlamydia unless they were tested or a partner informed them that they tested positive.

When there are symptoms, men notice a clear or pus discharge, some pain or burning when urinating and possibly painful inflammation of one or both testicles, usually 5 to 21 days after infection. Epididymitis—infection of one testicle causing scrotal pain, redness and swelling—is usually caused by chlamydia or gonorrhea.

Women with chlamydia may have more vaginal discharge than normal, and sometimes bleeding between periods and after intercourse. Some also have pain during urination, low abdominal and/or pelvic pain, elevated temperature, nausea and headaches.

Chlamydia is one of four nongonococcal urethritis (NGU) bacteria. *Ureaplasma urealyticum, Mycoplasma genitalium* and trichomonas all can cause NGU. Screening tests are essential to figure out which STD is active.

The most common bacterial STD in the U.S., there are nearly three million new cases of chlamydia a year, including 4% of 18- to 26-year-olds (Associated Press, MSMBC, May 11, 2004). Chlamydia appears to be declining primarily because of increased use of condoms, and better screening tests and treatment, but 74% of cases in 2000 occurred among 15- to 24-year-olds (Weinstock, Berman and Cates, 2004).

Left untreated, chlamydia can cause pelvic inflammatory disease (PID), a major cause of infertility in women, and less commonly in men. Seven in ten cases of PID occur with teenagers and young adults. Gonorrhea and other infectious organisms affecting the cervix, uterus and ovaries can also cause PID.

About 20% of women with untreated chlamydia and 10% with untreated gonorrhea develop PID (Clinical Practice in Sexually Transmissible Infections, 2002). Unfortunately, many women with PID are not diagnosed and treated. Many never realize they have PID until

they become infertile and are ultimately diagnosed with blocked fallopian tubes. In addition to the risk of PID, women with chlamyidia are three to five times more prone to HIV—another reason to get tested for both chlamyidia and HIV.

Since chlamydia and PID can be asymptomatic, regular culture and urine screening tests for chlamydia and gonorrhea are recommended for sexually active girls and guys, especially if current and previous lovers did not consistently use condoms. It's best to verify trust by sharing written test results with your partners.

When there are symptoms for PID, they are similar to symptoms for chlamydia and gonorrhea. Planned Parenthood and other health clinics screen for and treat chlamydia, gonorrhea and other STDs. Get tested and use condoms. Consistently using condoms cuts the risk in half for PID.

Chlamydia infections and other NGUs are treated with antibiotics, usually doxycycline or azithromycin. Since gonorrhea can occur with chlamydia, ofloxacin is sometimes prescribed to simultaneously treat both infections. Vaccines to prevent chlamydia may be available in coming years.

Particular strains of chlamydia can cause *Lymphogranuloma venereum* (LGV), a rare infection transmitted through unprotected anal, oral or genital contact. LGV appears to be most common among gay men. Accurate statistics in the U.S. are not yet available, but the CDC fears the disease may become more prevalent in the U.S. (Reuters, "CDC: Rare Infection Could Surface in U.S.," October 29, 2004). Symptoms often include genital, anal and mouth ulcers, swollen lymph nodes and flu-like reactions. Antibiotics cure the disease. Those who test positive for LGV should also be tested for other STDs (Marr, 1998).

Genital Herpes

The genital herpes virus (Type 2) is transmitted through skin-to-skin genital contact from intercourse and outercourse. Most infections are probably transmitted when there are symptoms, if not actual sores.

Herpes is often asymptomatic—one reason for widespread herpes transmission. If you had sexual contact with an asymptomatic infected partner for a year, you would have a 10% chance of getting herpes.

Herpes is becoming more common; there are about a million new cases a year, with about 640,000 cases for those 15 to 24 years old (Weinstock, Berman and Cates, 2004). Women have somewhat higher infection rates than men. African American infection rates are much higher (46%) than whites (18%) (Hyde and DeLamater, 2003).

When there are symptoms, painful red bumps appear on the genitals, mouth or rectum from 2 to 14 days after sexual contact with an infected person. Initial bumps become weeping blisters with a clear fluid, and then with pus, with a red ring encompassing open sores. Initial outbreaks may also be accompanied by fever, chills, headache and being run down and achy with flu-like feelings (Planned Parenthood, 2004).

An initial outbreak of sores may take two to four weeks to heal. Subsequent outbreaks, if there are any, are usually less severe and more infrequent (CDC, 2004). Even with unprotected intercourse, the average risk of infection for those who abstain from sexual contact while an outbreak is active is about 10% (Marr, 1998). This percentage would be lower if condoms were used.

Don't engage in oral sex or kissing if you or your lover has a cold sore. The oral herpes virus (Type 1)—cold sores and fever blisters on the mouth or lips—can also infect genitals from oral sex, or by touching genitals after touching a cold sore. Both Type 1 and 2 can be transmitted to or from mouth and genitals. Genital herpes is more likely from Type 2 than Type 1. Type 1 infections are milder with fewer recurrences.

If you notice sores or blisters, be sure to have them diagnosed by a doctor or a clinic. There is a pricey blood test for herpes, but it isn't very helpful and it can be misleading. The test only reveals whether you have ever been exposed to herpes, including oral cold sores.

There is no current cure, but vaccines are being developed. Clinics and doctors prescribe acyclovir and other medications to limit the duration and to suppress painful and communicable outbreaks. If you start acyclovir or another medication within the first 72 hours after symptoms begin, you are more likely to limit the duration of an outbreak. Taking a smaller dose of these antiviral medications can dramatically reduce recurrences.

The virus can shed when there are no symptoms, but most transmission probably occurs when there are symptoms, primarily the **prodome stage**—a warning that an outbreak is on the way. Prodome symptoms include a tingling sensation, itching and burning before an outbreak.

Most people don't feel like sex when they have painful sores. **Avoid skin-to-skin contact, including sex, when there are symptoms.**

Emotional and physical stress, fatigue, poor nutrition and direct sunlight, especially sunburn, may cause recurrences. Exercise and a healthy diet (avoid junk food!) bolster your immune system, making infections less likely. If you are infected, avoid anything with arginine, an amino acid in chocolate, peanuts and other nuts, and other foods that can cause outbreaks. Lysine supplements and foods with lysine—milk, potatoes, beef, lamb, brewer's yeast and fish—may counter the effect of arginine (Taylor and Sharkley, 2003) and stave off and/or shorten outbreaks.

Avoid skin-to-skin contact, including sex, when there are symptoms.

Using a latex or polyurethane condom prevents most herpes transmission, but the scrotum (testicles) and other uncovered areas may still become infected. Since herpes increases the chances for an HIV infection—and for transmission from a newly infected mother to a newborn infant—it is critical that condoms be used.

It is rare for a newborn infant to contract genital herpes from an infected mother during childbirth. Unfortunately, infants who become infected sometimes die or are left with permanent brain damage, a major reason for a pregnant woman with herpes to inform her doctor before the birth so necessary childbirth precautions are taken.

To further prevent transmitting herpes, don't touch sores, and wash your hands with soap and water to kill the virus. Avoid contact with your eyes without first washing your hands. You can also use alcohol swabs to kill the millions of virus particles contained in a herpes blister.

If you have herpes, inform current and new lovers. Genital herpes won't end your sex life. It's a **genital cold sore**, similar to a mouth cold sore, not a scarlet letter. You can learn to deal with it without a lot of misery or fear of rejection from your lovers.

Being rational, positive and having an open mind will help anyone with herpes live a productive and happy life. Although genital herpes can result in occasional recurrent sores, it is rare for them to cause widespread disease in an otherwise healthy person.

Now that you've learned about the four most prevalent STDs, we'll deal with some other STDs: gonorrhea, hepatitis, syphilis, HIV (AIDS), pubic lice, scabies and prostititis.

Gonorrhea

Gonorrhea is a bacterial STD transmitted through vaginal, oral or anal contact. Men usually have symptoms, including burning during urination and a smelly, cloudy penile discharge, usually from two to five days after sexual contact with an infected woman or man. Some men also have inflamed testicles and/or swollen and tender lymph nodes in their groin (Crooks and Bauer, 2002).

Women have fewer, if any, symptoms; 50-80% don't notice gonorrhea until it resides in their body for ten or more days. Symptoms are mainly painful urination and vaginal discharge or bleeding, sometimes a month after infection. Guys should always tell girls of a positive diagnosis so girls can be tested and treated too.

Gonorrhea affects about 650,000 per year, with 431,000 cases among those 15 to 24 years old (Cates, 2004; Weinstock, Berman and Cates, 2004). African Americans and Latinos have higher infection rates than whites. PID from gonorrhea is more severe than from chlamydia; infertility may result from gonorrhea or chlamydia. It is easy for doctors to confuse symptoms for gonorrhea with those for trichomoniasis and chlamydia; STDs must be properly cultured and diagnosed before they can be appropriately treated.

Sometimes more than one STD is present, which may necessitate multiple screening tests and treatments. Since some strains of gonorrhea resist treatment, clinics and doctors often simultaneously use more than one antibiotic.

Oral sex can transmit gonorrhea to the throat, sometimes without symptoms. Gonorrhea increases the chances of HIV transmission— another reason to be tested and use a condom for vaginal and anal intercourse and a condom or Saran Wrap for oral sex.

Hepatitis B (HBV)

HBV is a virus that causes liver damage. There are five hepatitis types, but hepatitis B (HBV) is the most likely to be transmitted sexually. HBV is 100 times more contagious than HIV. Manual stimulation, oral

181

sex, anal intercourse and possibly kissing are avenues of infection through semen, vaginal secretions and saliva. Blood and needle sharing can also transmit HBV.

Not all people have symptoms. A flu-like feeling, jaundice (yellowish skin), dark urine, abdominal and joint pain, an itchy rash and vomit-

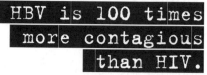

HBV is 100 times more contagious than HIV.

ing are somewhat common from one to three months after exposure. As many as 95% who are diagnosed with HBV from a blood test later are clear from the disease, and are protected against future infection. Only 5% have weak immune systems and become carriers throughout their lifetime (Marr, 1998).

There are about 200,000 to over 300,000 new cases of HBV each year with a trend toward more infections. About 120,000 new cases are sexually transmitted each year, usually from heterosexual intercourse (Cates, 2004). About 25% of new infections occur among those 15 to 24 years old (Weinstock, Berman and Cates, 2004). One large survey concluded that of all STDs, Americans were least knowledgeable about hepatitis, apparently not realizing it can be transmitted sexually, and not knowing about vaccines (American Social Health Association, 2004).

Intravenous alpha-interferon and steroids are sometimes used to treat HBV (Marr, 1998). Bed rest and drinking enough fluids to prevent dehydration are usually recommended for the weeks to months that the disease lasts.

Fairly expensive but safe and effective vaccines are available to prevent hepatitis B and hepatitis A. Those with an infected partner, men who have sex with men, those with recent cases of other STDs and those with multiple partners, especially if unprotected by condoms, should be vaccinated for both hepatitis A and B.

Gay men are at high risk of hepatitis A and B, but most have not been vaccinated (CDC, March 8, 2004). Using latex or polyurethane condoms and barrier protection for genital, anal and oral sex also helps prevent HBV transmission.

Syphilis

Syphilis was first discovered in the fifteenth century in Europe. A bacterial infection that spreads from sores or rashes to breaks in the

skin, syphilis is primarily transmitted by vaginal and anal intercourse, oral sex and kissing. Another avenue for infection, with or without symptoms, is from a pregnant woman to her unborn child.

A painless ulcer (chancre) is the first symptom, usually appearing about three weeks after infection (but may be noticed from 9 to 90 days) on the cervix, inner vaginal walls, the penis or the rectum or mouth. Women often don't know they have an internal chancre, which is extremely contagious and disappears on its own after one to six weeks.

If an infected person is not diagnosed and treated at this time, secondary symptoms occur after several weeks: a non-itchy but awful-appearing skin rash on the entire body, including the palms of hands and the soles of feet. Hair loss, flu-like symptoms, such as joint aches, lymph node swelling, fever and headaches, are additional symptoms—usually enough to convince a person to see a doctor.

If any of the above symptoms are noticed, immediately see a doctor or health clinic to be diagnosed—and treated, if the tests are positive. Blood tests and an analysis of fluids from ulcers are typical diagnostic tests. As with other STDs, anyone testing positive should immediately inform all past and current lovers.

Without treatment, syphilis can become latent for years. About half remain latent. The rest advance to the late stage, sometimes causing death. Those armed with the knowledge and availability of medical help can seek treatment.

Penicillin injections are the best treatment. Those allergic to penicillin are treated with other medications, such as doxycycline and tetracycline (Marr, 1998).

Syphilis is increasing, especially among gay men. There are at least—and probably more than—70,000 reported new cases a year. Infection rates in 1996 for African Americans were fifty times higher than for non-Hispanic whites—possibly from less access to health care and from poverty (Clinical Practice in Sexually Transmissible Infections, 2002).

A study in 2002 indicated that 88% of all syphilis cases were among gay men. Two-thirds of the syphilis-infected gay men were also infected with HIV, largely from unprotected anal intercourse (CDC, March 8, 2004).

Pre-sex testing, Pre-Sex Discussions and condoms are the best ways to prevent syphilis and other STDs.

HIV/AIDS

The human immune deficiency virus (HIV) is the cause for acquired immunodeficiency syndrome (AIDS). HIV is transmitted by vaginal or anal intercourse, and to a lesser extent by fellatio (giving oral sex to a man) through body fluids (semen, blood and breast milk) and possibly from secretions from the vagina and cervix. It is also communicated by contaminated blood transfusions, infected IV needle sharing and by an HIV-positive pregnant woman to her baby.

The highest risk of HIV transmission is unprotected anal intercourse—especially the person who receives the penis—followed by sharing IV drug needles and unprotected vaginal intercourse. The virus is not transmitted through eating together, hugging and other casual contact.

There may not be early symptoms for HIV. When there are symptoms, a brief flu-like illness may occur a few weeks after infection. Continued weakening of the immune system may result in fever, fatigue, swollen glands, muscle aches and headaches. The most contagious stage is just after being infected, usually before the infected person knows he/she has HIV.

The only way to accurately diagnose HIV is to get a confidential blood test for antibodies to the disease, which generally can be ascertained within four to six weeks—but up to six months—after infection. Planned Parenthood and local health departments provide free or low-cost tests. To be responsible to yourself and your lovers, every sexually active person should get regular HIV tests. A monogamous relationship does not protect you from HIV and other STD infections from previous lovers—so get tested.

According to the NCHS, 47% of men and 55% of women 15 to 44 report being tested for HIV (National Center for Health Statistics, 2005). As this book goes to press, the FDA is considering approving the first "do-it-yourself" AIDS test. If approved, you could test a swab of saliva, and within 20 minutes, you would know if you are infected with HIV with 99% accuracy. More people would be tested, but counseling for those who are positive would still be important, but not assured. It is estimated that about 300,000 people have HIV without being aware of it (Associated Press, MSNBC, October 26, 2005).

The diagnosis for AIDS is more complicated. The incubation period between HIV infection and AIDS is 8 to 11 years. As the immune

system continues to break down, opportunistic infections, such as pneumonia and cancer, occur—eventually causing death.

There is no current cure, but medications have been developed which greatly reduce symptoms, stop the virus from multiplying, prevent opportunistic infections and prolong life. Magic Johnson is a living example of the value

> There are about
> 60,000 new HIV cases
> a year in the U.S.
> About half probably
> don't know they are
> infected carriers.

of these drugs for HIV-positive people. He continues to lead a normal life in spite of HIV. A vaccine is likely in coming years.

There are about 60,000 estimated new HIV cases a year in the U.S. About half probably don't know they are infected carriers. About 30,000 new cases occur from intercourse, and about 15,000 cases are contracted by those 15 to 24 years of age (Weinstock, Berman and Cates, 2004). Gay men and African Americans are disproportionately represented; African Americans make up more than half of HIV cases (Ramshaw, *Seattle Times*, August 8, 2004).

Although repeated exposure to an HIV-infected partner is usually required for HIV transmission, heterosexual intercourse can spread the disease, and women are more vulnerable than men from sexual contact. Intercourse with an infected male partner explained 37% of all AIDS cases in women in the U.S. in 2001 (Guest, 2004). Proportionately more women, especially black women, are testing positive for HIV (King, *Seattle Times*, 2005). The cervix of young adult women is especially vulnerable to HIV and HPV, which underscores the importance of using condoms.

HIV can largely be prevented by widespread latex or polyurethane condom use and testing, followed by informing past and current lovers of positive tests so they too will get tested. Several studies show that latex condoms are extremely effective at preventing HIV. Even when one lover was HIV-positive, correct and consistent condom use protected the other lover from infection in 98-100% of cases (CDC and American Social Health Association, 2004).

Pubic Lice (Crabs)

Crabs make you crabby. They are bloodsucking, crab-like parasites that creep around body hair. If you notice pinhead-size black bugs in your pubic hair or on your bedsheets, clothing, towels or toilet seats, use a magnifying glass. They may be crabs.

Crabs often cause itching in the genital and/or anal areas. Crabs will appear about five days after you contract them. Don't scratch them. Scratching causes the little buggers to travel around your body. Other than skin irritation, there are no complications from hosting crabs.

Over-the-counter medicated shampoos and stronger prescription varieties will both kill crabs, but prescriptions usually work more quickly. Avoid contact with your eyes; if there are crabs in your eye-lashes, apply petroleum jelly twice a day.

Be sure to immediately inform roommates and lovers of your unfortunate bout with crabs so they can inspect their hair and apply the special shampoo too. All people who have shared towels or have been intimate with you should be treated even if they don't notice symptoms.

It is important to wash and dry or dry-clean all towels, sheets and clothing that have been in contact with an infected person. If you separate these items from people for about 72 hours, the lice will die, but the eggs can live for six days or more.

No one knows for sure, but a reasonable estimate is that about three million new cases of crabs occur each year (Marr, 1998).

Scabies

Another parasite is scabies, a microscopic mite with four to eight legs that lives in and on the skin. The disease is very contagious and can be transmitted sexually and through other close physical contact. Adult female mites burrow into skin to lay eggs, hatching in about ten days. The mites can travel to bedding and clothing, staying alive for up to 48 hours.

Symptoms include itching and a red rash on the hands, wrists and feet. Sometimes there are tiny bumps in the groin, genitals or armpits. Since scabies can be confused with other skin rashes, a

medical professional can test for scabies and offer treatment if they are found.

Scabies is treated with one of several prescription creams, which are left on while you sleep and washed off the next morning. Some mite infestations require more than one treatment.

As with crabs, all clothing, bedsheets and towels should be washed. Anyone who has been in close contact—lovers and room-mates—should seek treatment and wash everything too. If itching persists, use non-prescription medications that relieve itching; see a pharmacist.

Prostatitis

Prostatitis is an acute or chronic inflammation and/or infection of the male prostate, a gland surrounding the male urethra near the bladder. Symptoms include difficulty urinating (dribbling after urination and more frequent urinating), fatigue, fever, chills, dull pain in the perineal area between the scrotum and the anus and sometimes pain and blood during ejaculation and lower back pain (Marr, 1998).

Sexual transmission occurs, but is not necessary for prostatitis to occur. Genital and anal intercourse and oral sex can infect the prostate with bacteria with or without symptoms. Correct and consistent condom use offers considerable protection from sexually communicated prostate infections. Frequent ejaculations are healthy for the prostate; they also help get rid of prostate infections.

Diagnosis of prostatitis involves a urologist or another doctor doing a rectal exam and evaluating prostate fluid and/or urine. Even if bacteria are not clearly present, antibiotics are usually prescribed as a precaution. Some versions of prostate enlargement do not include bacterial infections; see a urologist to diagnose and treat these prostate conditions. If sexual transmission appears likely, all partners should be informed and treated too.

More information and advice follow from your questions about STDs.

Your STD Questions

QUESTION: "I'm an 18-year-old gay guy. I've had herpes from a guy performing oral sex on me. He had cold sores that I did not notice. I've had two lovers since being infected, but I have not had more attacks. I use acyclovir to prevent attacks. I feel awkward about telling guys ahead of time. How and when should I tell them? What can I do to prevent transmitting herpes?"

ANSWER: Acyclovir should help prevent attacks and lower the risk of transmission. Always use condoms for anal sex. To play it safe, you could use condoms for oral sex too. Be sure to inform any prospective lover about your herpes in a Pre-Sex Discussion. Be frank that you carry herpes, but have only had one attack so far. Your honesty, which is always the best policy, will help others decide if they are comfortable with the relatively low risk of contracting herpes from you.

> Always use condoms for anal sex. To play it safe, you could use condoms for oral sex too.

QUESTION: "I'm a 21-year-old lesbian. I've had three lovers, and so far I have not had any STDs. What STDs are transmitted between women, and how can they be prevented?"

ANSWER: Herpes, genital warts, hepatitis A and B and possibly C, gonorrhea and syphilis can be transmitted by cunnilingus and/or genital rubbing. Use Saran Wrap or dental dams to reduce STD transmission. Since many, if not most, lesbians have also had sexual contact with men, they are at risk for these infections and possibly chlamydia and trichomoniasis too.

QUESTION: "I'm a 21-year-old straight woman who has had intercourse—mostly unprotected—with ten guys. I got genital warts a year ago. The warts were frozen off my cervix and have not returned. What can I do to prevent reinfection, and how can I be sure I won't infect my lovers?"

ANSWER: Correctly and consistently use latex or polyurethane condoms. If any of your warts were on your labia, use the female condom. Condoms aren't 100%, but they greatly reduce the risk of HPV transmission.

QUESTION: "I'm a 22-year-old gay guy. I practice safer sex by using a latex condom for anal intercourse, but recently a condom broke. Are there condoms that are less likely to break from anal intercourse? What other precautions can I take to avoid HIV and other STDs?"

ANSWER: If one partner is infected with HIV, anal intercourse is more likely than vaginal intercourse or oral sex to transmit the disease. The lining of the anus has no natural lubrication, making it more likely to tear. Anal intercourse, whether gay or straight, is safer with plenty of water-soluble lubricant with a fairly thick latex condom. Avoid nonoxynol-9 lubricants, which make HIV transmission more likely. Some prefer the polyurethane female condom for anal intercourse.

QUESTION: "Where can I get condoms without feeling embarrassed?"

ANSWER: A Planned Parenthood clinic or another health clinic is a great place to go. You can also order condoms through the mail—see The Yellow Pages for Sex. Drugstore clerks are used to selling plenty of condoms—don't worry, most clerks aren't going to stare at you when you buy condoms. If you are worried, buy other items along with the condoms.

QUESTION: "I'm a 20-year-old woman who had crabs a few weeks ago. I slept with a new guy who was not the guy I got them from. We didn't have intercourse or genital-to-genital stimulation, but he gave me oral sex. We wore underwear and t-shirts. Could crabs have crawled up his shorts?"

ANSWER: If you slept with the new guy before shampooing away your crabs and any eggs, transmission to the new guy may have occurred. I would let him know that you may have had crabs when you were with him, but you have since treated them. Even if he doesn't notice crabs, he should use the medicated shampoo and wash all clothing, sheets and towels.

QUESTION: "I'm 21, and I've been in a monogamous relationship with a 19-year-old guy for two years. I contracted genital warts because I felt that I could not get an STD if I was monogamous. I am loosing interest in him, but I worry about spreading warts. Should I stay with this guy because of my fear, or should I move on and be honest with new lovers beforehand?"

ANSWER: You are one of many who are lulled into a false sense of security from STDs by being in an exclusive relationship. You too easily forget that previous lovers can infect either partner with warts, herpes or other STDs, sometimes without symptoms. This is why pre-sex testing for STDs, Pre-Sex Discussions and condoms are so important.

Pap smears and a pelvic exam are useful to diagnose warts with women, but warts are harder to detect, except when they are visible, in men. If your warts were on your labia, you might better protect new lovers by using the female condom.

If you are primarily staying with the guy because you fear you will transmit warts to others, I would consider redefining your current

relationship as a friendship so you can move on to men you would rather be sexual with. Always conduct honest Pre-Sex Discussions, and let any new guys know about your warts so they can decide if they want to be sexual with you.

QUESTION: "I was told by a doctor that it's possible for your body to suppress and eventually get rid of herpes. I had thought you could only treat the symptoms. Maybe I misunderstood. He said if there were no symptoms for five to ten years, it is possible that the virus is gone. What do you think?"

ANSWER: The herpes virus can shed and be transmitted without symptoms. There is no cure, but there is a low likelihood of communicating the disease if there have been no symptoms for five or ten years. The virus lives in your body forever, but I wouldn't overreact and live your life out of fear that herpes will recur after years and years. If you want more insurance, use a condom.

QUESTION: "I'm a 17-year-old guy. Whenever I use condoms with nonoxynol-9 spermicide, it always hurts when I urinate after intercourse. I want to play it safe with STDs and pregnancy. What can I do?"

ANSWER: Unfortunately, spermicides like nonoxynol-9 irritate the urethra, causing some to feel pain when they urinate. It may be that you are allergic to spermicides. I do not recommend spermicides; they irritate the urethra, vagina, penis and anus, and can increase the likelihood that some STDs, including HIV, will be transmitted because of genital abrasions. Use a condom correctly. You should be relatively safe from STDs and unwanted pregnancy.

QUESTION: "I'm a 19-year-old college girl. I love sex and enjoy it as often as I can. Our Human Sexuality class was somewhat helpful, but it basically came down on the side of sex-is-risky-so-watch-out or don't-do-it. The dangers of STDs and pregnancy get a lot of attention by those who preach abstinence or monogamy—mostly religious zealots and by-the-book medical people. Why isn't there more attention focused on the positive aspects of sex?"

ANSWER: Sexual dangers are publicized because those who are sex-negative and/or fearful have no other reason to advocate abstinence and monogamy. Once we deal with the dangers, what can these people use to speak against sexual pleasure?

The puritan heritage of America and the lack of objective sex education make it easier to take a repressive doom-and-gloom approach. If the government were more supportive of research and education about STDs and the benefits of sexual intimacy, we'd have more healthy and enthusiastic sex. Some university classes are helpful, but there often is a lack of playful humor to balance the sex-is-dangerous approach.

Safer sex also involves preventing unwanted pregnancies. The next chapter explains the pros and cons of specific contraceptive choices and the backups of emergency contraception and drug-induced and surgical abortion if contraception fails.

8

BIRTH CONTROL IS
A GOOD THING!

Monique and Doug are college juniors who date each other and others.

Although they both have had intercourse with others, they have not gone beyond making out and heavy petting together.

Their chemistry is electric. Recognizing their deepening intimacy, they discuss their feelings and expectations, birth control and STDs. As far as both know, neither has had an STD. Since both have had intercourse without a condom, they agree to go to Planned Parenthood to be tested for HIV and other STDs. Their tests are negative.

Monique has been on birth control pills since she was a junior in high school. They decide to use latex condoms in addition to the pill to further prevent unwanted pregnancy and STDs.

It is autumn and the fall foliage reflects on a secluded lake. A loon and a warm breeze enhance the stillness of the afternoon. They laugh as they chase each other between cedar and maple trees. They roll on a blanket as they French kiss and fondle each other. Monique takes off Doug's shirt and unzips his pants as he unbuttons her shirt and unsnaps her bra.

Before going any further, he pulls a package of condoms out of his front pocket and she opens one, adds some lubricant inside and outside, and carefully unrolls it over his penis. They have joyful intercourse in several positions and both enjoy explosive orgasms. He holds on to the condom as he withdraws from her vagina. They continue to caress and kiss without any fear that sexual dangers will ruin their pleasure.

Monique and Doug are a strong testament for exciting and worry-free safer-sex. They understand that open honesty and common sense encourage fun and responsible sex. Realizing that **birth control is a shared responsibility**, they chose condoms and the pill as a very effective and safe combination to prevent pregnancy and STDs.

Mostly because of increased use of efficient birth control, there are fewer unwanted teenage and young adult pregnancies. If you follow my safer-sex advice, you can proudly contribute to this positive change—and to slower population growth. Birth control and sex education are essential to control unintended pregnancies that would otherwise fuel overpopulation.

This chapter covers the effectiveness and side effects of birth control methods, including emergency contraception. It also discusses medication-induced and surgical abortions. Effectiveness should not be limited to pregnancy prevention. You also need to consider whether a method is healthy, with few, if any, negative side effects. A truly effective contraceptive prevents pregnancy without serious discomfort, pain and/or greatly diminished sexual desire. The challenge is to balance pregnancy prevention with good physical and mental health and with sexual satisfaction.

There isn't an abundance of safe, effective birth control without negative side effects. **Some methods may limit your pleasure or lower your libido—side effects you can minimize by carefully choosing and using a second method to back up proper condom use.** Just like you back up computer files, back up one method with another.

Typical use-effectiveness is a better predictor of the worth of a given method than perfect use effectiveness, which doesn't happen

for all contraceptive users. It's too easy to forget a pill or use a condom improperly. Since the combination of condoms and the pill or another hormonal method prevents both STDs and unplanned pregnancies, simultaneously use both methods to increase your chances for sex without undesirable consequences.

An Excellent Choice: Use Condoms and Birth Control Pills Together

If you follow the condom-use guidelines in Chapter 7, you are reasonably protected from STDs and unplanned pregnancy. In case a condom fails, the pill offers additional protection from pregnancy, but not from STDs (a compelling reason for pre-sex STD tests and discussions). Birth control and STD prevention is a shared responsibility. Girls can choose to go on the pill and both sexes can carry condoms. If a girl forgets a pill (not a good idea), you can still use male or female condoms.

In Chapter 7, you learned about the STD-prevention benefits of latex and polyurethane condoms. They also protect against pregnancy. There are no side effects unless you are allergic to latex. Almost no one is allergic to polyurethane condoms, which are usually more pleasurable than latex, especially the looser-fitting female condom. A few complain of genital irritation from the female condom, but this is not common.

Condoms reduce pleasurable sensations for some, but they also help guys put off ejaculation, which is a clear advantage. If a guy lasts longer, his partner is more likely to experience orgasm too. As sex educator Jay Friedman (2004) observes, "It's dull lovers, not condoms, that make for dull sex."

Users of the female condom who like it laugh about the squeaky noises it makes! One advantage is probable increased STD protection, which can be controlled by the female. The female condom has not been as effective as the male condom against unwanted pregnancies, but user mistakes are mostly responsible for both female and male condom failures. Never use a female and male condom together; they would stick together during intercourse.

For contraceptive purposes, properly used birth control pills (taken at the same time of the day, each day) are more effective than typical condom use, but less effective than IUDs, implants and injections. Perfect use of the pill has a .3% failure rate, but typical use results in

an 8% failure rate (Warner, Hatcher and Steiner, 2004). If girls use the pill as prescribed, without missing pills, they are effective against unwant-

A major disadvantage is that pills do not prevent STDs; be sure to use condoms too.

ed pregnancy. However, overweight women are 60% more likely to get pregnant than thinner women (Julie Davidow, *Seattle Post-Intelligencer*, December 29, 2004). **If you use condoms and the pill or another hormonal method together, the risk of pregnancy is very low.**

Girls: Be sure to follow instructions from the birth control pill packet information sheet and from your medical professional. Use condoms too, especially if you are on an antibiotic, which compromises the pill's effectiveness. If you miss a pill or if you are late starting a new cycle, be sure to use a condom until you take pills for seven consecutive days. You can also use emergency contraception when you miss a pill.

The pill may combine estrogen and progestin, or it may be progestin-only. Combination pills prevent ovulation—no egg, no pregnancy. Progestin-only mini-pills may allow for occasional ovulation, but sperm are blocked by thickening cervical mucus and, similar to combination pills, by making the uterus less susceptible to implanting a fertilized egg. Progestin-only pills have a slightly higher failure rate than combination pills, but the difference is negligible.

Contrary to pro-life groups, including a few pharmacists and doctors who refuse to offer the pill, the pill is not a form of abortion. In most cases, the pill stops ovulation. Especially with emergency contraception, if an egg were fertilized, it would not be implanted in the uterus; but mainstream medicine does not view this as a pregnancy (Jill McGivering, BBC, 2004).

Birth control pills reduce anxiety about pregnancy. They may also lighten periods and relieve menstrual cramps. In addition, the pill decreases the risk of ovarian cancer by 42% and uterine cancer by 31% if the pill is used for at least four years (Women's Health Initiative Study, 2004). The pill and other hormonal methods also lower the risk of PID and menstrual cramping (Boston Women's Health Collective, *Our Bodies, Ourselves*, 2005).

A major disadvantage is that pills do not prevent STDs; be sure to use condoms too. Pills sometimes have side effects: blood clots, stroke, high blood pressure and headaches affect some women. Young, healthy,

non-smokers are not usually affected by these problems. Girls who smoke are better off not to use combination pills or any other hormone method that contains estrogen. Another reason not to smoke.

Progestin-only pills and other progestin-only methods do not seem to pose a risk for smokers, but there is an increased risk of heart disease from smoking no matter which method you choose. If you smoke, get some help from your physician so you can quit.

Some girls notice that their sexual desire isn't quite as powerful, which can sometimes be solved by changing the type of pill. Triphasic pills with separate estrogen and progestin pills taken at different phases of your cycle don't restrict sexual desire as much as combination pills or progestin-only pills (McCoy and Matyas, 1996).

Some also complain of depression, initial nausea, weight gain, acne and vaginal dryness. The pill is relatively safe. There is a higher risk of death from pregnancy than from using the pill.

Pills cost more from a pharmacy than from Planned Parenthood, which offers condoms, the pill and clinic visits at little or no charge. The informed professionals at Planned Parenthood have much to offer teenagers and young adults who **plan** to enjoy intercourse rather than needlessly worry about it.

Some of you get carried away and have unplanned, unprotected intercourse, and condoms sometimes break or slip off. In these cases, you need emergency contraception right away.

Emergency Contraception
(The "Morning-After Pill" or The Copper IUD)

If a condom fails without additional protection from the pill or other birth control, immediately see Planned Parenthood, a doctor or a health clinic to get **emergency contraception**—the "morning-after pill"—progestin-only mini-pills or a series of estrogen pills. For optimal effectiveness, carefully timed doses of specific birth control pills are taken within 12 to 24 hours after unprotected intercourse—ideally not more than 72 hours, but research shows they can be effective up to 120 hours after sex (Stewart, Trussell and Van Look, 2004). **See The Yellow Pages for Sex for referrals to local emergency contraception services.**

If progestin-only emergency pills are taken as prescribed, they are 89% effective. Combination pills with progestin and estrogen

198

work about 75% of the time. The pills are most effective if taken within 12 hours.

Emergency contraceptive pills are not nearly as effective for pregnancy protection as correct use of the pill or the vaginal ring. A few states wisely allow emergency contraception without a prescription, which improves the odds that a girl will get the pills in time, but most states require a prescription. According to www.Teenwire.com (July 18, 2005), a study at the Imperial College Faculty of Medicine in London found that access to emergency contraception without a prescription did not increase unprotected intercourse. Common side effects are nausea, vomiting and cramping, but these are virtually nonexistent with progestin-only emergency contraception.

The FDA has been inappropriately influenced by pressure from the religious right wing in failing to accept its own panel's overwhelming recommendation to approve EC without a prescription. The FDA has twice put off a second decision on Plan B EC, this time to solicit public opinion for sixty days—and ostensibly to figure out how to enforce the 17-year-old age limit (previously, it was 16)—after falsely **promising** to render a decision by September 1, 2005 (MSNBC, August 26, 2005). As this book goes to press, the FDA has indefinitely put off this critical decision for the sexual health of all women, resulting in the resignation of Susan Wood, director of the FDA Office of Women's Health. Wood stated: "I can no longer serve as staff when scientific and clinical evidence, fully evaluated and recommended by the professional staff here, has been overruled (Associated Press, MSNBC, August 31, 2005).

Women of all reproductive ages (not just those 17 and older!) deserve the right to safe and effective over-the-counter EC. Teenagers and older women are clearly being held hostage by a federal agency that bases its decisions on conservative politics—including the politics of birth control and abortion—more than science and what is good for women and public health. **Ironically, over-the-counter access of EC would decrease the need for abortion!** According to Planned Parenthood ("FDA Delay on EC," 2005), "Experts estimate that wider access to EC would prevent up to 1.7 million unintended pregnancies a year—and 800,000 abortions."

The lack of separation of church and state underscores the real motive of the extreme right wing, which is to unconscionably force all

women—especially teenagers—to pay for their pleasure with an unwanted pregnancy. Both Planned Parenthood (2005) and the Center for Reproductive Rights (2005) reacted with understandable concern about the FDA's shameful lack of responsibility and deception in serving your birth control needs, and Senator Hillary Clinton called the decision "outrageous...disturbing" and "a wake-up call to everybody in this country" (Gardiner Harris, *New York Times*, 2005).

Another method of emergency contraception is a **copper intrauterine device** (IUD), which is implanted in the uterus from three to seven days after unprotected intercourse. It prevents fertilized eggs from attaching to the uterine wall. Emergency IUDs implanted up to seven days after unprotected intercourse are 99.8% effective (Stewart, Trussell and Van Look, 2004).

Neither method of emergency contraception is abortion. Both methods reduce unplanned pregnancy and the need for abortion. Unfortunately, very few young people are aware of these backup methods. Some confuse emergency contraception with a drug-induced abortion (RU-486) (NARAL, 2004), also discussed in this chapter.

Intrauterine Devices (IUDs)

IUDs are small T-shaped plastic objects that are most commonly implanted in women who have given birth and/or have not had ectopic pregnancies (fertilization in the fallopian tubes). They help prevent ectopic pregnancies. Some doctors also insert them in child-free women. There is a higher risk of IUDs being expelled by young women without children—a good reason to choose the pill, the vaginal ring or the birth control patch. Depending on the type of IUD, there is only a .1-.8% risk of pregnancy (Hatcher and Nelson, 2004).

IUDs do not cause an abortion. They are true contraceptives, as they prevent fertilization. They also make it much less likely that a fertilized egg will attach to the uterine wall. The IUD is an excellent contraceptive method for those who have been tested for STDs **who also use condoms**. IUDs may put women at a higher risk for STDs and pelvic inflammatory disease (PID), but there is much less risk if condoms are properly used too. The research is not conclusive, but IUDs may be safer for those in monogamous relationships. Whether you are sexually exclusive or not, use condoms along with an IUD, and periodically get screened for STDs.

Some women experience menstrual cramps, heavier menstruation and irregular bleeding. If you get an IUD, check the small plastic string to be sure it is in place, following your period every month.

In addition to the copper IUD, the Mirena® IUD with small amounts of progestin is available; it reduces menstrual cramps and bleeding for most users and it is quite popular. The copper IUD can be implanted for ten years, and the Mirena IUD for five years, before needing replacement.

The Vaginal Ring (NuvaRing®)

The vaginal ring is a small, flexible ring inserted by the girl high in her vagina for three weeks, and removed for the fourth week. The ring delivers estrogen and progesterone to prevent ovulation and to thicken mucus on the cervix to prevent fertilization. The ring is 99.7% effective, and it is effective one day after insertion, but it does not prevent STDs.

Like the pill, **using the ring with a condom** is commonsense safer-sex prevention of STDs and pregnancy. You don't have to remember to take daily pills and it doesn't require nonoxynol-9 spermicide, which increases your odds of contracting some STDs. The ring can result in regular, shorter periods and less cramping. About 90% of users would recommend the ring to a friend (Hatcher and Nelson, 2004).

Some girls report more vaginal discharge and irritation or infection (yeast) or headaches, but most seem to do very well with it. Since you only have to remember to put in a new ring once a month, there undoubtedly are fewer user mistakes than with the pill. The vaginal ring does not interrupt spontaneity, and it is safe, convenient and easy to use, as well as private—no one needs to know you are using the ring (Boston Women's Health Collective, *Our Bodies, Ourselves*, 2005). I predict that the ring will become a leading birth control method for young women.

The OrthoEvra® Patch

The OrthoEvra transdermal patch is similar to combination pills, except estrogen and progesterone enter your blood through a patch on your abdominal skin. The patch is 99.7% effective with perfect use and it is estimated to be 92% effective with typical use. It is adhered to

abdominal skin and changed weekly for three out of four weeks. The side effects are similar to those with the pill, including less sexual desire for some users. Some women complain of skin irritation and redness or a rash, and the patch can be hard to conceal.

Since the patch contains estrogen along with progesterone, smokers are better off not using the patch. According to MSNBC (July 17, 2005), "If you are a woman taking the pill who doesn't smoke and is under 35, the chance that you are going to have a blood clot that doesn't kill you is between 1 and 3 in 10,000. Your risk of dying from a blood clot while using the pill is about 1 in 200,000. By contrast, with the patch, the rate of nonfatal blood clots was about 132 out of 10,000 users...while the rate of deaths appears to be 3 out of 200,000."

Women who weigh more than 198 pounds should not use it; early research indicates these women are much more likely to become pregnant when using the patch. It can cause breast tenderness. Patches can detach if they are applied over lotion, creams or oils, or on a spot that repeatedly gets rubbed by clothing seams. When used with condoms, the patch is a good choice for many women.

Depo-Provera® Injections

Depo-Provera three-month progestin shots are very effective against pregnancy (99.7% with perfect use and 97% in typical use), but Depo-Provera can lower sexual desire. If I were to count the calls to my radio show and comments from women in my sex therapy practice about Depo-Provera's effect on sexual desire, I would have a large contingent of teenage and young adult women who have experienced a sagging libido and other unpleasant side effects. The same could be said for SSRI antidepressants, such as Effexor®, Celexa®, Paxil®, Prozac®, and Zoloft®, which may help your depression, but they all dampen your libido and make it more difficult to experience orgasm. Why not find another method with fewer negative side effects?

Other Depo-Provera side effects: weight gain (about five to seven pounds in the first year of use, especially women who already have excess weight, with more weight gain beyond the first year),

amenorrhea (no periods) or light periods, headaches, abdominal pain, fatigue and depression (Hatcher, 2004). Since it takes six or more months to leave your body, side effects like depression and lowered sex drive don't go away for a long time (Boston Women's Health Collective, 2005).

According to one study, Depo-Provera triples the risk of chlamydia and gonorrhea and it may well increase the odds of contracting other STDs too. Depo-Provera doesn't increase the odds for getting STDs; it is because methods that don't require as much diligence may "easily lead to a woman letting her guard down about STD prevention" (Howard LeWine, Harvard Medical School, August 24, 2004).

The status of progestin implant availability changes from time to time. A variety of progestin implants are likely to eventually become available: Norplant®, Implanon® and probably others. Although implants are extremely effective against pregnancy, they can lower sexual desire and they require surgical intervention to put them in and take them out. As with other hormone methods, implants do not offer STD protection, so be sure to use condoms too.

The Sponge and Other Spermicide Methods

The sponge was taken off the market in 1995, but it has again been approved by the FDA for distribution in the U.S. It is more effective if a woman has never had a child (91% with perfect use, and 80% with typical use), but it is only 80% effective with perfect use and 60% with typical use if she has had a child (Hatcher, 2004). One size fits all. It includes nonoxynol-9, a harsh detergent that irritates genitals and makes HIV and other STD transmission more likely. For this reason—plus it isn't nearly as effective as the pill, the ring or the patch—think at least twice before you use the sponge and other products with nonoxynol-9.

Vaginal contraceptive film, foam, suppositories, lubricants and creams with nonoxynol-9 all taste awful for oral sex and some are allergic to it—both valid concerns. About 29% become pregnant using spermicides alone, an unacceptable failure rate. The perfect use failure rate is 8% (Hatcher, 2004). These products are available without a prescription.

New microbicides/spermicides will hopefully be soothing lubricants that are equally adept at obliterating STDs and preventing pregnancy.

Diaphragms, Cervical Caps, Lea's Shield® and FemCap®

Diaphragms and cervical caps are prescription barrier methods that cover the cervix to prevent sperm from swimming past the cervix into the uterus. Neither method is very effective. The diaphragm with perfect use is 94% effective, but in typical use it is 80% effective. The cervical cap is 91% effective with perfect use, and 85% effective with typical use if a woman has never had a child, 69.7% if she has (Trussell, 2004).

Lea's Shield blocks the cervix and it has a valve that allows cervical secretions and air to pass. One size fits all. It fails about 8.7% of the time. The FemCap is another cap; it comes in three sizes and a medical professional must fit it. It fails about 4.8% of the time. It can be left in for up to 48 hours. The spermicide with nonoxynol-9 that you use with diaphragms, caps and shields irritates genitals and can cause some STDs to be more easily transmitted.

If you back up these barrier methods with a condom, you have good pregnancy prevention and increased STD prevention, but the nonoxynol-9 still compromises STD protection. On the plus side, diaphragms and caps won't lower your libido. For women not able to use or not wanting hormone methods, these barrier methods have something to offer when used with a condom.

Fertility Awareness/Rhythm Methods

If you have intercourse without any birth control, you have an 85% chance of a pregnancy. This is one reason why abstinence is not a good birth control method; when you fail to abstain, you are at high risk of getting pregnant. Any method is better than no method, but some are clearly more effective than others. Rhythm methods are intended to avoid fertilization by abstaining from intercourse before, during and after egg-producing ovulation, usually mid-cycle. Since eggs can live up to three days and sperm may be viable for three days, pregnancy prevention varies widely.

Rhythm methods are not very effective for most users. Typical-user failure rate is 25% for the calendar method (counting days),

with a perfect-use failure rate of 5%. For the standard days method, there is a 12% typical-user failure rate and a 5% perfect-user failure rate. For the ovulation/cervical mucus method, there is a 22% typical-user rate and 3% perfect-use rate, and for the symptom-thermal method, there is a 13-20% typical-user rate and 2% for perfect-use rate (Jennings, Arevalo and Kowal, 2004).

Rhythm is not effective enough when you consider the excruciating diligence required for the typically low effectiveness. It is best suited to those who don't like sex very much (Hyde and DeLamater, 2003). You can't have sex as frequently; a woman with irregular periods would have to abstain about 15 days a month and a woman with regular periods about 8 days a month, a definite disadvantage. Teenage and young adult women are poor candidates because your periods are usually irregular and you may not be patient enough to abstain enough to prevent pregnancy (Planned Parenthood, 2004).

Additional disadvantages are the lack of effectiveness, the total lack of STD protection and anxious stress about whether rhythm will prevent pregnancy and when you can safely enjoy sex. There is no backup method for birth control unless you use a condom too. Only 4% of women use rhythm methods. Not recommended unless you are prepared for a possible pregnancy.

Douching and Withdrawal

Douching and withdrawal are not very effective for birth control, and not at all for STDs. Some douche for hygienic purposes, but douching is not healthy. It destroys the natural environment of the vagina, sometimes resulting in a vaginal infection, PID and ectopic pregnancy (Cates, 2004). Douching may also make STD transmission more likely. Not recommended.

Withdrawal doesn't work well, with 27% typical-use failure and 4% perfect-use failure. If you have repeated intercourse, there may be enough sperm swimming in pre-ejaculatory fluids to unite with an egg. Also, there is no STD protection and it interferes with both lovers' satisfaction by stopping stimulation as the man nears ejaculation. Not recommended.

> Some douche for hygienic purposes, but douching is not healthy.

Sterilization

For most of you, male and female sterilization are not appropriate birth control for quite a few years, but when you are older and are sure you don't want more children, this would be an excellent, highly effective (99.9% for a male vasectomy and 99.5% for a female tubal ligation) choice (Hatcher, 2004).

Sterilization does not lower your libido. If you ever choose sterilization, consider it permanent. Reversing sterilization cannot be assumed. Unless condoms are also used, there is no STD protection.

Abortion

If you have unprotected intercourse, get emergency contraception. If it is 9 to 10 days since intercourse, get a pregnancy test kit at a drug store, at Planned Parenthood or a doctor's office. A urine home pregnancy test is not very reliable, with 84% accuracy predicting a pregnancy and 62% accuracy predicting negative results. A lab urine test or blood test in a medical office is much more accurate (98-99%) than a home test (Klein and Stewart, 2004 and Hyde and DeLamater, 2003).

If you use a home pregnancy kit and the result is positive, you should repeat the test, preferably at a medical office, to be sure you are pregnant. If you are pregnant, you can discuss whether to keep the child, put it up for adoption, or to terminate the pregnancy. **See The Yellow Pages for Sex for adoption and abortion counseling and services.** Avoid referral agencies listed in the phone book as "problem" or "crisis" centers or "pregnancy resource" centers—these are usually thinly disguised antiabortion groups intent on persuading women not to get abortions (*Our Bodies, Ourselves*, 2005, 1998).

The decision is rarely easy. That's why discussing it with the potential father, your parents, other adults, a specially trained counselor at Planned Parenthood or another women's health clinic, and your friends makes good sense. Many pregnant girls bring their partners or someone else when they talk with a counselor, but you can choose to go alone.

It is a shared responsibility for you and your lover to deal with birth control, including an unintended pregnancy. A pregnant woman has the final legal and personal right to choose whether to have a child or terminate a pregnancy through medicine or, depending on

the stage of pregnancy, through vacuum aspiration or surgery.

According to a prominent college textbook, pro-choice groups and scientists who developed RU-486 don't refer to this method as abortion; as a contragestational drug, they claim it induces menstruation (Hyde and DeLamater, 2002). You have to decide where you stand on this issue. No one else can decide for you.

If you decide to end a pregnancy, the earlier the better. Drug-induced abortions are easier, safer and cost less than surgical abortion (Planned Parenthood, 2004). Women choosing this method are able to complete the process soon after discovering they are pregnant (Crooks and Bauer, 2002). Medication abortions are administered from about five to nine weeks after the last period, while most early surgical abortions can be obtained as early as five to six weeks after the last period, so timing is not necessarily a decision-making factor.

RU-486 (mifepristone) abortion is most effective when carried out within seven weeks since the first day of your last period, although some clinics use this method for up to 63 days from the first day of the last period. Medication procedures typically require two or three visits to Planned Parenthood or a doctor's office—the first to be counseled about the procedure, sign a consent form, provide a medical history, conduct lab tests and have a physical exam. This is followed by RU-486, and two days later by a prostaglandin, misoprostol (Planned Parenthood, 2004).

RU-486 abortion is 92-99% effective (Crooks and Bauer, 2002). Don't overreact to right-wing groups attributing fatality risks to RU-486. Although four California women died from sepsis—a bloodstream infection—after using RU-486, none of the women who died followed the FDA-approved instructions for taking the drug (Change, *Seattle Post-Intelligencer*, July 25, 2005). If the drugs don't work, a vacuum aspiration abortion is performed. The entire process can take up to two weeks, usually a week or less. Other than possible psychological distress, research shows that most don't have serious negative responses to abortion (Adler, et al., 1992).

Adverse complications from surgical abortions within 13 weeks are very uncommon; 97% of women report no serious after effects (*Our Bodies, Ourselves*, 1998). Cramps and bleeding are expected effects. Possible side effects include headache, nausea, diarrhea, dizziness, fever and chills (Stewart, Ellertson and Cates, 2004).

Canada has approved over-the-counter (Plan B) emergency contraception. Hopefully Canada's wise decision will pressure the FDA to get beyond the influence of right-wing religious groups and finally approve emergency contraception without a prescription too.

Since a woman can get pregnant soon after an abortion, effective birth control should be discussed and used. The cost for medically induced abortion varies, but it usually costs $350 to $575 (Planned Parenthood, 2004). RU-486 has been widely used in France and other European countries for more than fifteen years; the FDA approved it for use in the U.S. in 2000. I predict that it will become a frequently used method in the U.S.

A vacuum aspiration abortion is an outpatient surgical procedure performed 7 to 13 weeks after the last period. The method suctions out the contents of the uterus. It currently is the most widely used method in the U.S. In 1999, 96% of abortions were by aspiration. It is "safe and simple" (Stewart, Ellertson and Cates, 2004).

Laws about parental notification for women under 18 vary by state, but the extreme right wing is gathering momentum to force their restrictive agenda on young women through Congress, the White House and the Supreme Court. In some cases, girls appear before a judge rather than inform or ask permission from a parent. It is clear that too many legislators are determined to limit your access to emergency contraception and abortion in apparent—and perhaps unconstitutional—effort to make you "pay if you play."

A **dilation and evacuation surgical abortion** is performed in clinics and hospitals when a woman is 13 to 16 and up to 21 weeks pregnant. The procedure involves suction and scraping the uterine walls. It is considered safer than older methods and it does not require prolonged hospital care (Stewart, Ellertson and Cates, 2004).

Considering the constant legal threat of limiting or denying the right to choose abortion, it is critical to recognize that more than 25 million Americans have chosen to obtain abortions since 1973 when the Supreme Court legalized abortion. Fewer teenagers seek abortions now than since 1990, but this is mostly from easier access to contraception—not from increased abstinence.

Currently, more than 20% of pregnancies end in abortion. More teenage pregnancies are probably carried to term, in part because of 487 laws enacted by states to demand waiting periods, parental consent for minors and mandatory counseling. Unfortunately, the private

right to choose abortion is being chipped away by some legislators and judges (John Leland, *New York Times*, September 18, 2005).

Abortions are an essential and legal backup to unprotected intercourse, contraception that fails and coerced sex. It is safer to have a legal abortion than to carry a pregnancy to term (Stewart, Ellertson and Cates, 2004). Abortions would be much less necessary if there were more support for comprehensive sex education and for Planned Parenthood and other health clinics offering accurate information, effective contraception and emergency contraception.

New Contraceptive Methods

You truly can "double your pleasure, double your fun" if you don't have to worry about STDs—including HIV—and pregnancy. Researchers are emphasizing methods that women will be able to use to prevent STDs and unwanted pregnancy, but more funding for new research is needed.

It is likely that new, non-caustic microbicides will eventually replace nonoxynol-9, offering superb STD prevention and birth control, including HIV prevention. At least one microbicide safer-sex gel applied topically in the vagina has been shown to reduce virus levels of HIV-infected women. The gel may also reduce herpes simplex virus. The new gel will be tested with thousands of women (Nicholas Bakalar, 2005). New barrier, IUD and hormonal methods and a contraceptive vaccine are also on the horizon (Stewart and Gabelnick, 2004). If you back up new products with a condom, you probably will enjoy sex that is almost trouble-free.

When you consider emotional and relationship issues, no sexual relationship is entirely trouble-free. Few activities are perfectly safe; cars put you in some danger, and so can sex and other common activities. That's why you use seat belts and condoms. An adventurous life without some risk is impossible.

A good sexual choice is one that makes you—and others—happy. If you rationally and positively deal with relationship and self-esteem issues, you are more likely to make good choices; see the next chapter.

Future contraception includes new male methods, such as male pills. Studies around the world point to an effective, safe and reversible hormonal contraceptive for men. Pills, patches, surgically implanted rods and three-month injections are all being tested with

men. It may be that these new choices will be available in five to ten years or more (Stewart and Gabelnick, 2004).

A common approach is to cease sperm production with hormones, including testosterone and progestin. When these methods have been empirically evaluated and not found to lower sexual desire or have other side effects, the FDA is likely to approve them (John Schieszer, MSNBC News, 2004).

Because some new male methods lower both sperm and testosterone, injections of testosterone sometimes accompany pills, patches or implants. So far, libido changes, mood swings, increased muscle mass, sweating and acne are common side effects (www.Kaisernetwork.org, August 4, 2004).

A get-real question: Will women believe a man who says he's on the pill or another form of hormone contraception? This will be a humorous topic for Pre-Sex Discussions! "Your method or mine?" will complement "Your place or mine?" Most men and women welcome a balance of male and female methods—a huge support for equality and shared responsibility that enhances trust and intimacy.

Your Birth Control Questions

QUESTION: "I'm a sexually active college sophomore who loves to make love with a select few guys. I have never had a pregnancy or STDs and I want to keep it that way. I've consistently used condoms and I have never had one break or slip off. I am also on a triphasic pill, which I like very much. Do you think I am at much risk for STDs and/or pregnancy?"

ANSWER: In a word, no. You are using common sense in religiously using condoms and birth control pills. Unless you miss pills or a condom fails, you are not likely to have problems. As long as you can handle it all emotionally with honesty with yourself and your lovers, go for it.

 QUESTION: "Since being on Depo-Provera, I have had absolutely no sex drive. I'm 20, I love my boyfriend and we used to have a great sex life. Now it is zero. What can I do?"

ANSWER: Don't get another Depo-Provera shot. It could take six to eight months, but you will regain your desire as long as you don't pick another birth control method that greatly reduces your desire. Why not try the NuvaRing, a triphasic pill, the OrthoEvra patch or an IUD with condoms?

 QUESTION: "I'm a technical virgin. Is it possible to become pregnant without having intercourse? What if semen were to accidentally enter my vagina? I just missed a period. I'm scared."

ANSWER: Technical virgins can get pregnant without having intercourse. If you engaged in outercourse without clothing as a partial barrier and your lover ejaculated near your vaginal opening, his sperm could conceivably wiggle their tails and swim into your vagina and past your cervix to unite with an egg if there is one. If you were not close to ovulation, there would be no egg to fertilize.

Since you have missed a period, I would go to Planned Parenthood or your doctor for a blood or urine test to see if you are pregnant. You could also get a home pregnancy urine test at your local drug store. If you find that you are pregnant after a couple of home urine tests or one laboratory urine or blood test, you will have to decide whether to use RU-486 to induce your period, or to continue your pregnancy.

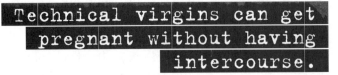
Technical virgins can get pregnant without having intercourse.

 QUESTION: "I'm 18 and I have had frequent intercourse while on the pill. I missed a pill and forgot to double up on pills. I

haven't been using condoms. I have been spotting, but no period. Could I be pregnant?"

ANSWER: You might be pregnant, but I would not assume you are. Get a pregnancy test at a medical office and from now on double up on a missed pill and use condoms! Spotting doesn't necessarily mean you are pregnant. Girls miss periods or spot when they are stressed out, not just when they are pregnant.

QUESTION: "I am home for the summer from college. My parents are very strict and do not approve of premarital sex. When my gynecologist recommended I go on the pill for my cramps, my mother freaked out and said no way. Now that I am sexually active I feel I need more protection from conception than just condoms. I've tried spermicide and condoms, but my most frequent lover is allergic to spermicide. Is using condoms enough? Is there a time when I shouldn't have sex? Where can I get cheap or free birth control that is safe?"

ANSWER: You should not have allowed your mother to affect your gynecologist's recommendation to use the pill. Go to Planned Parenthood and you will save on the cost of the pill. Continue to use condoms too. Avoid spermicides; they are caustic and they are not reliable prevention for STDs or pregnancy. You need a backup to condoms. You could consider other backups, such as the NuvaRing too. I would not use the calendar rhythm method as a backup to condoms, because this method is not very effective unless you are extremely patient and also use the temperature and/or mucus methods.

QUESTION: "I'm a 17-year-old guy and my 16-year-old girlfriend and I enjoy oral

212

sex and hand stimulation. I was at her house and we decided to go further. She is not on the pill and we didn't have condoms. I entered her, but did not ejaculate. She missed her period. She took a home pregnancy test a few days after she missed her period, and it was negative. Do you think she could be pregnant?"

ANSWER: There is no way I can say for sure. She could be anxious and this could cause a missed period. If her home pregnancy test was done before 9 to 10 days since intercourse, or if the test was used late in the day, it could be a false negative. You could repeat the home test in the morning when it is most accurate, but I would recommend that you both go to Planned Parenthood and get a more accurate urine or blood test.

It is possible for you to ovulate more than once in a cycle.

QUESTION: "My boyfriend and I have been dating for six months. We have great sex, but we haven't been very careful about using a condom and I am not using another method. A couple of days ago we ran out of condoms, which is no excuse. I was still having my period and he didn't come in me. What are my chances of getting pregnant?"

ANSWER: There is less of a chance that you would get pregnant during your period, but it is possible for you to ovulate more than once in a cycle. If he didn't ejaculate, there is less of a risk than if he did. Your chances of being pregnant are not very high. Wait a week or so and get a pregnancy test, and from now on use condoms and an effective backup method.

QUESTION: "My 19-year-old boyfriend and I are considering having intercourse. His

sperm count is barely above sterile, and he knows that he doesn't have any STDs. He doesn't think we should have to use protection, but I disagree. Who is right?"

ANSWER: You are. How do you know his sperm count is low? Most guys don't get their sperm tested unless they are trying to conceive. Have you seen the test results? Also, how does he know he doesn't have any STDs? There aren't always symptoms. Has he had STD screening tests? Have you seen the results? I'm skeptical about his claims.

QUESTION: "I'm a 21-year-old college student. When I have intercourse, the condom always loses its lubrication and irritates my vagina. I'm wet and the condom goes dry. I've tried different brands of latex condoms with the same result. I've tried Astroglide and K-Y Jelly to no avail. I was on the pill until about a month ago. I stopped the triphasic pills because they were affecting me psychologically. My moods were all over the planet, and I felt insecure and unattractive. Should I try different pills? What can I do about the irritation and dryness?"

ANSWER: It is quite possible that you are allergic to latex. Try polyurethane condoms with a water-soluble lubricant without spermicide to see if you can get rid of the irritation and dryness. Your hormones may be a reason for the problem too. If you can't solve it this way, see a gynecologist or Planned Parenthood to test your estrogen and progesterone and to further evaluate how to treat your problem.

QUESTION: "I am 20 and so far contraception has worked well, but if I ever get pregnant I want the option to use

emergency contraception, and RU-486 or a vacuum abortion if necessary. Those who try to pass laws to limit my fertility choices appall me. My body is mine. The right wing doesn't own it. What can we do to preserve our right to choose?"

ANSWER: It has been over thirty years since the Supreme Court legalized abortion. It may seem inconceivable that the court would reverse the landmark Roe v. Wade decision, but never assume that you will always have the right to choose. Outspoken minorities and a slightly different court might limit or make abortion illegal again.

Since contraception is not currently foolproof, drug-induced and surgical abortion are important backup birth control methods. Before legal abortion, there were many unnecessary deaths from illegal abortions.

Without abortion, there would be much less sexual freedom. Some misguided politicians are determined to go back to the you-will-pay-if-you-play mentality. Play is essential to your health. To advocate negative consequences for normal sexual expression among young people is unhealthy and totally unnecessary.

You can participate in pro-choice demonstrations, elect pro-choice politicians and write articles, columns and letters to the editor to reaffirm your belief in choice. You can also make charitable contributions to Planned Parenthood, the Alan Guttmacher Institute and NARAL Pro-Choice America. Your efforts can make a difference.

Before legal abortion, there were many unnecessary deaths from illegal abortions.

QUESTION: "I'm a 16-year-old guy who has never had intercourse. I plan to go all the way when I am out of high school. I worry that I won't fully understand contraception and STDs so I can avoid sexual problems. My high school health teacher preaches abstinence and refuses to answer our questions about safer

sex. My parents are not very helpful even though they wish they were. Where can I go to get accurate information and advice?"

ANSWER: Attend Planned Parenthood orientation sessions and read and discuss this book with your friends, parents and other adults. Do not have intercourse until you can nurture your well-being by knowing a lot about STDs, birth control and what it takes to be emotionally healthy in intimate relationships.

I hope your kids will approach you and their teachers to discuss sex and relationships. Your caring openness will go a long way to help your kids understand more than you did during your teenage and young adult years.

Until now, safer sex has primarily been focused on avoiding STDs and unwanted pregnancy. In the final chapter, sexual fears from distorted thoughts, self-esteem and emotional/relationship/boundary issues, the politics of censorship, abstinence and comprehensive sex education, the role of parents and The Next Sexual Revolution will be explored with an eye to improving mutual joy and intimacy.

CHOOSE HEALTHY, SAFE AND FUN SEX!

S-E-X. What a delicious, delicate blend of pleasure and emotion. Sex can be playful, lusty, spiritual, intimate, loving, passionate, fun, funny, safe and cerebral.

In spite of potential dangers—STDs, unwanted pregnancy, and hurt feelings—you can use accurate information and common sense to enthusiastically say yes to wonderful sex. If you follow my suggestions, safer sex, not just intercourse, is a fun stress reducer for your emotional and physical wellness.

In this chapter, I offer cognitive tools to get rid of negative thinking so you can improve your self-esteem, body image and relationships. Equality, realistic relationship boundaries and values, real friendship—based on honesty, openness and trust—and caring sex are encouraged as an attractive alternative to selfishness, manipulation, aggression and abuse. I also make suggestions for more comfortable and helpful communication with your parents.

I address unwarranted censorship—by some politicians and clergy and by school-based abstinence programs and some media—of legitimate sexual choices. The attempt to put down and censor scientific sex research is viewed as a misguided attempt to deny responsible sexual freedom. Finally, I offer insights for better sex and more productive relationships—with open, imaginative minds and collective activism—to enthusiastically plan and playfully create what I refer to as The Next Sexual Revolution.

Get Rid of Negative Thoughts, Bad Moods and Hurt Feelings

Some of you have fearful, distorted thoughts about yourselves and about sexual encounters and relationships. To fully enjoy sex, you have to let go of irrational fear.

You are inundated with sexy images on MTV and the Internet and in movies and magazines. These smoldering images may arouse you, but some of you feel inadequate or unattractive because you don't look like models, actors and actresses.

Being sexy and sexual starts in your mind. You don't have to be physically gorgeous or handsome to be fun, flirty and sexy, but a healthy body image is important to desire and enjoy sex. If you don't feel desirable, you are much less likely to desire others.

You create needless misery by being embarrassed, ashamed and disliking your body. Make peace with your body. Stand in front of a mirror and touch every part while talking to yourself about how delightful your body really is. Believe others when they compliment your body and the way you present yourself.

You may **feel** too heavy and out of shape. If you **are** overweight, daily exercise and a balanced diet allow you to slowly lose weight and tone your muscles. This takes a special effort in a society that largely fails to emphasize healthy exercise and eating habits. You will succeed if you don't give in to peer pressures to consume Twinkies, french fries and other fatty, sugary and high-calorie foods.

You may feel you are too heavy because you don't look like a model or an athlete, but this doesn't mean you are overweight. There is more than one way to be attractive and healthy. Don't compare yourself to the current media fad. If those who care about you tell you that you look good, believe them.

Nurture your self-worth. If you don't feel good about your body, you can slowly streamline your physique. Participating in sports and exercise classes will give you the extra support you need. If you have an eating disorder, consult a medical professional. You may also want to look into attending meetings of Overeaters Anonymous, a program for overeaters, anorexics and bulimics (see www.overeatersanonymous.org). No girl should starve herself to be sexy and no guy needs to work out five hours a day to be a stud muffin. It's all in your head.

If you have negative thoughts about your body and/or your self-esteem, talk with your close friends, your parents and possibly a counselor. In the first and fifth chapters I mentioned replacing negative thoughts with more rational and positive thoughts. I highly recommend *The Feeling Good Handbook*, a self-help book by Dr. David Burns. If you have self-doubts, a poor body image, depression, anxiety or problems with sex, love and relationships, complete the get-real exercises in Dr. Burns' book.

I constantly see the fruits of this rapid and powerful approach to change a negative, self-defeating thought pattern. Like Dr. Burns, I am a cognitive therapist and I use his insightful book in my sex therapy practice.

When you automatically have the same negative thoughts, you get depressed and convince yourself that the future will repeat the past and nothing can get better—this is fortune-telling. If you believe nothing can change, your thoughts become a self-fulfilling prophecy, you continue to think in self-defeating ways and you stay miserable.

You can change your thoughts and feel better about yourself if you refuse to stay stuck in a mental rut. Negative thoughts are caused by failing to distinguish between real and imagined problems. This happens when you obsess about the past or worry about the future. The happiest people live in the pleasure of the moment. No one can change the past, so why not enjoy the present?

Your emotions will be more balanced if you think clearly and rationally. Distorted thoughts get in the way of your happiness. Dr. Burns includes Mood Logs to help you understand why you think negatively so you can change your thoughts. Your moods change as quickly as you **choose** to change your thoughts. You can help yourself by using more common sense and logic.

If you write down your negative thoughts as you think them, you can identify the distortions that cause you to think irrationally and **let them go**. It's like studying for an exam. If you read a book, you remember some of the message, but if you take notes you recall more. You learn to let go of unproductive thoughts by writing them down; then you remember what you wrote and get rid of the same thoughts as they continue to pop into your head.

If you blame yourself or others for problems, you never solve whatever is bothering you. You just spin your wheels in the sand. Similarly, if you try to read someone else's mind instead of asking

them what they are thinking and feeling, you easily jump to false conclusions, sometimes resulting in hurt and angry feelings.

You may call yourself a "loser" or a "jerk" instead of telling yourself and others that you made an honest mistake. You may also magnify a problem out of proportion to reality and jump to ill-founded conclusions ("I just **know** he/she will notice my unattractive body and won't want to date me").

Instead of putting yourself and others down with a bunch of "shoulds" and "should nots," realize that people differ and everyone has the right to their beliefs. If you feel pressured to give in to parents, friends or others who say you "should not have intercourse unless you plan to marry the person," you may not be staying true to yourself. Take into consideration what others have to say, but ultimately live your life as **you** see fit. Don't assume that all of your friends should or will make the same choices.

Distortions mess with your mind, your self-esteem and your communication with dates, friends and parents. If you figure out which thoughts are distorted and let them go, your moods, self-esteem and relationships will improve. It's as simple as that!

Emphasize Equality, Openness, Honesty and Playful Caring

Your sexual health and pleasure are more fulfilling when you treat your lovers as equals, with openness, honesty and playful caring. Manipulative game playing and being loose with the truth does not show respect or kindness. Instead, manipulators reveal their selfish willingness to distort their real intentions so they can try to get what they want—sex, ego strokes, power and control.

Guys and girls who exploit others for their own needs lose out themselves. They fail to reap the rewards of genuine emotions and ongoing friendships. They may "steal" an orgasm or a short-lived relationship under false pretenses, but they don't feel good about themselves. What goes around comes around; they are lonely and sad until they realize their behavior hurts themselves along with those they have exploited.

If you are compassionate and caring, you communicate in an unselfish and non-aggressive manner. Some are too busy putting others down to focus on their own problems and their personal

growth. It doesn't make you look good when you judge others and make them feel unwanted and unappealing.

If you desire sex, express your desire without demanding or expecting the desired person to feel the same way. A line like "You would have sex with me if you really loved me" confuses desire with an expectation or duty. Sex should never be an obligation.

In his book, *Nonviolent Communication* (1999), Dr. Marshall Rosenberg points out that to be caring and sensitive, you need to use compassionate language. If you use moralistic language, you lack compassion. For example, it is insensitive and destructive to label those who have more sex than you do "sluts," "hos," "promiscuous" and other inaccurate and derogatory terms.

Why not focus on getting your own act together? It is not healthy or appealing to try to be someone you aren't, or to judge and compare yourself with others. Value your uniqueness, not how much you are similar to your friends and media stars. You appear phony if you imitate others rather than be yourself.

To be yourself, you need to get in touch with who you **really** are. Focus on your personal growth so you will become even more interesting and special. Self-honesty and self-love are prerequisites to being honest and loving with others. Like the Velveteen Rabbit, you have to get real with yourself to get real with others. There is a fine line between honesty and sensitivity; it is important to be honest with some empathy and compassion.

Women, lesbians, gays and bisexuals do not deserve to be discriminated against or treated as second-class citizens. The lack of genuine equality and respect for those who are different sets the stage for sexual aggression, force, abuse, violence and date rape.

Dr. Ira Reiss and Harriet Reiss (1997) correctly conclude that date rape occurs because women are portrayed as "sexually reluctant," while men are viewed as the "persuader." As long as you buy into these traditional roles, you limit your pleasure and intimacy, and you open yourself and others to exploitation.

If men treated women as equals with comparable social and economic power, women would encourage more and better sex. This means women must be as free as men to initiate. Equality encourages appropriate physical and emotional boundaries and mutual consent. Both sexes should feel equally comfortable suggesting a Pre-Sex Discussion and to say yes or no to a sexual overture.

Whether you are straight, bisexual, gay or lesbian, sex should contribute to the quality and meaning of a relationship. It isn't immoral to enjoy sex; those who abstain aren't more moral than those who love sex. If you treat each other as equals and are honest, open, caring and responsible, how can sex be immoral?

Censoring sex and emphasizing abstinence encourages frustration, aggression and violence. My cross-cultural study with Dr. Murray Straus (1980) concluded that the more a society represses caring sex, the more sexual aggression and violence are encouraged. This explains why Sweden is less violent than America; there is more support for sexual pleasure and sex education in Sweden.

Wouldn't it be wonderful if our country were more sexual and less violent? It is not healthy or normal to restrict and censor sexual pleasure. When you weigh the pros and cons of being sexual, it is smart to ask, "Will it harm anyone?" and "Will it benefit myself and my potential lover?" and "Does this relationship make me happy?"

You don't always know whether someone will get hurt or whether an STD or a pregnancy will happen, but you can rationally calculate potential risks and benefits during a Pre-Sex Discussion. If you choose to be sexual, you can be responsible and practice safer sex.

Sex can be serious, but it can also be fun, playful, caring and exhilarating. In Chapter 4 you learned that dating, friends-with-benefits and hooking up have their pros and cons. Teenage and young adult magazines and web sites regularly feature these sexual choices. Some authors confuse hooking up with being friends-with-benefits, but these choices are not the same. Being a true friend is a far cry from going through the motions with a stranger that you may not see for long.

No matter which choice you make, when you get sexually involved it is hard to totally control your feelings. Some of you **fake** that you don't care for a lover when you really do—a bad idea. **Express yourself without smothering and being possessive, but do express your feelings.** Being emotional doesn't make you weak; it means you are healthy and normal.

If you view sex as a game, no one wins. It is possible to care for more than one person even though you may be more emotionally connected to one partner than to others. **Most of you aren't ready or able to get serious and committed to one person, so why not wait until you are older, more emotionally available and clearly**

223

ready? Otherwise, you will probably go through a series of dramatic relationships and painful breakups. Who needs it? Your choices largely shape your peace of mind. Leave high drama to television soap operas.

It would be a lot easier to make informed sexual choices if you were really aware of the pros and cons of each choice. Instead, censorship of your mind and body is a scary cancer that continues to grow in education, the media (including the net), the government and families.

Resist Unhealthy Censorship of Your Mind and Body

When schools and colleges, the media, the government, your parents and clergy are determined to put the lid back on pleasure—if the lid was ever on—they fail to respect your right to make informed choices. As Judith Levine observes in her book, *Harmful to Minors* (2002), "sex is not *ipso facto* harmful to minors," but it is harmful to "protect" teenagers from sex. Censorship is based on ignorance. Restricting full information and open dialogue doesn't protect you from anything; it is dangerous to your mental and physical health.

It is common for government and parents to be equally concerned with censoring sex and violence, but repressing sex encourages violence. In their zeal to control the sexual activity of teenagers and young adults, some authority figures fail to understand the inverse relationship between sex and violence. They wrongly conclude that sex and violence are equally bad for you.

No one can legislate sexual morality. Outmoded sex laws are often religious edicts made into laws—a clear lack of separation of church and state. Religious fundamentalism of any stripe is determined to define sex as dangerous and subversive. Contrary to misguided preaching and teaching, responsible lust is healthy and normal, providing the driving force for passionate love and joy. Rather than labeling lust a sin or something to fear, you benefit by encouraging playful pleasure.

Censorship is a form of mental abuse. It is intended to indoctrinate rather than educate. From the pioneering sex research by Alfred Kinsey over fifty years ago to current studies, the government has often refused to fund or has restricted empirical data about sex. For many years, private funding has been used to uncover the truth about sexual beliefs and practices.

A few moralists calling themselves "independent scholars" continue to try to discredit Kinsey's groundbreaking research because it revealed that most Americans masturbate and are sexual apart from marriage, among other "shocking" findings. If Kinsey's research were inaccurate, subsequent scientific research would have come to different conclusions, which is **not** the case.

Censoring sex sounds like the thought police in George Orwell's *1984.* By putting down Kinsey and other studies that show how sexual Americans are, some politicians and media figures hope they can prove that the sexual revolution never happened. Happily, the liberal changes in sexual expression have continued in spite of censorship.

It is more difficult to censor your mind if you are exposed to scientific studies in the media. How can schools have any credibility when they refuse to discuss the same research? Educators, administrators and the school board need to realize that **education without knowledge is impossible**.

The abstinence agenda (aptly referred to as "No-Sex Education" by Judith Levine) in Congress and in right-wing political and religious groups is long on money but short on responsibility. Failing to support comprehensive sex education is dangerous. You deserve objective, thorough, non-moralistic sex education.

Instead, many fifth and sixth graders learn about AIDS before they learn what sex is. This is very destructive. Their **first** lesson from a teacher is that you need to fear sex because it can cause AIDS and death. To begin sex education with the dangers of sex limits students' knowledge and their potential for healthy pleasure. It also leaves a lasting impression that sex is dangerous and, therefore, must be bad.

Abstinence-only "education" received more than a billion tax dollars from 1996 to 2004 (Jane E. Brody, *New York Times*, June 1, 2004). If this large sum were used to **develop** get-real, comprehensive sex education with scientific information about sex, birth control, STDs and emotional health/self-esteem, you would have fewer sexual dilemmas.

Unfortunately, comprehensive sexuality education is more theory than fact. So far, the great majority of programs labeled comprehensive sexuality education push abstinence so much that a sense of honest balance is lacking. More objective and non-moralistic programs have to be **developed** before their probable effectiveness can be scientifically evaluated.

When widespread get-real sex education is finally developed and when parents become more actively supportive, older teenagers will probably be more prepared to safely and responsibly enjoy sex, including intercourse. For now, most of you have intercourse by, or before, your senior year in high school without much sex education. This is dangerous. Ill-informed sexual choices may lead to STDs and unwanted pregnancies.

You are mostly stuck with inaccurate, irresponsible and judgmental abstinence programs. According to a Planned Parenthood Fact Sheet (2004), "Abstinence-only programs force-feed students religious ideology that condemns homosexuality, masturbation, abortion, and contraception. In doing so, they endanger students' sexual health."

Textbooks are censored and students suffer in sexual darkness. For example, Texas mandates textbooks that push abstinence and fail to include essential and accurate sexual information. Ironically, Texas has the highest teenage birth rate in the nation for girls 15 to 17. To make matters worse, nearly half of new STDs in Texas are contracted by those 15 to 24 (Bethany Thomas, MSNBC, 2004).

A congressional report reviewing abstinence curricula by Rep. Henry A. Waxman concluded that only two of thirteen of the most commonly used programs were accurate about sex. Among other issues, he found lies about condom effectiveness, abortion and AIDS and other STDs (Ceci Connolly, WashingtonPost.com, Dec. 2, 2004). Maine, Pennsylvania and California are the only states who have refused to accept federal abstinence-until-marriage funds for public school programs (Marty Klein, 2005).

A joint statement **opposing** abstinence-only education and endorsed by forty-five organizations—including the National Education Association, the American Civil Liberties Union, Planned Parenthood, the Sexuality Education and Information Council of the United States and the National Coalition Against Censorship—argues that abstinence-only programs are censorship, they "silence speech about sexual orientation," and they are an affront to the separation of church and state (National Coalition Against Censorship, 2001).

A Kaiser Family Foundation/*Seventeen* magazine survey (2004) found that 65% of parents of high school students expect abstinence from sexual activity outside marriage, but the same percentage also wanted comprehensive sex education, including how to get condoms and other birth control!

Another Kaiser study (2004) of junior and senior high school principals with sex education in their schools concluded that 30% of the programs are abstinence-only and 47% emphasize abstinence, but also include contraceptive information. According to their perception, 20% of the programs do not view abstinence from intercourse as the most important issue, and they teach teenagers to make responsible decisions about sex.

Some of the national organizations that advocate comprehensive sexuality education include the American Medical Association, the American Psychological Association, the American Public Health Association, the National School Boards Association and the YWCA of the U.S.A. (ACLU, April 1, 1998).

After you read and discuss this book with your friends and parents, take it to school and urge your sex education teacher to read and converse with you about it too. Compare the comprehensive, accurate information in this book with the limited information found in abstinence-only programs.

Even if schools eventually are funded to develop comprehensive sex education from K-12, teachers will need to be trained and sex education for parents will have to be offered. A visiting nurse who gives a few brief lectures about AIDS and warns students not to be sexual until marriage is not offering **get-real** sex education. It's not enough. Unfortunately, too often, this kind of education caters to the biases of a few politicians who may not be tuned in to the reality of teenage and young adult sexuality.

Luckily, the public schools are not the only source for relevant sex education. The media, including the Internet, have an extremely critical role. See The Yellow Pages for Sex for some sex-positive web sites. Reporting sex research findings and commenting about sexual health helps you make responsible choices. Sex in the news provides an opportunity to openly discuss sex with your parents and your friends. Use the opportunity!

Broadcast media are fined—**censored**—by the Federal Communications Commission (FCC), which arbitrarily labels partially nude bodies and frank sex talk "indecent" when it doesn't legally qualify as "obscene." Broadcast corporations are punished with hefty fines—and the possible loss of their license—to assure that sex and nudity are not explicit. The problem with censorship is that it delivers a subliminal

message, that sex is bad or dirty. The subconscious message is, "If it needs to be censored, something must be wrong with it." **There is nothing indecent about your body and sex.**

In her book, *Defending Pornography* (1995), ACLU president and New York University law professor Nadine Strossen observed that the women who wrote anti-pornography laws were primarily responsible for the too-loosely defined EEOC sexual harassment statute. The link between censorship of pornography and sexual harassment is inescapable: One restricts fantasies—the mind, and the other limits flirtatious and sexual overtures—the body.

Professors and others who discuss sex and women are vulnerable to a sexual harassment charge. Such repressive censorship of sexual thoughts and actions is unhealthy, unnecessary and unacceptable.

This doesn't mean there is no such thing as sexual harassment. Real harassment should be stopped and prosecuted. Sexual harassment involves a predatory approach where a boss expects an employee to have sex with him or her to get a raise or to remain employed, or a co-worker doesn't give you a choice by repeatedly and aggressively approaching you for sex you have clearly refused.

Most of you are flirts. Flirting and kissing are arts that you love to practice. You enjoy playfully coming on to those who attract you. Flirtation and touching are open to misinterpretation when you can be falsely accused of sexually harassing someone when you flirt with them. This is censorship of the body (behavior). As I said on the *NBC Nightly News*, men are particularly fearful about flirting with women because of the lack of reasonable legal and social distinctions between flirtation and harassment.

Earlier, you learned that your government distorts scientific facts about the effectiveness of condoms on its web sites, apparently to try to scare you into being abstinent until marriage. In this book, I have criticized government lies about safer sex. In its continued effort to distort the truth about teenage sex, the U.S. Department of Health and Human Services is responsible for **www.4parents.gov**, which underestimates the extent of teenage intercourse, as well as the effectiveness of condoms against STDs and unwanted pregnancies.

This ill-conceived site also claims that non-marital sex (remember, the median age for marriage is 26) jeopardizes your chances for a happy marriage, which is absolutely untrue. It is reprehensible when your government, which is mandated to serve your needs, manipu-

lates the truth in such a reckless and irresponsible manner.

It is censorship of your body when government and some older adults try to restrict your access to contraception, emergency contraception and abortion. As gynecologist Dr. Felicia Stewart observes: "It is not only abortion that is under attack. Emergency contraception and OCs [oral contraceptives] are challenged by arguments based on hypothetical grounds that are sustained despite compelling scientific evidence to the contrary" (Stewart, 2004).

In spite of attempts by government to censor your mind and body to "protect" you from being sexual, there are some media, parents, educators and clergy who are candid and helpful. They know that censoring the truth is dangerous to your health and your life. Be sure to thank these brave souls for caring enough to level with you.

As citizens, you deserve comprehensive sex education so you can choose to experience a happy, healthy sex life. Get-real sex education would minimize your need to be exposed to pornography. Think about what kind of sex education your kids will get. Get involved and demand scientifically accurate, non-judgmental sex education.

My own in-depth interview study with 250 parents in the sixties and more recent studies indicate that an overwhelming majority of parents want high school sex education. Unfortunately, the majority of parents wanting sex education allow a vocal minority of school board members and parents to speak loud enough to censor or delete sex education curricula.

Your mind is your main sex organ. It needs to be stimulated to fantasize sexual adventures. But even if your mind is alive with erotic thoughts, some parents and politicians are determined to control your sex life.

Instead of censoring explicit sexual images, why not revere them for their beauty and their power to inspire arousal? Some erotica is tasteful while other depictions may seem crude and unimaginative. The answer to unimaginative sexual imagery is not censorship. Each of you can decide what you like and don't like. Sometimes it takes being exposed to sexually explicit visualizations and descriptions to know what turns you on.

There cannot be sexual freedom and pleasure without contraception and abortion. The constant attempt to restrict the availability of emergency contraception and abortion is another example of governmental censorship of the body. The right to privacy and the separa-

tion of church and state are under attack, and unfortunately may be compromised by the transitions in the Supreme Court. Without these important backups to imperfect contraception, women would not have the ability to control their bodies so they can be comfortable being sexual. If you want to continue having the right to choose, it's important that you speak out at rallies, write letters to your elected representatives and vote for pro-choice politicians.

Many of the words used to describe sex are negative. Rather than using negative words, why not use positive, affirming words? Instead of the exploitive connotation of someone "hitting on" you, why not say they desired you? Desire is a wonderful, powerful word that connotes lust with a focus.

All of this sounds great, but how can you openly discuss sexual desire, sound information and feelings with your parents?

Improve Conversations with Your Parents

If your parents and others put down the allure of unleashed desire and non-marital sexual adventures, gently ask them what they experienced when they were your age. Don't expect them to confess their sexual secrets—neither you nor your parents need to spill your guts. Just engage in a give-and-take conversation.

Partly because of the natural, healthy and necessary incest barrier, it is hard for you and your parents to see each other as sexual. After a few conversations, you should be able to relax and gently acknowledge and appreciate each other's sexuality.

Ideally, your parents are a primary source of your sex education. In reality, this usually is not the case. Studies show that kids want their parents to talk about sex and love. Some parents discuss puberty, reproduction and a few other non-threatening topics. Most parents don't discuss hot topics like masturbation, lovemaking, pornography and abortion very much, if at all. Interestingly, research shows that parents report more sexual conversations with you than you recall.

Some of your parents and some of you are uncomfortable talking because you are embarrassed and you fear that you will argue. If your parents' attempt to talk becomes a judgmental lecture ("Keep it in your pants" and "Wait until you are married" and "Sign this abstinence pledge"), it is understandable why you would prefer discussing sex

with more open-minded adults—perhaps with some of your friends' parents. If your parents and you are **good listeners**, there is less likelihood that a conversation will become a lecture or a confession.

Mothers discuss sex more than fathers, but fathers can learn to be respected role models for sons and daughters too. My doctoral dissertation research showed that a mother's sexual attitudes affect your attitudes and behavior more than your father's attitudes do. Your friends—who often are more liberal about sex than your parents—wield a strong influence on your sexual values and behavior, sometimes leaving you confused about what sex means and what you should and should not do.

No matter what your parents say about sex, it is their **actions** that have the most influence on your sexual beliefs and behavior. Do they show affection for each other? Are they clearly in love and do they appear to be vibrant lovers? If the answer is yes, they have a positive, loving influence on your sexuality. If the answer is no, you need to make up for what they lack from other sources.

Parents don't have to be sex experts to talk with you. Let them know that you don't expect them to know everything and you are willing to look up answers to questions that none of you fully understand.

Parents may think they are helpful when they ask you to approach them if you have sexual questions, but this can also be a convenient way to escape their responsibility. You aren't as likely to ask questions if they don't initiate some of your conversations.

If your parents don't bring up sex, you still can. It is best to have ongoing discussions, not an obligatory, one-time sex talk. Take advantage of spontaneous occurrences, such as a new sex study in the media, a helpful magazine article, a television documentary or a romantic comedy. Once again, **loan this book to your parents and then discuss it**. This should improve your communication.

Emphasize that you want conversations to be confidential. Be honest and respect your parents' views even if you don't agree with all of them. Agree to disagree agreeably. Your parents may be insecure about their sexuality, which limits how much they can guide you. If you are sex-positive, they may become more so too. Ask them to balance their worries about sexual dangers with an emphasis on sexual joy and love.

The deepest kind of friendship, love is a wonderful, energetic, exhilarating feeling of attraction and affection. When you love someone, his/her needs are at least as important as your own. Love is a

risk; you are vulnerable to being rejected when you love someone, but for most people love is worth the risk. Ask your parents if they agree with this view of love.

Use humor with your parents—laughter helps break the ice! And be sure to laugh at yourself. If you are light and funny, your parents may loosen up and have some great conversations with you. They may surprise you with their honesty. They may not be quite as prudish as you think.

With the exception of hooking up—which usually doesn't result in an ongoing friendship—sex is part of a relationship. In your conversations, emphasize that you understand that you can't separate sex from the rest of a relationship, that being friends who share other interests is important too. This will help your parents take a deep breath and relax so they can openly share their insights.

If you ask to be included in the development of guidelines or rules that apply to dating, your parents will probably consider your concerns. Most parents realize that your choices are yours to make. Some are realistic and offer to pay for birth control when they know you are, or are about to be, having intercourse. Others may try to control you—they can't seem to allow you to spread your wings and fly. Most parents understand that you deserve freedom to live your life, especially if you are a college student.

You are not carbon copies of your parents. Nor should you be. Hopefully, your parents support your uniqueness. Be open to developing your own values and ask your parents to honor and respect your choices. By supporting your individuality, parents nurture your self-esteem.

You can learn from each other. If you are reliable, honest and responsible in general, they are more likely to trust you to make healthy sexual choices too.

Your parents want to be approachable because they love you and they want to help you avoid dangers. They worry about your safety and your happiness. They don't want you to make mistakes because you feel the need to rebel against them. It is normal to assert yourself by experimenting with sex, but don't give your parents a heart attack by being careless!

Each generation of parents is more open about sex, but there is more progress to be made. As you look to the future of sex and sex education, it is my hope that you will become more open, honest and responsible role models for your kids, if you choose to have them.

Start The Next Sexual Revolution Now!

As citizens, you deserve "life, liberty and the pursuit of happiness." Sexual happiness and the liberty to make your own sexual choices is a right, not a privilege.

In 1929, James Thurber and E. B. White wrote a classic humor book, *Is Sex Necessary?* They observed: "the heavy writers got sex down and were breaking its arm." Moralistic writers continued to put sex down, but the sexual revolution of the late sixties to the mid-seventies successfully challenged repression, censorship and the unhealthy and boring "Just-Say-No" approach. Young people became more delightfully sexual and the double standard weakened.

The birth control pill and the sexual revolution permanently liberalized sexual values and behavior, but we have more progress to accomplish. Women deserve equal pay for equal work. AIDS and other STDs need to be prevented and cured with microbicides, vaccines and other innovative medical technologies.

More effective contraception that does not negate pleasure or health needs to be developed along with improved access to emergency contraception and abortion. Widespread sex research needs to be funded and true comprehensive sex education developed.

Even though the age of first intercourse is similar to ours, Judith Levine (2002) observes, "Rates of unwanted teen pregnancy, abortion, and AIDS in every Western European country are a fraction of our own." Northern European countries offer more thorough sex education and easier access to condoms and other contraceptives. There is a get-real, non-judgmental approach to teenage sex rather than the tired, boring and irrelevant "Just Say No" motto.

In spite of the sexual revolution, America is still part puritan. Americans will do much better dealing with sexual dangers when politicians, educators, parents and the clergy commit to a more open, honest and thorough approach to sex education and easier access to birth control, abortion and STD prevention and treatment.

It's time to create a new vision for sexuality that accurately reflects teenagers and young adults in the twenty-first century. Let's call this vision The Next Sexual Revolution. It will get rid of repressive censorship and enthusiastically encourage more responsible, healthier, hap-

pier sex. **There is no turning back to "Just Say No." Sex is not a drug or an addiction–it's a wonderful part of us.**

The anti-choice abstinence movement cannot survive in a culture saturated with sex in the media, on the Internet and cell phones, and in frequent coffee shop conversations–it's just not realistic. An 18-year-old high school graduate gushed about how much she enjoys oral sex and intercourse–and how useless the abstinence approach was by her high school health teacher and her parents, who had **no clue** about her sex life. Many of you visit sex shops for vibrators and sexy lingerie.

Explicit sex has driven the popularity of the Web, cable television and other innovative technologies. Cell phone companies are next, although some parents will pressure companies to allow them to block sexual access (Matt Richtel and Michael Marriott, *New York Times*, September 17, 2005). In spite of AIDS and other STDs, most of you realize you can be careful and still enjoy a jubilant and safe sex life.

When women purchase Andrea Lavinthal and Jessica Rozler's *The Hookup Handbook: A Single Girl's Guide to Living It Up* (Simon Spotlight Entertainment, 2005), Alexa Joy Sherman and Nicole Tocantins' *The Happy Hook-Up: A Single Girl's Guide to Casual Sex* (Ten Speed Press, 2004) and books on using vibrators and other sex toys in relationships and when alone, it is clear that the hedonism of the sexual revolution continues. The double standard continues to weaken as more women enjoy sex for its own sake without **having** to be swept away by romance and high drama.

This doesn't mean there will be a sexual free-for-all with no moral guidelines or romance, but the "walk of shame" some women take after a casual hook-up is one reason why friends-with-benefits is usually a healthier choice than hooking up. The Next Sexual Revolution will encourage mutually responsible, honest and joyful sex for more than one reason, from casual to intimate, sometimes with more than one partner.

There will continue to be more sex, and the quality of sexual relationships will improve as soon as you support real equality between the sexes. The economy will improve, so desperation and the need to survive won't continue to interfere with playful leisure. People will become more important than things. Leisure time will be increased and materialism—which often interferes with intimacy—will no longer top most of your priority lists.

The tide is changing. "Just Say Yes" encourages mutual consent without the pressure to be sexual. Love and caring will continue to influence your choices. Caring will be expressed in friendly and brief, as well as long-term, relationships.

There will be more social and legal support for gays, bisexuals and lesbians. Hate crimes will be less prevalent as our society becomes more sexual and more loving from improved education and more realistic policies and laws about sex and violence.

Almost no one will worry about or try to censor sexually explicit images, and fewer people will be obsessed with it. Sexual images and erotica will become more appealing and more stimulating for both sexes without moral stigma. With equality and more realistic and respected sexual harassment statutes, flirtation will be encouraged and sexual harassment and sexual force will become historical footnotes.

Some will say my predictions and my hope for the future are idealistic dreams. This doesn't bother me at all. If we don't visualize and support The Next Sexual Revolution, it is less likely that we will develop a blueprint to happily act on our collective hope of a more sexual and caring society.

It is hard to predict how many years it will take for these positive changes to happen, but you will probably witness some and hopefully all of them in your lifetime. You can either throw up your hands and proclaim that you can't make a difference, which makes you part of the problem, or you can speak out for sexual sanity, which makes you part of the solution. It's your choice.

With soap and water, common sense and laughter, sex isn't dirty and dangerous—it's fun, clean and healthy. Sex isn't something to be ashamed and embarrassed about. It inspires proud enthusiasm and vibrant smiles. Joy is the essence of peace and love.

We are the conspiracy. We can conspire together to create The Next Sexual Revolution. We can successfully combat and defeat those who relentlessly wage war against lust and women. To unleash our sexual potential, we must decisively reject rigid rules, shame and guilt. Each of you, by choosing to embrace your sexuality and make responsible, healthy, affirmative sexual choices, will participate in The Next Sexual Revolution. The time to start is **now**!

The Yellow Pages for Sex

This final section is a resource list for solving problems and pursuing special interests and services. This list is not intended to be exhaustive. To be included, resources must complement the sex-positive theme in this book.

STDS, BIRTH CONTROL, ABORTION AND ADOPTION

www.adoptioninformation.com
Provides unbiased information and resources for adoption.

The Alan Guttmacher Institute
212-248-1111 and www.agi-usa.org
An excellent resource for research findings and education about contraception, abortion and reproductive health and rights.

American Social Health Association
800-230-6039 and www.ashastd.org
Information about herpes and genital warts.

America's Pregnancy Helpline
888-672-2296 and www.thehelpline.org
A national health organization that provides facts, support and referrals so you can decide whether to keep a child, adopt or seek an abortion.

Ann Rose's Ultimate Birth Control Links Page
www.ultimatebirthcontrol.com
Offers useful information and many helpful links for information and services related to contraception, emergency contraception, abortion and adoption.

Association of Reproductive Health Professionals
Emergency Contraception Hotline, 888-668-2528 and www.not-2-late.com
Provides information and referrals for local sources for emergency contraception.

Catholics for a Free Choice
202-986-6093 and www.cath4choice.org
Information about contraception, abortion, HIV/AIDS and an activist approach about Catholic sexual restrictions for birth control, abortion and other critical sexual issues.

Center for Reproductive Rights

917-637-3600 and www.reproductiverights.org

A courageous, nonprofit, legal advocacy organization that promotes and defends everyone's sexual and reproductive rights, including contraception and abortion. Legal challenges include an important lawsuit filed against the FDA for refusing to accept its panel's recommendation to approve over-the-counter emergency contraception.

Centers for Disease Control National STD Hotline

800-227-8922 (special AIDS Hotline 800-342-2437)

Community Health Clinics

(see your local listings)

Offer sexual health services, including services for STDs and contraception, usually on a sliding-fee scale.

Condomania

800-9-CONDOM and www.condomania.com

Condom information and online condom ordering.

National Abortion Rights Action League (NARAL) Pro-Choice America

202-973-3000 and www.naral.org

A critically important activist pro-choice organization that is actively involved with keeping abortion legal and accessible.

Planned Parenthood

800-230-7526 and www.plannedparenthood.org for a nearby clinic

A prominent and extremely critical frontline service, Planned Parenthood offers contraception, emergency contraception, abortion, STD services, pelvic and breast examinations, pap smears and counseling on a sliding-fee scale.

Planned Parenthood Foundation of Canada

613-241-4474 and www.ppfc.ca

Offers the same services as Planned Parenthood in the U.S.

SEX EDUCATION, SEX THERAPY AND SEX RESEARCH

www.AltSex.org

An informational celebration of alternative forms of sexual expression. Some of the topics include homosexuality and bisexuality, bondage and discipline and sadism and masochism (BDSM) (not including abuse or other non-consensual activities), polyamory (carrying on simultaneous relationships with more than one partner) and transgender issues.

American Association of Sexuality Educators, Counselors and Therapists (AASECT)

www.aasect.org

A credentialing and referral organization that emphasizes comprehensive sex education.

American Board of Sexology (ABS)

www.sexologist.org

Credentials sexologists and makes referrals to board-certified sex therapists in your area.

American College of Sexologists

www.AmericanCollegeofSexologists.org

Credentials sexologists.

Institute for the Advanced Study of Human Sexuality (IASHS)

415-928-1133 and www.iashs.edu

Located in San Francisco, this totally sex-positive institute provides the finest in academic training in sexology, with a focus on graduate programs and degrees through its libraries, faculties and advisors.

The International Academy of Sex Research (IASR)

www.iasr.org

A scientific society that promotes high standards of sex research and scholarship.

The Kinsey Institute for Research in Sex, Gender and Reproduction

www.KinseyInstitute.org

Started by famous sex researcher Dr. Alfred Kinsey, this vibrant Indiana institute promotes interdisciplinary research and scholarship, and offers an online catalog for extensive materials in its world-famous library.

www.Nerve.com

A hip site with information, advice, fiction and sexy photos that especially appeal to women, but also to men. Sex is viewed as "beautiful and absurd, remarkably fun and reliably trauma-inducing."

www.Oxygen.com

Includes sex-positive articles, polls, chat, quizzes and erotic videos.

San Francisco Sex Information Line

415-989-7374

Helpful, anonymous, accurate, nonjudgmental sex information.

Sexual Health Network

www.sexualhealth.com

A very helpful site dedicated to sexuality information, support, counseling, therapy and resources for persons with disabilities, illnesses and natural changes through their life spans, about those who care about them.

Sexuality Information and Education Council of Canada (SIECCAN)

416-466-5304 and www.sieccan.org
The Canadian counterpart to SIECUS features the Canadian *Journal of Human Sexuality* and a newsletter, as well as resources and a library.

Sexuality Information and Education Council of the United States (SIECUS)

212-819-9770 and www.siecus.org
A superb resource for comprehensive sexuality education, curriculum guides, bibliographies, a newsletter and a library and information service. Opposes abstinence-only programs.

Society for Human Sexuality

www.sexuality.org
A sex-positive, liberal information site for those 18 and older.

The Society for the Scientific Study of Sexuality (SSSS)

www.sexscience.org
Dedicated to the advancement of knowledge about sexuality through research and scholarship.

ANTI-CENSORSHIP ORGANIZATIONS

American Civil Liberties Union (ACLU)

www.aclu.com
A critical guardian of liberty, the Constitution and the Bill of Rights, including freedom of speech, the press and the strict separation of church and state. Dedicated to rights for lesbians and gays, women, contraception and abortion, and sex education for teenagers. Opposes abstinence-only programs.

Americans United for Separation of Church and State

www.au.org
A vital religious liberty watchdog group devoted to the separation of church and state.

National Coalition Against Censorship

www.ncac.org
An important group opposing censorship—with a focus on sexual censorship—with many famous organizations and people actively involved. The NCAC publishes a newsletter covering current sexual censorship of libraries, schools and other public places.

SEXUAL ABUSE, RAPE AND INCEST COUNSELING

National Domestic Violence Hotline
800-799-7233 and www.ndvh.org
Crisis intervention, information and referrals to local service providers.

Rape, Abuse and Incest National Network (RAINN)
800-656-HOPE and www.rainn.org
The nation's largest anti-sexual assault organization, RAINN offers referrals to local counselors.

GAY, BISEXUAL AND LESBIAN GROUPS AND COUNSELING

Bisexual Resource Center
www.biresource.org
An educational site with information and news updates on bisexuality, relevant organizations and The Bisexual Liberation Movement.

Gay & Lesbian National Hotline
888-843-4564 and www.glnh.org
Offers free and confidential peer counseling, information and local resources and support groups throughout the U.S.

The Human Rights Campaign (HRC)
www.hrc.org
A national voice on gay, lesbian and bisexual issues, HRC lobbies Congress and supports the election of supportive politicians.

OutProud
www.outproud.org
A useful site run by the National Coalition for Gay, Lesbian, Bisexual and Transgender Youth. Offers information and local sources of friendship and support, among other helpful services.

Parents, Families and Friends of Lesbians and Gays (PFLAG)
202-467-8180 and www.pflag.org
Promotes the health, education and wellness of gay, lesbian, bisexual and trans-gendered young people and their allies.

Queer Resources Directory
www.qrd.org
An extensive directory with information, groups and files about "everything queer."

Youth Guardian Services
877-270-5152 and www.youth-guard.org
An impressive youth-run, nonprofit site that offers Internet support services for gay, lesbian, bisexual, transgendered, questioning and straight supportive youth.

FURTHER READING
Sexologists and other qualified professionals authored the following useful books:

Barbach, Lonnie. *For Yourself: The Fulfillment of Female Sexuality.*
New York: Signet, 2000.
An extremely helpful, classic book first published in 1975, then revised by Dr. Barbach, a well-known psychologist who specializes in human sexuality, this book helps women become orgasmic through masturbation and lovemaking.

Boston Women's Health Book Collective. *Our Bodies, Ourselves for the New Century.*
New York: Simon and Schuster, 2005.
A classic feminist book by health care professionals devoted to women's health, relationships and sexuality—including contraception, abortion, STDs and self-esteem.

Burns, David D. *The Feeling Good Handbook.*
New York: Plume, 1999.
A useful cognitive behavioral therapy self-help book by a famous psychiatrist. Dr. Burns' Mood Logs help you recognize and get rid of distorted thoughts to improve your self-esteem and relationship communication, and to lower anxiety, depression and anger so you can enjoy sex and relationships without hassle after hassle.

Comfort, Alex. *The Joy of Sex.*
New York: Crown Publishers, 2002.
A classic book first published in 1972 by Dr. Comfort, a recognized authority on sex. This updated lovemaking manual includes illustrations and color photos to help you become a gourmet lover.

Dodson, Betty. *Sex for One: The Joy of Selfloving.*
New York: Three River Press, 1996.
Dr. Dodson is a sexologist who has pioneered workshops on masturbation and other sexual expression. Her book captures the essence of her emphasis on self-pleasuring.

Hooper, Anne. *Sexopedia.*
New York: DK Publishing, 2003.
In this book with color photos, Hooper discusses sexual chemistry, how sex works, foreplay, gay sex and other relevant topics.

Hooper, Anne. *Ultimate Sex.*
New York: DK Publishing, 2001.
A famous sex therapist in England, Hooper's book is a colorfully illustrated sex guide with the many positions for lovemaking.

Joannides, Paul. *Guide to Getting It On!*
Waldport, Oregon: Goofy Foot Press, 2004.
Dr. Joannides is a psychologist specializing in human sexuality. His illustrated book is a huge, hip, humorous and unorthodox adult sex guide that is frequently updated.

Signorile, Michelangelo. *Outing Yourself: How to Come Out as Lesbian or Gay to Your Family, Friends and Coworkers.*
New York: Simon and Schuster, 1995.
Signorile is a gay activist and journalist with many credits. His book is a useful 14-step, coming-out guide.

Strossen, Nadine. *Defending Pornography: Free Speech, Sex, and the Fight for Women's Rights.*
New York: New York University Press, 2000.
An original book on the critical importance of the First Amendment and what women lose by attacking and trying to censor sexually explicit images. Emphasizes that being sexy and sexual is not sexist. "Constructive approaches to reducing discrimination and violence against women" are explained.

Zilbergeld, Bernie. *The New Male Sexuality.*
New York: Bantam Books, 1999.
Dr. Zilbergeld is a recognized sex therapist. Tips are included about premature ejaculation, intimacy, relationships and what a man should know about women.

TEENAGE AND YOUNG ADULT SEX WEB SITES

Advocates for Youth
www.advocatesforyouth.org
An important education and activist organization that helps young people make informed and responsible decisions about their sexual health; parent/teenager communication is encouraged. Rights, respect and responsibility are emphasized.

Alice! Health Education

www.goaskalice.columbia.edu
A superb health question and answer service. Includes a gay health advocacy project and sexual violence prevention and response.

Ask Beth

Planned Parenthood of Southeastern Pennsylvania
www.ppsp.org/askbeth
Answers your questions about STDs, birth control and your body.

Coalition for Positive Sexuality

www.positive.org
A "Just-Say-Yes" site answering your questions on sex and sex education.

Our Whole Lives/owl

www.uua.org
The Unitarian Universalist Association's sex-positive Lifespan Sexuality Education Curricula.

Scarleteen: Sex Education for the Real World

www.scarleteen.com
Created in 1999 by teenage sex web pioneer Heather Corinna, this is a superbly original sex-positive educational site for teenagers and parents, with a pro-choice and activist tone.

SEX, Etc.

www.sexetc.org
A web site for and by teenagers. Also includes information for parents and educators.

Teensource

www.teensource.org
An accurate site affiliated with the California Family Health Council "that appeals to its audience with music, videos, contests and prize giveaways." Created by teenagers for teenagers, this site offers up-to-date information on birth control, STDs and related concerns.

Teenwire

www.teenwire.com
An excellent site operated by Planned Parenthood. Offers nonjudgmental information about sexual health to encourage responsible sexual choices.

SEX TOY CATALOGS AND ONLINE ORDERING

Eve's Garden
800-848-3837
www.evesgarden.com

Good Vibrations
800-289-8423
www.goodvibes.com

Toys in Babeland
800-658-9119
www.babeland.com

References

Ackerman, Diane. *A Natural History of the Senses.* New York: Random House, 1990.

Adler, Nancy E., et al., "Psychological Factors in Abortion: A Review," *American Psychologist,* Vol. 47, 1992.

The Alan Guttmacher Institute, "Microbicides: A New Defense Against Sexually Transmitted Diseases," a report by Deidre Wulf, Jennifer Frost and Jacqueline E. Darroch from www.agi-usa.org, 1999.

The Alan Guttmacher Institute, "Sexually Transmitted Diseases Among American Youth: Incidence and Prevalence Estimates, 2000," by Hillard Weinstock, Stuart Berman and Willard Cates, Jr., *Perspectives on Sexual and Reproductive Health,* Vol. 36, January/February, 2004.

Albert, Alexis. *Brothel: The Mustang Ranch and Its Women.* New York: The Random House Publishing Group, 2002.

American Civil Liberties Union, "Campaigns to Undermine Sexuality Education in the Public Schools," April 1, 1998.

American Social Health Association, data reported by the Associated Press, "Chlamydia Affects 4 Percent of Young Adults," May 11, 2004.

Associated Press, "How Well Do Condoms Work Against STDs: Debate Over Whether Warning Labels Should Be Changed," MSNBC, June 29, 2005.

Associated Press, MSNBC, "FDA Considers First Do-It-Yourself AIDS Test," October 26, 2005.

Associated Press, MSNBC, "FDA Official Quits Over Morning-After Decision," August 31, 2005.

Associated Press, MSNBC, "More Couples Delaying Marriage, Census Finds," October 13, 2005.

Associated Press, MSNBC, "More Evidence Supports Cervical Cancer Vaccine," October 6, 2005.

Associated Press, MSNBC, "More Women Experimenting with Bisexuality," September 15, 2005.

Bakalar, Nicholas, "Gel for Safer Sex Shows Promise," *New York Times,* March 8, 2005.

Barbach, Lonnie. *For Yourself: The Fulfillment of Female Sexuality.* New York: Signet, 2000.

Bearman, Peter S. and Hannah Bruckner, "Promising the Future: Virginity Pledges and First Intercourse," *American Journal of Sociology,* Vol. 106, January, 2001.

Bloomberg News, "Study: Teens Who Pledge Virginity Try Other Sex Acts," *Seattle Post-Intelligencer,* March 19, 2005.

Boston Women's Health Book Collective. *Our Bodies, Ourselves.* New York: Simon and Schuster, 2005, 1998.

Brody, Jane E., "Abstinence-Only: Does It Work?" *New York Times,* June 1, 2004.

Brody, Jane E., "Fact of Life: Condoms Can Keep Disease at Bay," *New York Times*, January 21, 2003.

Brody, Jane E., "Getting to Know a Virus, and When It Can Kill," *New York Times*, October 18, 2005.

Brody, Jane E., "The Politics of Emergency Contraception," *New York Times,* August 24, 2004.

Burns, David D. *The Feeling Good Handbook.* New York: Plume, 1999.

Cassell, Carol. *Swept Away: Why Women Fear Their Own Sexuality.* New York: Simon and Schuster, 1984.

Cates, Willard, Jr., "Reproductive Tract Infections," in Robert Hatcher, et al., *Contraceptive Technology.* New York: Ardent Media, 2004.

Cates, Willard, Jr. and Felicia Stewart, "Vaginal Barriers: The Female Condom, Diaphragm, Contraceptive Sponge, Cervical Cap, Lea's Shield and FemCap," in Robert Hatcher, et al., *Contraceptive Technology.* New York: Ardent Media, 2004.

Center for Reproductive Rights, "Shame on FDA: More Deception and Delay," August 26, 2005.

Centers for Disease Control and Prevention, "Genital Herpes," Fact Sheet, 2004.

Centers for Disease Control and Prevention, "HIV/AIDS Surveillance Report," Vol. 14, 2004.

Centers for Disease Control and Prevention, letter to professionals, March 8, 2004.

Centers for Disease Control and Prevention, "Teens Delaying Sexual Activity: Using Contraception More Effectively," December 10, 2004.

Centers for Disease Control and Prevention, "Youth Risk Behavior Surveillance, U.S., 2003," *Morbidity Weekly Report*, Vol. 53, May 21, 2004.

Centers for Disease Control and Prevention and American Social Health Association, "Frequently Asked Questions about AIDS," 2004.

Chang, Alicia, "Abortion Pill Deaths Puzzle Officials," *Seattle Post-Intelligencer*, July 25, 2005

Connolly, Ceci, "Some Abstinence Programs Misleading," WashingtonPost.com, MSNBC News, Dec. 2, 2004.

Corinna, Heather, www.Scarleteen.com, 2004.

Crooks, Robert and Karla Baur. *Our Sexuality.* Pacific Grove, CA: Wadsworth, 2002.

Davidow, Julie, "Effectiveness of Pill Linked to Weight," Seattle Post-Intelligencer, December 29, 2004.

Elders, Joycelyn. "Foreword" in Judith Levine, *Harmful to Minors: The Perils of Protecting Children from Sex.* Minneapolis: University of Minnesota Press, 2002.

Ellis, Albert. *The American Sexual Tragedy.* New York: Lyle Stuart, 1962.

Friedman, Jay, personal communication, November 24, 2004.

Gold, Sunny Sea, "The Hook-Up Report," *Seventeen*, December, 2004.

246

Goodson, Patricia, et al., "Abstinence, Education, Evaluation, Phase 5, Technical Report," Texas A&M University, September, 2004.

Guest, Felicia, "HIV/AIDS and Reproductive Health," in Robert Hatcher, et al., *Contraceptive Technology.* New York: Ardent Media, 2004.

Harris, Gardner, "FDA Puts Off Decision on Sale of Birth Control," *New York Times*, August 27, 2005.

Hatcher, Robert, "Foreword," *Contraceptive Technology.* New York: Ardent Media, 2004.

Hatcher, Robert and Anita Nelson, "Combined Hormonal Contraceptive Methods," in Robert Hatcher, et al., *Contraceptive Technology.* New York: Ardent Media, 2004.

Ho, Vanessa, "Putting Off the Marital Knot," *Seattle Post-Intelligencer*, December 2, 2004.

Hyde, Janet Shibley and John D. DeLamater. *Understanding Human Sexuality.* New York: McGraw-Hill, 2003.

Jemmott, John B. III, Loretta Sweet Jemmott and Geoffrey T. Fong, "Abstinence and Safer Sex Intervention for African-American Adolescents," *Journal of the American Medical Association*, Vol. 279, May, 1998.

Jennings, Victoria, Marcos Arevalo and Deborah Kowal, "Fertility Awareness-Based Methods," in Robert Hatcher, et al., *Contraceptive Technology.* New York: Ardent Media, 2004.

Kaiser Family Foundation, National Public Radio and Harvard University, "Sex Education in America: Principals' Survey," 2004.

Kaiser Family Foundation and *Seventeen*, "Sex Education in America: General Public Parents Survey," 2004.

www.Kaisernetwork.org, "Companies Testing Male Hormonal Contraceptives in Human Clinical Trials," August 4, 2004.

King, Warren, "HIV/AIDS Pandemic Spreading in Women," *Seattle Times*, June 12, 2005.

Klein, Luella and Felicia Stewart, "Preconception Care," in Robert Hatcher, et al., *Contraceptive Technology.* New York: Ardent Media, 2004.

Klein, Marty, "Sexual Intelligence," Electronic Newsletter, Issue 68, October 2005.

Lavinthal, Andrea and Jessica Rozler. *The Hookup Handbook: A Single Girl's Guide to Living it Up.* New York: Simon Spotlight Entertainment, 2005.

Leland, John, "Under Din of Abortion Debate, An Experience Shared Quietly," *New York Times*, September 18, 2005.

Levine, Judith. *Harmful to Minors: The Perils of Protecting Children from Sex.* Minneapolis: University of Minnesota Press, 2002.

Lewin, Tamar, "Nationwide Survey Includes Data on Teenage Sex Habits," *New York Times*, September 16, 2005.

LeWine, Howard, "News Review from Harvard Medical School—Depo-Provera May Raise Risk," August 24, 2004.

Lewis-Denizet, Benoit. "Whatever Happened to Teen Romance? (And What Is a Friend with Benefits, Anyway?)," *New York Times*, May 30, 2004.

Libby, Roger and Murray Straus, "Make Love, Not War," *Archives of Sexual Behavior*, Vol. 9, 1980.

Marr, Lisa. *Sexually Transmitted Diseases.* Baltimore: The Johns Hopkins University Press, 1998.

McCoy, N. and J. Matyas, "Oral Contraceptives and Sexuality in University Women," *Archives of Sexual Behavior*, Vol. 25, 1996.

McGivering, Jill, "Pill Propelled into Abortion Debate," BBC, September 14, 2004.

McMillan, Alexander, Hugh Young, Marie Ogilivie and Gordon Scott. *Clinical Practice in Sexually Transmissible Infections.* London, England: Elsevier Science Limited, 2002.

Mosher, William D., Anjani Chandra and Jo Jones, "Sexual Behavior and Selected Health Measures: Men and Women 25-44 Years of Age, United States, 2002," National Center for Health Statistics, September 15, 2005.

MSNBC, "Birth Control Patch Linked to Higher Fatality Rate," July 17, 2005.

MSNBC, "FDA Delays Decision on Morning-After Pill," August 26, 2005.

MSNBC, "More Than a Million Americans Living with HIV-AIDS," June 13, 2005.

MSNBC/Zogby Interactive Survey, Cross-tabs for 18-24 by Sex for Never-Marrieds, September 12-20, 2005, October 10, 2005.

NARAL, "Expanding Choices: The Need for Contraceptive and STD Prevention Research and Development," Facts and Issue Briefs, 2004.

National Center for Health Statistics, "Sexual Behavior and Selected Health Measures: Men and Women 15-44 Years of Age, United States, 2002," 2005.

National Coalition Against Censorship, "Campaign Against Abstinence-Only Education Online Press Kit," www.ncac.org, 2004.

Orwell, George. *1984.* New York: Harcourt, Brace, 1949.

Planned Parenthood, "Abstinence-Only 'Sex' Education," Fact Sheet, 2004.

Planned Parenthood, "Birth Control Choices for Teens," Fact Sheet, 2004.

Planned Parenthood, "FDA Delay on EC: Public Health Ignored; Ideology Trumps Science— Emergency Contraception Is Safe, Effective and Meets all FDA Criteria for Over-the-Counter Status," August 26, 2005.

Planned Parenthood, "Herpes—Questions and Answers," Fact Sheet, 2004.

Planned Parenthood, "HPV—The Most Common Sexually Transmitted Virus," Fact Sheet, 2004.

Planned Parenthood, "Medical Abortion—Questions and Answers," Fact Sheet, 2004.

Planned Parenthood, "Nonoxynol-9—Benefits and Risks," Fact Sheet, 2004.

Planned Parenthood, "Screening for Chlamydia: A Cost-Effective Way to Promote Health," Fact Sheet, 2004.

Planned Parenthood, "The Truth About Condoms," Fact Sheet, 2004.

Planned Parenthood, "Your Contraceptive Choices," Fact Sheet, 2004.

Ramshaw, Emily, "Half of New HIV Patients in U.S. are Young People," *Seattle Times*, Aug. 8, 2004.

Reiss, Ira L., phone call, July 27, 2004.

Reiss, Ira L. and Robert Leik, "Evaluating Strategies to Avoid AIDS: Number of Partners vs. Use of Condoms," *Journal of Sex Research*, Vol. 26, November, 1989.

Reiss, Ira L. with Harriet M. Reiss. *Solving America's Sexual Crises.* Amherst, New York: Prometheus Books, 1997.

Reuters, "CDC: Rare Infection Could Surface in U.S.," October 29, 2004.

Reuters, "Study: Many Parents Unaware of Teen Sex," (Society for Adolescent Medicine study), Aug. 12, 2004.

Richtel, Matt and Michel Marriott, "Ring Tones, Cameras, Now This: Sex Is Latest Cellphone Feature," *New York Times*, September 17, 2005.

Rosenberg, Marshall. *Nonviolent Communication: A Language of Compassion.* Encinitas, CA.: PuddleDancer Press, 2002.

Schieszer, John, "Male Birth Control Pill Soon a Reality," MSNBC News, October 1, 2004.

Sherman, Alexa Joy and Nicole Tocantins. *The Happy Hook-Up: A Single Girl's Guide to Casual Sex.* San Francisco: Ten Speed Press, 2004.

SIECUS, "Issues and Answers: Fact Sheet on Sexuality Education," 2001.

SIECUS, "Public Support for Sexuality Education," www.siecus.org, 2004.

Stepp, Laura Sessions, "Study: Half of All Teens Have Had Oral Sex," Washingtonpost.com, September 16, 2005.

Stewart, Felicia, "Preface," in Robert Hatcher, et al., *Contraceptive Technology.* New York: Ardent Media, 2004.

Stewart, Felicia and Charlotte Ellertson and Willard Cates, Jr., "Abortion," in Robert Hatcher, et al., *Contraceptive Technology.* New York: Ardent Media, 2004.

Stewart, Felicia and Henry Gabelnick, "Contraceptive Research and Development," in Robert Hatcher, et al., *Contraceptive Technology.* New York: Ardent Media, 2004.

Stewart, Felicia and James Trussell and Paul F.A. Van Look, "Emergency Contraception," in Robert Hatcher, et al., *Contraceptive Technology.* New York: Ardent Media, 2004.

Strauziuso, Jason, "Teens Who Vow Abstinence Get Sex Diseases, Study Says," *Seattle Post-Intelligencer*, March 10, 2004.

Strossen, Nadine. Defending Pornography: *Free Speech, Sex, and the Fight for Women's Rights.* New York: New York University Press, 2000.

Taylor, Emma and Lorelei Sharkey. *The Big Bang: Nerve's Guide to the New Sexual Universe.* New York: Plume, 2003.

www.Teenwire.com, "Report: Access to EC Doesn't Increase Unprotected Sex," July 18, 2005.

Thomas, Bethany, "Textbook Debate in Texas Over Sex Education," MSNBC, July 21, 2004.

Thurber, James and E.B. White. *Is Sex Necessary? Or, Why You Feel the Way You Do.* New York: Harper and Row, 1929.

Tiger, Lionel. *The Pursuit of Pleasure.* Boston: Little, Brown and Co., 1992.

Townsend, Mark, "Oral Sex Lessons to Cut Rates of Teenage Pregnancy," www.observer.guardian.co.uk/uk, news story, May 9, 2004.

Trussell, James, "Contraceptive Efficacy," in Robert Hatcher, et al., *Contraceptive Technology.* New York: Ardent Media, 2004.

"The Truth About Sexual Pressure," *Seventeen*, September, 2005.

Warner, Lee and Robert Hatcher and Markus Steiner, "Male Condoms," in Robert Hatcher, et al., *Contraceptive Technology.* New York: Ardent Media, 2004.

Weaver, Jane, "Many in U.S. Playing a Risky Game of Sex," MSNBC.com, October 10, 2005.

Weill, Sabrina. *The Real Truth About Teens and Sex.* New York: Perigee Press, 2005.

Weinstock, Hillard and Stuart Berman and Willard Cates, Jr., "Sexually Transmitted Diseases Among American Youth: Incidence and Prevalence Estimates, 2000," *Perspectives on Sexual and Reproductive Health*, January/February, 2004.

Williams, Margery. *The Velveteen Rabbit.* New York: Doubleday, 1922.

Wilson, John. *Logic and Sexual Morality.* Baltimore: Penguin Books, 1965.

Women's Health Initiative Study, "Use of Birth Control Pill Lowers Risk of Disease," Reported by Marilynn Marchione in *Seattle Post-Intelligencer*, October 21, 2004.

Index

About the Author

Roger Libby, Ph.D., is an internationally recognized sexologist, social psychologist, sociologist and a board-certified sex therapist with a practice in Poulsbo and Seattle, Washington. He is the author of the illustrated humor book, *Sex from Aah to Zipper: A Delightful Glossary of Love, Lust and Laughter*.

For three years he hosted *The Pleasure Dome* on 99X in Atlanta, one of the largest alternative rock stations in the U.S., developing a huge young adult following. He is currently undergoing negotiations to restart the show nationally.

Dr. Libby received his Ph.D. from Washington State University, his M.A. from the University of Connecticut, and his B.A. from Western Washington University. He also completed a post-doctoral fellowship at the University of New Hampshire.

Currently, Dr. Libby is an adjunct professor and a distinguished lecturer at the Institute for the Advanced Study of Human Sexuality in San Francisco. He has held academic appointments at The University of Massachusetts, Syracuse University and The University of Georgia, and he originally was a high school English and journalism teacher in Pasco, Washington.

He is a fellow of The Society for the Scientific Study of Sex, a charter member of the International Academy of Sex Research, and a member of the American Association of Sexuality Educators, Counselors and Therapists. Dr. Libby is board certified by The American Academy of Clinical Sexologists, The American Board of Sexology and The American College of Sexologists.

Dr. Libby has been widely published, including a college textbook, *Sexual Choices*, which received the Book-of-the-Year Award from the American Nurses Association. He is co-host and co-script-writer for the original version of the *Better Sex Video Series*. Dr. Libby has been a featured sex expert on national television and radio shows, including *The NBC Nightly News*, *CNN News Night* and *The Oprah Winfrey Show*.

Roger Libby can be contacted for campus-wide and other guest lecture appearances or personal consultations at www.drrogerlibby.com.